Francisco Asensio Cerver

WATERCOLORS
for Beginners

Ramón de Jesús Rodríguez Rodríguez (text)
Vicenç Badalona Ballestar (illustrations)
Enric Berenguer (photography)

KÖNEMANN

Copyright © 1999 Könemann Verlagsgesellschaft mbH
Bonner Straße 126,
D-50968 Cologne

Original title: Acuarela
Managing editor, text, layout and typesetting: Arco Editorial, S.A.

Translation from Spanish: Harry Paul Carey
English language editor: Peter Starkie
Project coordinator: Kristin Zeier
Cover design: Peter Feierabend, Claudio Martinez
Production manager: Detlev Schaper
Printing and Binding: Neue Stalling, Oldenburg
Printed in Germany

ISBN 3-8290-1931-9

10 9 8 7 6 5 4 3

CONTENTS

Materials

THE MEDIUM

The watercolorist does not require much in the way of materials to paint, but in as delicate a medium as watercolor the few items you do need are of fundamental importance. This section is concerned with the basic materials used in watercolor painting. Their use will be explained in detail throughout the pages of this book. It is indispensable to become acquainted with the quality of the materials, and accessories without which many effects and techniques cannot be achieved.

Watercolor painting, just as its name indicates, is based on water. The watercolor medium mainly comprises arabic gum and color pigments.

Watercolor paints are sold in solid or liquid form. Solid color must be wetted in order to soften it so that it can be loaded on the brush; the liquid paints, which are creamy in consistency, also require water for painting with, but they dilute much more easily.

THE BEGINNER'S PAINTING KIT

To get started in watercolor does not require a lot of materials. A little paintbox, a brush and paper are enough. These first items should be selected with great care. You will find an abundance of materials to choose from in your local fine arts store: a fact that can create confusion.

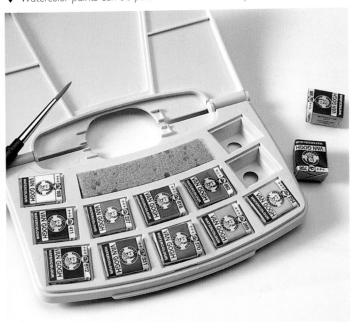

▼ *Watercolor paints can be purchased in tubes or in pans.*

You only need a brush, a glass of water, a piece of paper and, of course, a paintbox to get started in watercolor painting.
▲

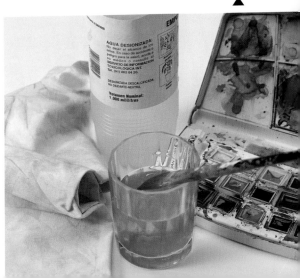

WATERCOLOR PAINTS

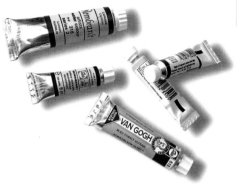

Watercolor paints come in a wide variety of sizes and qualities. The cheapest types are so-called school paints. If you really want to learn how to paint with watercolors, these paints should be automatically excluded, since they will not produce good results. The most recommendable for the beginner are medium quality paints, regardless of whether you buy tubes or pans. These paints are manufactured by well-known brands and allow all manner of painting styles.

Tubes of watercolor paints.
*This option is recommended
once beginners have acquired
experience and know how to
use the colors of their paint-
boxes. Tubes of paint are sold
in a variety of sizes, depending
on the manufacturer.*

Paintboxes with moist colors in pans. ◄
*This choice of watercolor is a question
of taste. Dry colors require more work
to paint with than moist paints. Moist
colors are more convenient because
they are ready to paint with.*

▶ *Paintbox containing
tubes of watercolor
paint. Paintboxes nor-
mally contain a com-
plete range of colors,
although they may be
minimal. The lid of the
box can be used as a
palette. This paintbox
has a medium range,
highly recommended
for the beginner.*

PAPER

Whereas other pictorial media can be painted on all manner of supports, watercolor can only be applied on paper. Nonetheless, watercolor cannot be painted on any type of paper. This medium requires a paper support with special characteristics. The right weight of paper, and thus its density, is fundamental. Another essential factor to bear in mind is the degree of absorption of the paper which depends on how it has been sized. The grain of the paper determines its smoothness; fine-grain paper is smooth, while coarse-grain paper has a rougher surface. The most commonly used paper in watercolor is medium-grain paper, which weighs about 250 grams per square meter.

Among the most widely used watercolor pads are the type which come glued on all four sides so there is no danger of it wrinkling when it is painted on. The sheets must be separated with a knife.

▼ *Watercolor drawing pads. This is one of the most convenient types of paper. As a general rule, the cover of the pad indicates its characteristics. We recommend you use semi-rough paper for painting in watercolor (the heavier type). There is a wide variety of formats and sizes of pads on the market; the smaller type are ideal for traveling with and painting sketches; the larger sizes are used for full-size watercolor paintings.*

◀ *Handmade paper. Handmade paper is normally of the highest quality, and therefore it is usually reserved for very special work.*

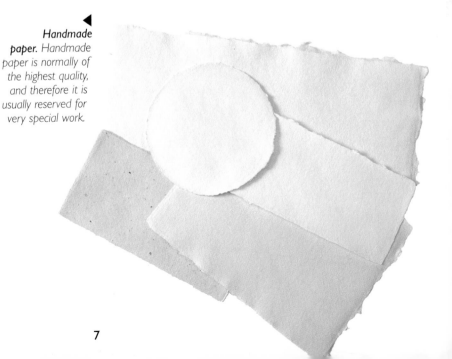

▼ *Brand-name paper. Manufacturers who specialize in drawing and watercolor paper normally produce various qualities and thicknesses. These sheets usually have a watermark or a stamp in relief on each sheet. This type of paper is sold in units, although these manufacturers also produce pads or blocks of paper.*

WATERCOLOR BRUSHES

If such importance is placed on the color and paper, this must also be the case with the brush. Watercolorists are the most demanding artists when it comes to the quality of the brushes they use. Watercolor requires special brushes. The main requirements of a good watercolor brush are its capacity of absorption and retention of water; flexibility to respond to the slightest pressure; and spring, meaning a brush that resumes its initial shape and a perfect tip regardless of how hard it has been applied to the paper.

SUITABLE BRUSHES

The painter does not need many brushes to paint in watercolor. This is because a single brush can be used in a variety of ways.

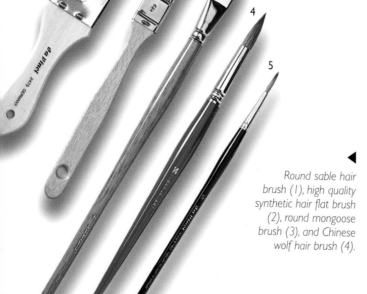

▲ This selection of brushes is appropriate for watercolor painting: A number 40 paintbrush (1), a number 9 paintbrush (2), a number 17 flat brush (3), a number 14 round brush, a number 5 round brush (4).

PARTS OF THE BRUSH

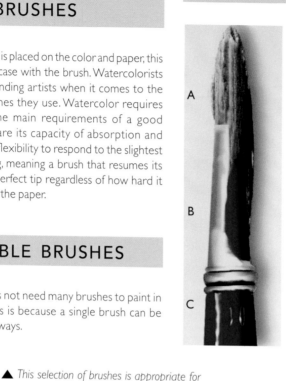

Since watercolorists demand quality brushes, they should be aware of the different parts of this implement.

▶ **A. The Hair.** *It may be synthetic, hog bristle or mongoose hair, the latter being the highest quality. The hairs must form a perfect tip. The hair is attached to the handle and is held securely together by the ferrule.*

B. The Ferrule. *This is the metal band that keeps the hairs firmly attached to the brush. It should be chrome plated and made in a single piece. The shape of the ferrule is what determines the shape of the brush.*

C. The Handle. *Since the handle is made of wood, it is indispensable that it be of high quality. The reason for this is that brushes are often submerged in water and are thus exposed to the consequences of its action. The handle should be varnished, painted or lacquered. High-quality brushes are given anti-dampness treatment in order to protect the wood from peeling or rotting.*

THE SHAPE AND SIZE OF THE HAIR

The shape of the hair is usually either round or flat. Round brushes allow fine strokes, even when the hair is thick; flat brushes allow thick or fine lines, depending on how the brush is applied to the paper.

◀

Round sable hair brush (1), high quality synthetic hair flat brush (2), round mongoose brush (3), and Chinese wolf hair brush (4).

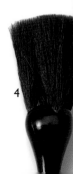

CARING FOR AND CONSERVING BRUSHES

Watercolor brushes are extremely delicate. There are several rules that the artist should bear in mind in order to use, care and preserve these precious implements. Above all, you must always regard the brush as a priceless precision instrument; a well-cared for brush will not only last many years, with time it will adapt to the hand of its user. Always remember that it is easy to damage an expensive brush.

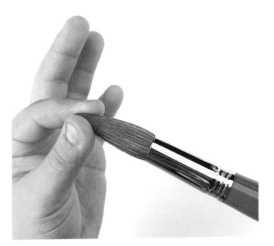

▶ Round brushes are sold with a transparent tube to maintain their shape. It´s a good idea to keep the tube for later use. The brush should always be dry before you place the tube over the hair. If you don´t follow this rule, you could destroy a very expensive brush.

▼ New watercolor brushes are sold with the hair glued together in order to maintain the form and keep the hair rigid. The hardness is removed by wetting the brushes in clean water just before you begin painting. Never try to force the tip with your fingers while it is still glued together; doing so could irreversibly deform the brush.

A PIECE OF ADVICE

If your brushes are going to be left unused for a considerable period of time, the best thing to do is to store them wrapped up with camphor balls. This will keep insects at bay and thus preserve your brushes from attack.

Brushes can be carried very easily by rolling them up in a type of mat. This highly useful item allows you to gather up and store your brushes very quickly and conveniently.

▲

◀ Brushes are easy to clean under the tap, but when you want to give them a thorough clean, just put a little soap in the palm of your hand. Having washed them, rinse and drain out the excess water.

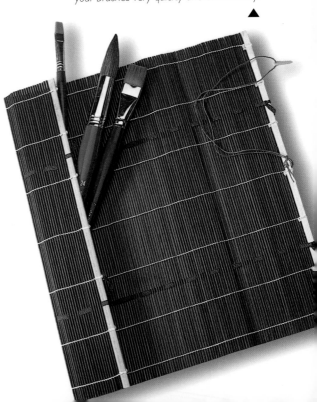

Materials

TESTING YOUR BRUSHES

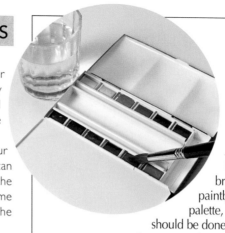

Once you have the necessary materials for painting with watercolors, you should try them out on a sheet of paper so as to see and practice the different results that can be obtained with them.

Place a color on the palette and use all your brushes in order to see the type of stroke that can be obtained with each one of them. First wet the brush in clean water and rinse it. Now load some color on the brush by turning it around on the palette to impregnate it with enough color.

MATERIALS REQUIRED FOR THIS EXERCISE

To carry out this simple exercise you will need everything that has been mentioned up to this point: several sheets of watercolor paper of various brands and qualities, round brushes (thick and thin), a flat brush, and wide paintbrushes; a paintbox with a lid that doubles as a palette, and a glass of water. The test should be done on fine-grain paper, medium-grain paper, and coarse-grain paper.

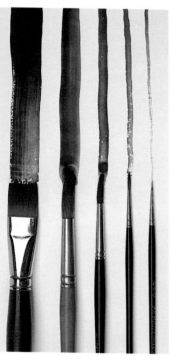

▶ This exercise is carried out with each one of the brushes. Make sure you load each brush with as much paint as it can absorb. First paint a line with the widest paintbrush; then apply strokes with the other brushes from the widest to the thinnest. Of course, it goes without saying that the finest brushes absorb less paint than the wider ones.

HOW TO LOAD COLOR

Place a little paint on the palette. This should not pose a problem, although there is a slight difference between paint in a pan and liquid paint from a tube. Once the paint is on the palette, load the brush. This is carried out in the same way, regardless of the type of watercolor paint you are using.

If the watercolor paints are from a tube, apply a little more pressure on the surface in one of the corners or near the edge of the compartment of the palette in order to be able to work comfortably with the brushes. In this case, a porcelain palette with compartments is necessary.

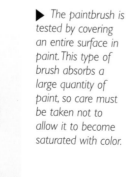

▶ The paintbrush is tested by covering an entire surface in paint. This type of brush absorbs a large quantity of paint, so care must be taken not to allow it to become saturated with color.

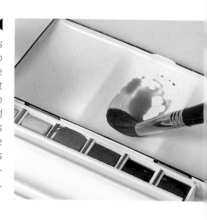

If the watercolor paint comes in a pan, it must be picked up with a clean wet brush. Make sure the brush is merely wet and water does not drip from the brush. The brush is passed over the paint until it softens and soaks into the hair of the brush. Once you have done this and the paint is in a compartment, you are ready to paint.

FINE-GRAIN PAPER

This type of paper is not especially suited to the watercolor medium, nonetheless it can be used for works that require a specific degree of detail. The virtual lack of texture of fine-grain paper prevents the brush from depositing paint on the paper. Very thin paper should also be avoided, since it wrinkles easily.

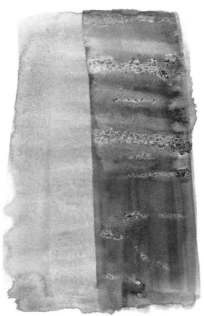

This is what happens when watercolors are applied to low quality paper and paper that has very little grain. The color does not spread well and the paper wrinkles.

MEDIUM-GRAIN PAPER

This is the most commonly used paper for painting with watercolors. It has enough texture to allow all manner of work, from the most delicate to the freest and most expressionist. As a rule, most watercolor pads are sold in this type of paper.

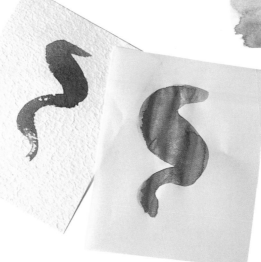

▶ *This type of test is very easy to do. Take two pieces of different paper and paint a similar stroke over each one. In this case, use very thin fine-grain paper and a coarser one. Now paint almost identical lines on each paper. The paint on the fine-grain paper collects in pools and the paper wrinkles; the paint on the medium-grain paper spreads evenly over the surface without the slightest alteration.*

This exercise demonstrates the degree of absorption of each paper. Paint similar strokes on the three papers. Note how each paper responds in a different way to the applied paint. ◀

COARSE-GRAIN PAPER

This type of paper has a lot of texture and is only used in special paintings. Coarse-grain paper is only made in large sizes sold in a specific weight. Many manufacturers produce this type of paper by hand or partially by hand.

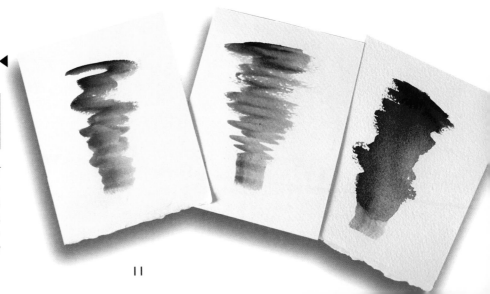

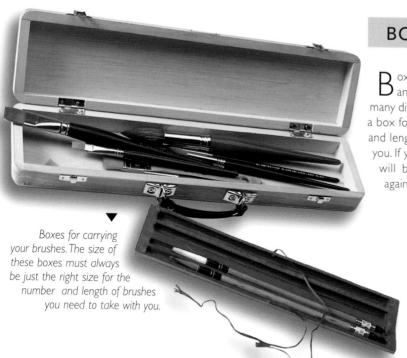

BOXES FOR BRUSHES

Boxes for brushes are handy both for carrying and for preserving your brushes. There are many different sizes of boxes. When you purchase a box for your brushes, bear in mind the number and length of brushes you will want to take with you. If you put too few brushes in a big box, they will become damaged every time they roll against the wooden walls.

▼ *Boxes for carrying your brushes. The size of these boxes must always be just the right size for the number and length of brushes you need to take with you.*

RECIPIENTS FOR THE BRUSHES

There should be many household items you can use, including those that contained food, such as a yogurt pot or a jam jar.

Keep a variety of empty containers handy for watercolor painting.

PLASTIC BRUSHHOLDER

This type of jar is ideal for holding the brushes or water. A white plate makes a handy palette.

▲

This is a relatively new invention. Because it can be sealed hermetically and carried with the brushes in water without touching the bottom, this holder is especially useful for painting outdoors. It can also be used in the studio thanks to the grips which keep the brushes securely fastened so that the tips do not touch the bottom and the wooden handles do not get wet.

▶ *This plastic holder can be hermetically sealed so that the brushes are suspended by the handle and do not touch the bottom.*

STUDIO AND OUTDOORS

Watercolor is an ideal medium for painting outdoors or in the studio. We recommend you paint in the open air as much as you can; painting outdoors is much more fun. As you may imagine, painting outside the studio requires other materials in addition to those used in the studio.

PALETTEBOXES AND PALETTES

The main advantages of the palettebox is that its lid doubles as a palette and that the colors can be used without the need to clean the recipient after the session. Regardless of the type of color you paint with, palettes are far more convenient for use in the studio rather than outdoors.

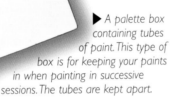

▶ *A palette box containing tubes of paint. This type of box is for keeping your paints in when painting in successive sessions. The tubes are kept apart.*

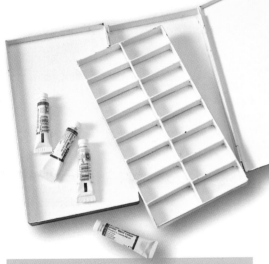

▼

These palettes are normally made of porcelain in order to make them easier to clean. They are useful as long as they don't have to be carried around. A white plate is a good option, as well as this type of palette with mixing wells.

PORCELAIN PANS

Although these large pans are generally only used in a studio, they can be painted with in the open air. They tend to be high quality colors; the shape of the pan is specifically designed to support the brush.

OUTDOOR BOXES

Miniature boxes are a delight to many an artist. Despite their smallness, the quality of the colors can be exceptional. These tiny boxes, with the colors included, tend to be the best choice for painting all manner of work.

This truly marvelous palettebox contains all the necessary materials for painting with watercolor. There is even a water container and a small tray for wetting the brush. Once you have finished painting, the compartments fold up into a box that fits into the palm of your hand.

▲

▶ *Porcelain pans. These are best for studio use. Their size makes them inconvenient for carrying and handling with ease.*

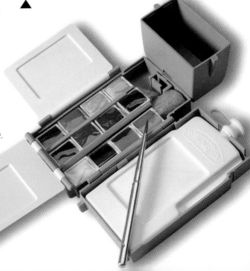

SUPPORTING THE PAPER

The paper has to be attached to a rigid support. This provides a firm surface over which smooth lines can be painted. When paper is wetted with color, it tends to wrinkle. Therefore it is essential to fasten the paper down at all four corners in order to prevent any creasing.

The paper should be attached to a rigid surface. The best support is a piece of board or wood. The paper must be fastened down at all four corners before the artist begins painting; this way, the paper won´t crease or warp when the paint is applied on top. The following is a list of accessories that are used for the purpose of attaching the paper. (1), adhesive tape (2), three-pointed thumb-tacks (3), thumb-tacks with a large head (4), or clips (5). The latter are good for attaching the paper to a folder, so long as the paper is as big as the folder itself.

▲

FOLDERS

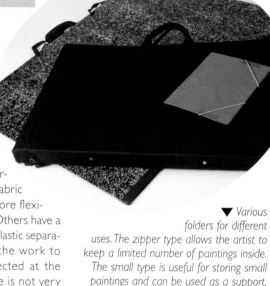

There is a wide variety of folders to choose from, all of which are as practical as they are aesthetic. The simplest folders are made of rigid cardboard and have a corner piece made of fabric that makes them more flexible at the opening. Others have a zipper and contain plastic separators, which allow the work to be seen and protected at the same time. This type is not very appropriate for outdoor work, since they are too pliable and as a result it is difficult to place a piece of paper on them.

▼ *Various folders for different uses. The zipper type allows the artist to keep a limited number of paintings inside. The small type is useful for storing small paintings and can be used as a support, although it deteriorates easily. The simple cardboard folder is a good one to have because the paper can be easily attached to the surface with thumb-tacks.*

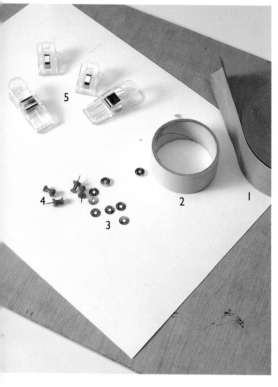

STRETCHING THE PAPER

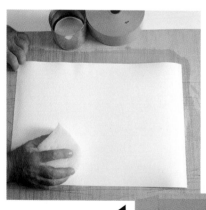

This is a relatively simple process to carry out. When done successfully, the result is a sheet of paper that will not wrinkle when you are working with abundant water.

▶ *1. Place the paper on a wooden support and wet it with a sponge.*

◀

2. Once the paper is soaked, apply the waterproof adhesive tape round the edges. Once the paper has dried, it is stretched as if it were the skin of a drum. Once you have finished painting, cut round it with a knife.

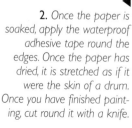

OUTDOOR EASELS AND TABLETOP EASELS

The easel is one of the artist's most important tools. This accessory allows the paper to be supported at a certain height and inclined according to the artist's taste. There are many shapes and sizes of easels. Here you can see some of the most practical.

Since watercolor requires water, when the artist has to apply color over the entire surface of the paper, it is essential that the paint is spread evenly. The fact that painters work on a practically vertical surface allows them to cover the surface by using gravity.

◄ *The easel keeps the paper in a vertical position, which is far more convenient and stable than painting over a flat horizontal surface such as a drawing pad.*

TABLETOP EASEL

It is small, but very useful for painting in the studio. The table easel is slightly bigger than a notepad and can be used with various formats, large ones included.

▶ *A folding easel (1) and a tabletop easel (2). These can be used in the studio, but the metal one (1) is highly convenient as an outdoor easel.*

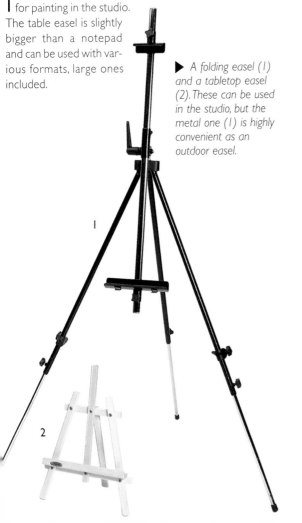

1

2

OUTDOOR BOX-EASEL

When the painter is used to working in the open air, there is nothing better than a box-easel. Although somewhat more expensive than the tabletop easel or outdoor easel, this implement is extremely versatile for the artist.

The box-easel, as its name suggests, is a box in which your paints and brushes can be kept. This easel has three folding legs, which can be adjusted to the desired height by unscrewing the wing nuts. To summarize, the outdoor box-easel provides the artist with a convenient portable studio.

▲

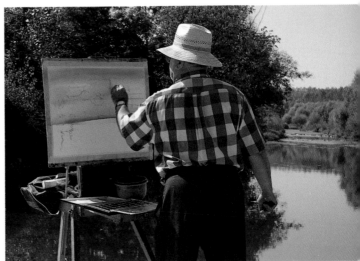

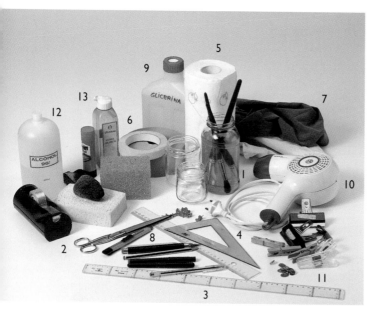

SUPPORT MATERIALS

Until now, we have shown you what the basic tools required for watercolor are. But once you have had some experience in this medium and want to take it one step further, other accessories are necessary. Most of the accessories used by the watercolorist in the studio are easy to find: many of them are everyday household items.

▶

Pots and jars for holding water, brushes and pencils (1).
Scissors and a utility knife for cutting paper, sponges (2).
Long and short rulers for measuring (3).
Set-squares for cutting paper at a right angle (4).
Roll of water-absorbent paper towels (5).
Adhesive tape and special adhesive tape for water (6).
Rags for cleaning and mopping up (7).
Pencils, pens; any kind of drawing material can be used in watercolor painting (8).
Arabic gum for sticking paper (9).
Hair dryer, for speeding up the drying process (10).
Thumbtacks and clips; for attaching the paper to the board (11).
Alcohol, which can be used to speed up the drying time of a watercolor painting (12).
Glycerine, which slows down the drying time of watercolor (13).

THE IMPORTANCE OF A STUDIO

The artist must have a corner which is exclusively dedicated to the painting. It can be a small room, a corner, an alcove or a niche in a back room. Light is a very important factor. A good window is ideal but, as this will not always be available, one will have to make do with adequate artificial lighting.

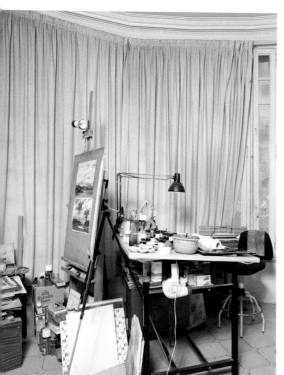

▶ *It is important that the painter adapts a corner of the home so that he or she can work at any moment, without setting up all the equipment every time that he or she wants to paint. The space does not have to be too big but it must be comfortable. The diverse tools always have to be at hand and neatly stored.*

USING A HAIR DRYER

The watercolor painter often superimposes colors. As yc will learn later on in this book, the artist does not usual want the underlying color to mix wit the superimposed one; the are where the painter wants t apply a new color ove another must b dry in order t prevent th two from blenc ing together.

▼ *It´s best to work with an old hair dryer, and not necessarily the one you use at home. Since abundant water is used in this medium, take care not to leave the dryer in any wet areas. Always unplug it after every use.*

1

Wash

COLOR AND WATER

A small amount of paint is placed on the watercolor palette. Watercolor paint from the tube is denser and more concentrated than solid colors, which are wetted and softened by running the brush back and forth across the pan. Once the color is on the palette, water is added with the brush. The more water you add, the more transparent the tone then appears.

▶ *You will find that paints from the tube are easier to place on the palette; pastel-form paint, on the other hand, must first be wetted until it is soft enough to be loaded onto the brush, and then be transferred onto the palette. Here we are using a porcelain palette, although the painter can also make do with the lid of the paintbox.*

The first technique a beginner needs to know in order to get started in watercolor is the wash technique. The principle of watercolor painting is simple: all one needs to do is wet the brush with color and water and spread it over the paper. Before painting with all colors, we recommend you practice the basics of the wash technique with a single color. Once you understand the possibilities that this technique can offer, it will be much easier to try out more complex procedures. For the present, we will concern ourselves with one color, although in the examples reproduced in this section, we can carry out our tests with different colors, without mixing any of them together.

APPLYING THE COLOR

O nce the color is on the palette, a little is placed in a compartment. Then a little water is added with the brush in order to lighten the color.

First apply the color with a moist brush. Next the brush is washed in water and rinsed and the color is spread a little. A tone is made more transparent by adding water to it. By repeating this procedure, adding more water each time, you can obtain a gradation of the tone.

▲

GRADATIONS ON WET BACKGROUNDS

M oistening the paper before you apply color is the best way to execute gradations, but it is difficult to handle the color using this technique.

◀

Paint is applied where the gradation begins. Since the paper is wet, the color will spread much more easily. The more you extend the paint, the more transparent the color becomes.

◀

With a clean brush, you wet the area where you want to paint the gradation; in this way, the color seeps into the wet area, since wet paper allows the paint to spread on its own.

GRADATION TONES

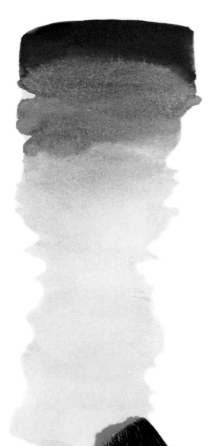

The wash technique is apparently simple: it mainly consists of loading some paint on a wet brush and applying it to the paper, "stretching" it out by adding ever larger amounts of water to obtain a gradation of the tone from dark to light. As the gradation becomes lighter, the tone becomes so light that it can barely be distinguished from the white of the paper.

▶ As we have just seen, the color on the palette can be extremely dark (more so if tube paint is used). The density of the color allows you to paint an opaque stroke that completely masks the color of the paper.

◀ In the same way we painted the previous gradation, we recommend you try your hand at this technique by first wetting the paper. The gradation on the left was painted on dry paper, the one on the right was applied over previously wetted paper. Note how different the results are. In future exercises we will show you how to use both techniques in a single painting.

▶ If you pass a clean wet brush over the previous application and stretch the color in zigzag form, the color lightens as the water from the brush mixes with it. If you clean and rinse the brush and repeat the procedure, the tone gradually becomes more transparent until it practically merges with the white of the paper. Later on we will demonstrate more complete and interesting possibilities.

◀ This landscape was painted with only one color. The different tones were obtained by adding more or less water to the original color in order to lighten it, as well as applying pure color in the darkest zones of the painting.

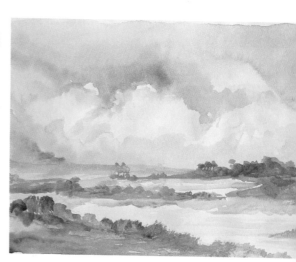

THE WHITE OF THE PAPER

The greater the amount of water added to the paint, the lighter and more luminous the resulting color is. The less water added to the paint, the more opaque it will be. Thus, it is easy to see that the color white does not exist in watercolor. It is represented by the color of the paper.

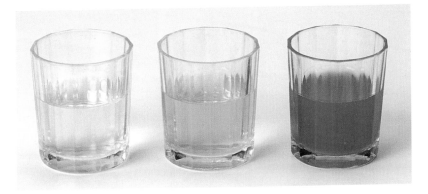

▼ *If you gradually add paint to a glass of clean water, it will become more noticeable, while at the same time reducing the water's degree of transparency. Exactly the same process happens with watercolor; the maximum degree of transparency reveals the white of the paper, while the most opaque color becomes less transparent, thus less luminous.*

Look at the beautiful snow-covered landscape in this example. This type of work requires great skill in the technique, but it is a good example to see the utility of transparency in watercolor and how diverse tones can be obtained from washes of different colors. The highlights and bright parts of the picture are always represented by the white of the paper. This is another reason why watercolors are not painted on colored paper. ▲

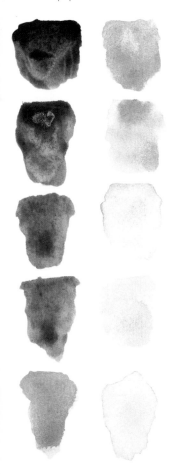

▼ *Add water to this darker tone; gradually add more water with the brush to lighten the tone. Note how the lightest tone is the most transparent. The color white is the color of the paper itself.*

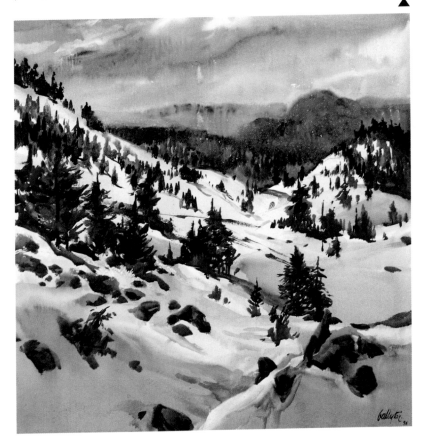

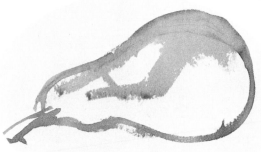

This short exercise is for practising drawing with a brush and gradating the color. It is not essential for your final result to resemble the one reproduced here. The main purpose of the exercise is to carry out the procedure and try to achieve a result akin to the example. All you need to concentrate on here is how to handle the brush in the same way you would a drawing instrument. In addition, just as we demonstrated in an earlier exercise, you will also attempt to gradate the model using a single color in order to study tones.

▶ 1. *First outline the shape of the pear; the line must be continuous and constant. Once the outline is closed, some paint is applied to the interior with a slightly more diluted application of the same color.*

▶ 2. *Continue painting the surface of the pear, but not all of it. The fragment that corresponds to the highlight is left unpainted. Before the color has time to dry, wet the brush and load it with a darker tone and paint the curve. Since the rest of the paper is still wet, the new tone quickly blends.*

DRAWING AND WASH

Despite the fact that wash is executed with watercolor, it is really a drawing technique. No matter whether you are experienced at drawing or not, you will see how closely wash is linked to drawing. The brush is used to apply lines in the same way one forms lines with a pencil.

Moreover, the gradation technique is similar to stumping or shading, progressing from dark to light using a single color. In both cases the artist can achieve a great number of tones.

In this example you can see how the wash technique allows the type of line akin to a drawing. Exercises of this nature are recommended in order to gain experience with brush and paint.

▲

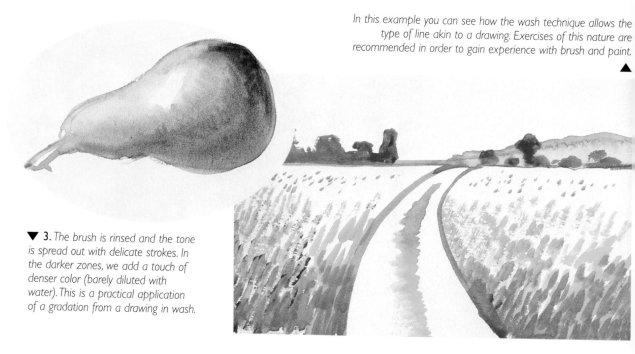

▼ 3. *The brush is rinsed and the tone is spread out with delicate strokes. In the darker zones, we add a touch of denser color (barely diluted with water). This is a practical application of a gradation from a drawing in wash.*

Step by step
Landscape with wash

Wash allows the artist to paint different tones of the same color, according to the amount of water that is added to the paint on the palette. If you have understood the previous exercises, the one included on this page should not pose any problems for you. Before you begin to paint, it is advisable to go back and review the theory explained up until now.

MATERIALS

Watercolors and palette (1), medium-grain watercolor paper (2), watercolor brushes (3), pencil, (4), adhesive tape (5), board for attaching the paper to (6), jar or similar container filled with water (7), and a rag (8).

1. *We are going to apply the basic notions that we have demonstrated at the beginning of this topic. We will go about this in successive steps in order to make it easy for you to paint this beautiful landscape. First we make a simple drawing in pencil; it does not have to be exact but it should be roughly correct. In the lower part of the paper, draw a straight line, on top of which you sketch the little house and the trees. Above these elements, draw a line to mark out the mountains and, slightly above that, draw the tallest mountains.*

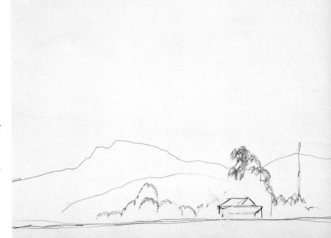

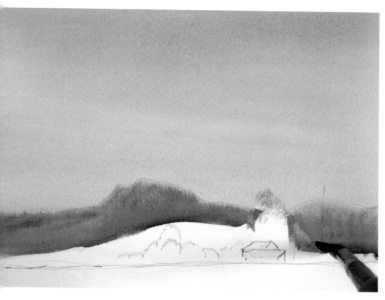

2. As you have seen at the beginning of this topic, you must gradate a broad area of the background. The entire surface of the paper is first wetted with a clean brush. Before it dries completely, load the brush with some sienna and draw a line on the top part of the paper. The dampness of the paper causes the color to spread out. The brush is then cleaned and run over the color to spread it; the procedure is repeated until the first gradation is achieved. Now dip the brush in a slightly darker tone and paint the mountains in the furthermost background.

The white areas of the painting must be left unpainted. If you want to reserve a white area, it should be wetted with clean water.

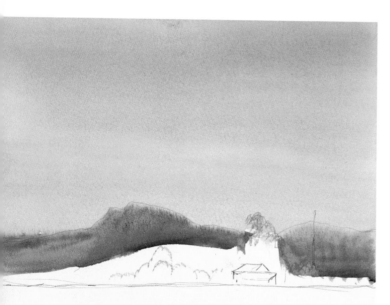

3. Pay attention to the steps carried out until now: first paint the sky as a gradation and then the mountains in the background. They were painted while the area of the sky was still wet. The tone has spread out from the outline in the sky.

Take care when you are measuring amounts of water with the brush not to load so much that it drips off the brush.

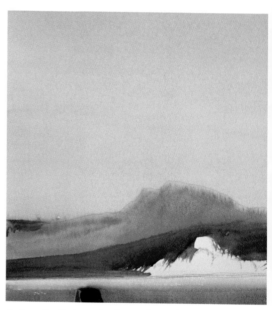

4. Load a little paint from the palette. This time your brush should only be damp, rather than wet, in order to paint a medium-dark tone. Now apply another stroke on the mountain; it is located on a closer plane than the former. This time, the background is much drier so the new tone does not blend with the previous one. Take care not to allow the paint to penetrate the areas reserved for the trees and the house. A long straight line is applied across the foreground.

5. *The work has been simple up to this point: it was no more difficult than choosing the color; the tone is lightened by adding more water or darkened by adding more paint. The drawing is the artist's guide to each area of the picture, something that you will continue to do as you progress with this painting.*
Now load a dark tone, almost without water, and paint the trees with the tip of the brush. Don't fill in all the reserved area; the upper part is left unpainted.

6. *With the same dark tone used in the last step to paint the trees in the center, the right-hand zone is painted; these dark areas are different to the previous ones. Here two dark tones have been combined. Outline the house with the same dark tone, leaving it unpainted.*

> The drawing is the foundation of a watercolor painting. It is used as a guide as to where to apply the various tones or colors. Therefore, it is essential that the artist draw the lines correctly before starting to paint.

7. *With the same dark tone utilized for painting the trees, heighten the contrast of the mountain on the right-hand side of the picture. Finish off the remaining trees on the right. Wait a few minutes for the paper to dry completely. Once it is dry, paint the little house with a very light tone, leaving the triangular form unpainted. Once again you must wait for the layer of paint to dry before going on to paint the darker tone of the shadows without their mixing or merging with the contours of the previous tone. The preliminary drawing allows you to paint with precision, since the lines indicate the limits of each area.*

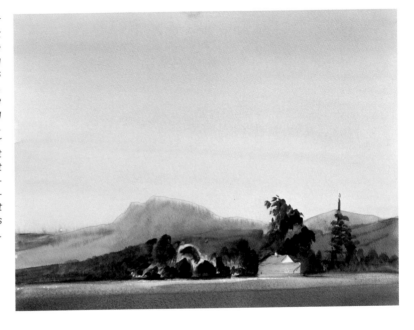

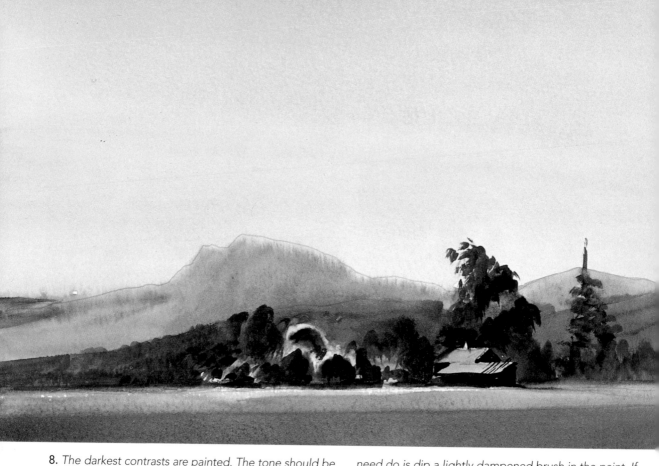

8. *The darkest contrasts are painted. The tone should be the closest you can get to applying the color without water. If you are painting with tube watercolor paint, there is no problem, since the paint is so creamy that all you* *need do is dip a lightly dampened brush in the paint. If, on the other hand, you are working with pans of tablet-form colors, you will have to be more persistent adding a little water, until you acquire the desired thickness.*

SUMMARY

The background was painted with a gradation. First the corresponding part of the paper is wetted. Before it has time to dry, a brush loaded with a dark tone is applied lengthwise across the paper. The brush is cleaned and then passed over the area in order to "spread" the tone.

If you paint when the **tone below** is not completely dry, the edges will blend together.

Very dark tones barely contain water. The brush must be dampened so that its hairs can absorb the paint and are able to glide across the surface of the paper.

A darker tone is painted with barely any water added to the color.

The whites are the color of the paper.

24

2 Color theory with watercolor

WASH WITH THREE COLORS

The three basic colors, also known as primary colors, are yellow, magenta and cyan. By mixing these three colors in different amounts you can obtain all the other colors. You can paint with the three primary colors without ever having to mix colors together. The pure colors are treated as if they were independent washes of three different colors. Nonetheless, this is not entirely true, since wash can only be made with one color or with a mix of two. This question will be examined later.

There are an infinite number of colors, but all of them are comprised of the three basic colors, the primary colors: yellow, magenta and cyan. By mixing two primary colors together we obtain secondary colors. All painters should understand how these colors behave when mixed together in differing amounts. Such knowledge allows the artist to obtain a good palette and ensures that the hues applied to the painting appear planned, rather than improvised.

▶ 1. *Place the three primary colors on the palette. Separate them in order to avoid mixing them together. First practice a simple exercise similar to the one we did in the last topic. You are going to gradate each one of the three colors in order to see the kind of tones each color can produce. Begin with the most luminous color, yellow. Dampen the brush, and load the color onto the hairs of the brush.*

2. *Gradate the yellow, the most luminous color of the three, since it is brighter and thus reflects the light. Gradate the other two colors, magenta and cyan, without allowing any of the three stripes to blend together. These three colors allow you to obtain a wide range of tones.*
▲

3. *The last part of this exercise involves painting a simple flower without allowing any one of the three colors to come into contact with one another. It is slightly difficult, since wet tones mix and change into other colors. So what are these colors produced by the mixes?*
▲

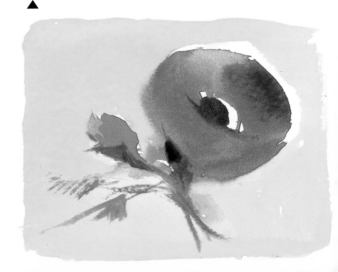

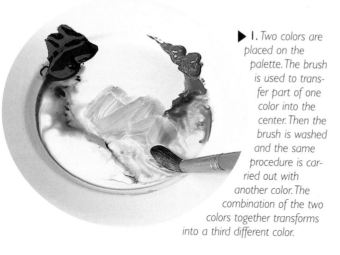

▶ 1. *Two colors are placed on the palette. The brush is used to transfer part of one color into the center. Then the brush is washed and the same procedure is carried out with another color. The combination of the two colors together transforms into a third different color.*

TWO COLORS IN THE PALETTE

By mixing two colors together you obtain a third color, but the pureness of the color depends on how much of each of the two colors are used. With a wash containing two colors the resulting color may be different to the two used to produce it. Equally, by gradating the color change, you can create intermediate tones that gradually take on the definitive color of the mix.

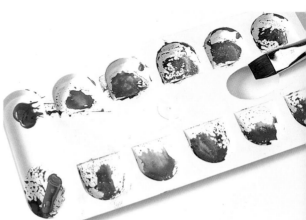

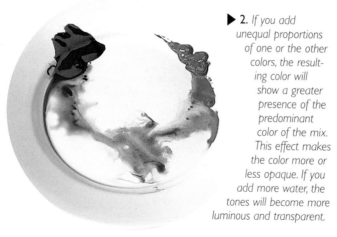

▶ 2. *If you add unequal proportions of one or the other colors, the resulting color will show a greater presence of the predominant color of the mix. This effect makes the color more or less opaque. If you add more water, the tones will become more luminous and transparent.*

▼ *From the mixes obtained on the palette, you can organize enormous palette from two colors, which, in reality, is far more complete since it comprises all the possible intermediate tones between the two colors and the intensity of each color according to its transparency on the paper.*

This in an interesting exercise to understand the transition from one color to another. Gradually add small amounts of the secondary color to the main color. The effect can be observed in each gradation.

3. *Here you have tested the colors on paper. The tones are never completely definitive on the palette; on the contrary, they look much better on the paper, since they can be seen as they really are, once they have dried.*

▲

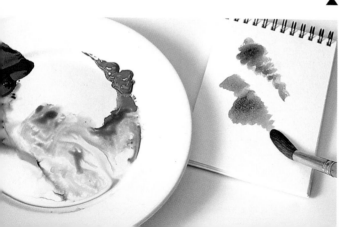

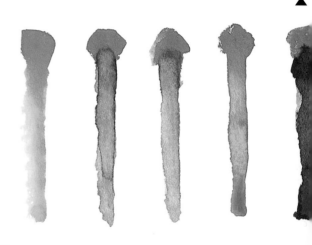

SECONDARY COLORS

Up to this point you have studied how to paint with one color, with two primary colors, and with a combination of two colors. When you mix two primary colors together, you obtain a secondary color. At first you may find the mixing of colors to be rather difficult, but with a little practice you will quickly master it. Try the exercises reproduced on this page and the theory will be better understood in practice.

▲

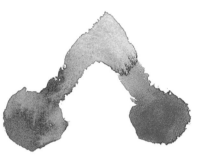

1. *The artist always requires two primary colors to obtain a secondary color. In this exercise, use the same colors that were employed in the previous exercise. This time mix the colors together in the center of the palette. A secondary color can only be obtained by mixing two primary colors together, so choose a combination of yellow and cyan which produces the secondary color, green.*

3. *By mixing the primary colors in different proportions you get secondary colors. Thus with only three colors you can obtain all the colors of nature. If you compare this flower with the one done in this topic (see page 25) you can see that the color combinations have produced a wealth of colors.*

▲

▼ 2. *You can practice obtaining secondary colors on the palette, but it is better to carry out the tests on paper. Reproduced here are three possibilities. The first is a mix of yellow and magenta which produces the secondary color, orange. The second mix of yellow and cyan gives way to green, another secondary color. Lastly, the combination of magenta and cyan produces violet, another secondary color.*

▶ 1. *First paint with one primary color, cyan blue, to begin this entertaining exercise. There is no need to wet the paper. Load the brush with color and apply several long vertical strokes. Then, at the bottom, paint short energetic strokes in zigzag fashion. Lastly, with a touch of paint -there is only a little paint left on the brush-paint the thin branches.*

FROM MONOCHROME TO CHROMATIC RICHNESS

B eginners should regularly experiment with their colors, both on the palette and on paper. The more mixes you try out, the more colors you will obtain. With your three primary colors you can produce a wide range of colors. This exercise will help you to consolidate what you have learned up to this point. First you learned to paint with one color; then you combined two to obtain a third color; finally you learned how the three primary colors can be mixed to obtain all the colors of the rainbow.

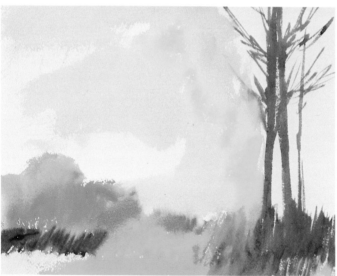

▶ 2. *Straight away, so as not to give the cyan paint time to dry, load some yellow and paint the background. The contact between the two primary colors produces a secondary color in the area of the grass and the areas where the color dampens the blue branches. A broad patch of magenta is painted on the left-hand side. Paint yellow around this color, applying more quantity in some areas and less in others. The result of the combination of magenta and yellow is a variety of orange tones, another secondary color.*

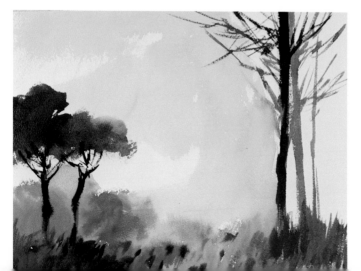

▶ 3. *Place some blue paint over the magenta on the palette. The result of this mix is another secondary color, violet. With the different tones of violet, paint the small trees on the left and darken the trunk on the right.*

Flowers with three colors

The best subject for a beginner to study color is a small bunch of flowers. The primary colors are yellow, cyan, and magenta. With these colors you can obtain all the colors of nature. The bunch of flowers we have chosen contains a great variety of colors and tones, but we are going to place three basic colors on our palette. Nonetheless, with a little concentration, we will obtain all the necessary colors for this still life.

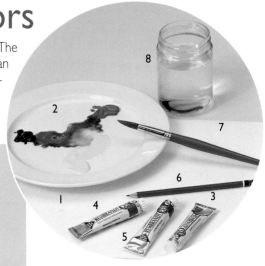

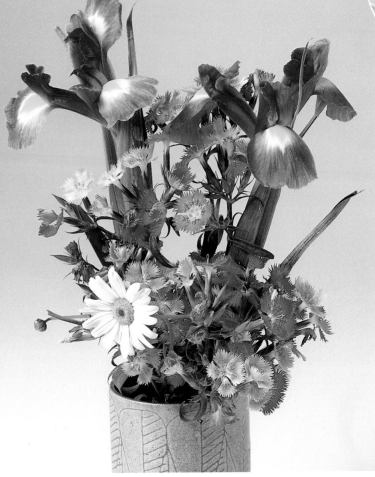

MATERIALS

Watercolor paper (1), white plate (2), watercolors: yellow (3), magenta (4), and cyan (5), pencil (6), watercolor brush (7), water container (8).

1. Draw the model as accurately as possible. Since watercolor is transparent, the drawing will provide you with a guide to the different areas of color. The drawing should not include shaded areas or too many details: it must be simple and concise, although each of the areas you are going to paint in must be indicated. Once you have finished drawing the subject, mix some blue and magenta on the palette. The result is violet which is used to paint the uppermost flowers. Use two intensities, one with abundant paint and little water, and the other one more transparent.

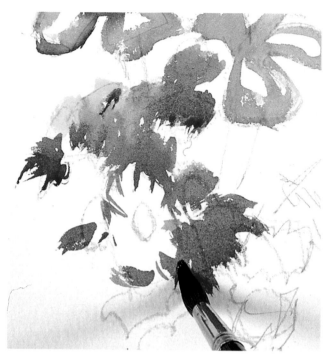

2. *Begin to paint the red flowers with pure magenta. The brightest and pinkest are painted with watered-down magenta. The darkest flowers are also painted with this color, but with less diluted paint. Since there is no white in watercolor, the color white is the color of the paper itself. Trace with your brush the shape of the daisy.*

Once the color has been mixed, it can be made more transparent on the palette by adding water with a brush.

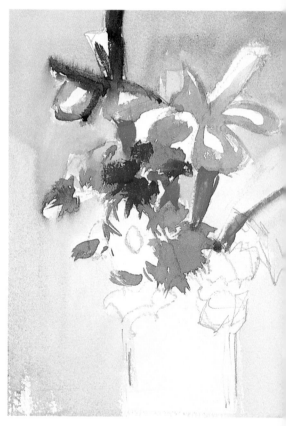

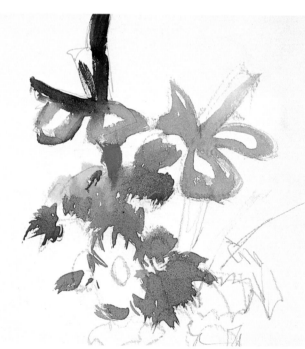

3. *A mix of yellow and cyan produces a yellowish green. To make the tone more yellow, add a smaller amount of blue. In order to control the proportions, always add dark colors to a mix in small doses to the light one of your combination. This way you can decide how intense you want the tone to be.*

4. *The combination of yellow and blue produces green. If you add a touch of red to this color, you obtain an orangy tone. The tone is first watered down and then used to paint the background. Remember to allow the previously applied color to dry first, otherwise the two colors will mix together. When painting the background, do not enter the areas where light or very luminous colors are to be applied, neither should you touch areas reserved as highlights.*

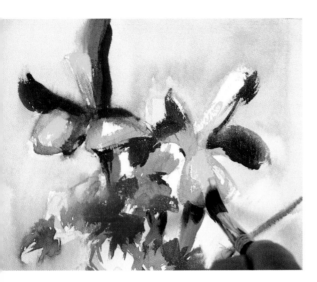

5. *In the same way as the violet was applied, now work with another tone, this time much darker. The best way to obtain such dense tones is to load the paint onto the brush straight from the tube. Here you are painting with a violet tone tending toward magenta. Use this tone to paint the uppermost flowers. Now, with a pure, not too diluted yellow, paint the flowers' lighter areas.*

The mixture of two primary colors produces a secondary color. Therefore, yellow mixed with cyan gives the color green. Yellow mixed with magenta gives orange. Magenta mixed with cyan makes violet.

7. *The stems and the leaves are painted with two tones of green, one very luminous tone in which yellow predominates, the other very dark and dense, obtained with more blue and a touch of magenta. From this, mixed with yellow, the various orange tones of the flowers in the lower area are obtained. First the orangy colors are painted; then before they dry, superimpose several magenta strokes that softly blend over the orange. Once again, with the violet mix obtained with magenta and cyan, paint the petals of the uppermost flowers. Now with almost pure magenta, barely watering it down, paint the darkest petals of the reddish flowers.*

6. *This is the palette that has been used up until now. Observe how the colors have been mixed. In the zone on the left you can see the green that has been used for the stems. On the right, on top of a blue tone, a yellow tone appears, in this case to make the green darker. In the center of the palette the much more liquid colors are placed. You can also see the colored edge of the plate. This is due to the number of times that the painting brush has been squeezed out.*

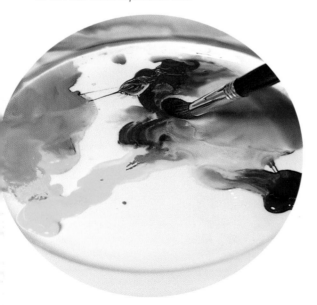

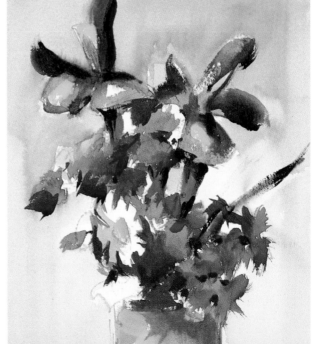

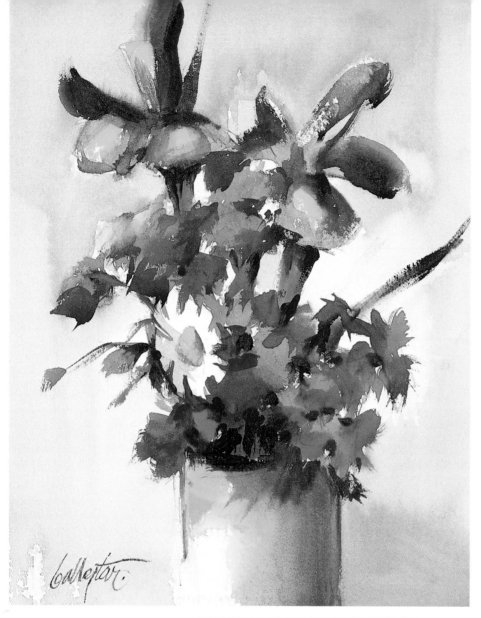

8. *Finish the lower parts of the flowers with magenta. It is necessary to paint another even darker tone over this one. Therefore on the palette mix a touch of blue with the magenta.*
In order to paint the jar, mix magenta and yellow, to obtain an orangy color.
Over this add a touch of blue; the mix becomes a more orangy color.
Using this color, paint a gradation from right to left, leaving the brightness unpainted.
You can now consider this floral subject, painted with only three basic colors, finished.

SUMMARY

The yellow is completely pure here. In order to avoid dulling it, it should only be applied once the underlying colors have dried.

Green obtained with a mix of cyan and yellow.

Orange obtained with a combination of magenta and yellow.

Luminous violet. First the violet was painted with cyan and magenta, after first watering it down on the palette.

Dark violet with a magenta tendency. It was obtained with violet and a greater amount of magenta. In order to avoid transparency, it has been mixed with very little water.

3

Color ranges

THE COOL RANGE

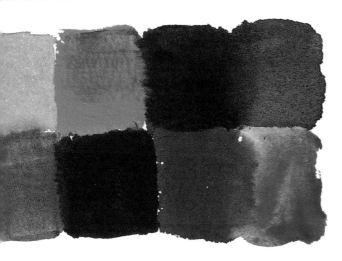

Depending on the chromatic "temperature," colors can be classified into ranges. A range is a group of colors that share certain characteristics and form a harmony. When you look at a monochromatic gradation, what you see is the tonal harmony of this color. If you put together two similar colors that contain some of the aforementioned color, we can be said to be building a chromatic range or harmony. To summarize, a color range is comprised of colors that are classified according to coolness, warmth or neutrality. The first are cool colors, the second, warm, while the last are called dirty or broken colors.

▼ *The cool range of colors encompasses everything that begins as a mix of yellow and cyan, from which an entire range of yellows, greens, and blues can be obtained. You can also add magenta to this mix in combinations that turn blues into violets. There is also the possibility of painting transparencies with this color range. It is essential to try some simple tests in order to understand the nature of the colors.*

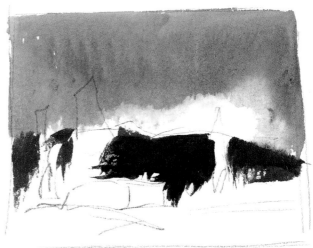

You can mix together colors from different color ranges. For instance, a warm color range can include green in order to obtain yellowish greens or warmer greens by means of mixes.

◄ *1. The area of this landscape corresponding to the sky is painted with blue and green. The clouds are left unpainted. The intermediate zone is painted with a very dark bluish violet.*

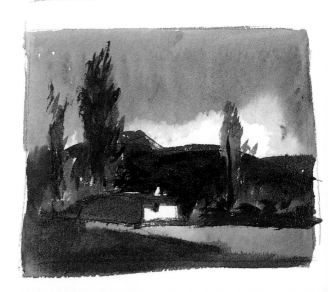

◄ *2. Paint the lower area with a watered-down green. Over this add various tones of cobalt blue; thus the foreground is significantly darker than the previous color. With the same blue, paint the trees and the wall of the house in shadow. In this way, all the luminosity of the paper is reflected. As you can see, in this example you have worked only with the cool range of colors. This is called the cool harmonic range.*

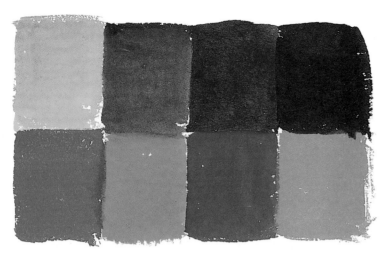

THE WARM RANGE

The warm range of colors comprises red, magenta, yellow and the mixes obtained from them. Therefore, you can include red in the range of cool colors in order to obtain violet. Likewise, you can also add a cool color such as blue to obtain a specific warm tone or to obtain a green of a warm tendency.

▶ *This is a good example of the warm range. The colors do not have to be pure, but they must always share a common harmonious factor. Even when green is used, the color does not appear excessively cool. Yellow is added and a touch of orange to tone down the contrast with the rest of the range. Colors from other ranges can be included with a warm range of colors, as long as they do not appear too dominant.*

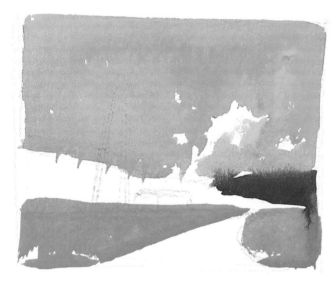

▶ *1. A combination of red and yellow produces a very luminous orange which is used to paint the landscape´s entire sky. On the right-hand side paint a sienna-umber tone. Earth colors form part of the warm range, although certain earth tones, such as green oxide, approach the cool range of colors. In the lower area apply green; but to continue with the warm range of colors, orange has been added. This results in a warm tone akin to ochre.*

Complementary colors are those of the chromatic circle that face or oppose one another. Complementary colors create enormous visual impact; examples of complementary colors are yellow and deep blue, magenta and green, cyan and red. These colors are used in all color ranges in order to achieve effects of contrast to reduce the monotony.

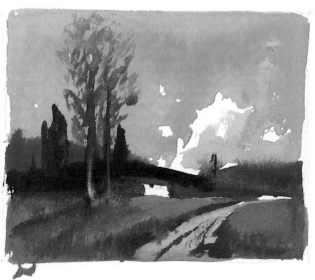

▶ *2. The background is painted with sienna mixed with red. Over this, paint an almost black tone that separates the focal planes, but the tree trunks are left unpainted. The path is painted ochre. Over the greenish tone, now apply a somewhat darker green, but without allowing it to appear entirely cool. In certain areas sienna is painted with the green to make it appear warmer. Lastly, the trunks are painted with dark colors of the palette. The treetops are painted with short, supple strokes of orangy green.*

BROKEN COLORS

A broken color is an undefined and "greyish" color. A broken color is nothing more than a "dirtied" color. Colors dirty when two secondary colors are mixed together or a secondary color is mixed with a primary color. This chromatic range is somewhat ambiguous and can include both the cool and warm ranges of colors.

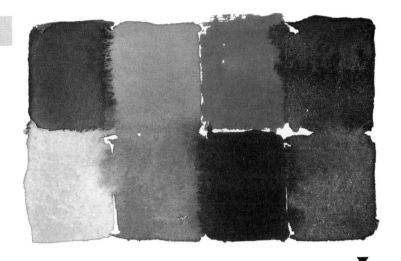

1. A simple exercise to practice painting with broken colors: With a violet "broken" with green you obtain brown. We make a pale wash and paint the sky. Add some sienna to red and use it to paint the strip in the middle, leaving the areas destined for other colors unpainted. You then produce a broken green stained with ochre; it is diluted on the palette and painted over the foreground.

Broken colors are obtained by mixing two secondary colors together. For instance, the combination of magenta and yellow produces orange. If a little green is added, you get a broken earth tone. Dark blue can also be broken by adding a touch of brown to the mix. Earth colors are ideal for obtaining broken ranges with watercolors.

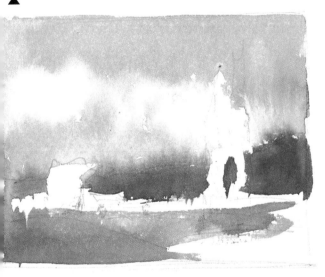

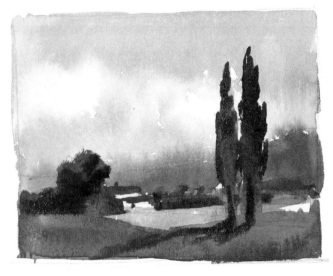

The top row of colors are those that create the color patches below. You can carry out this kind of test on the palette and on paper.

2. Give the paint time to dry before painting over it, without blending the two layers together. On the palette, the same green used before is now mixed with a touch of blue and a little slightly darker green. If the result is too clean, add ochre in order to break the tone.

Topic 3: Color ranges

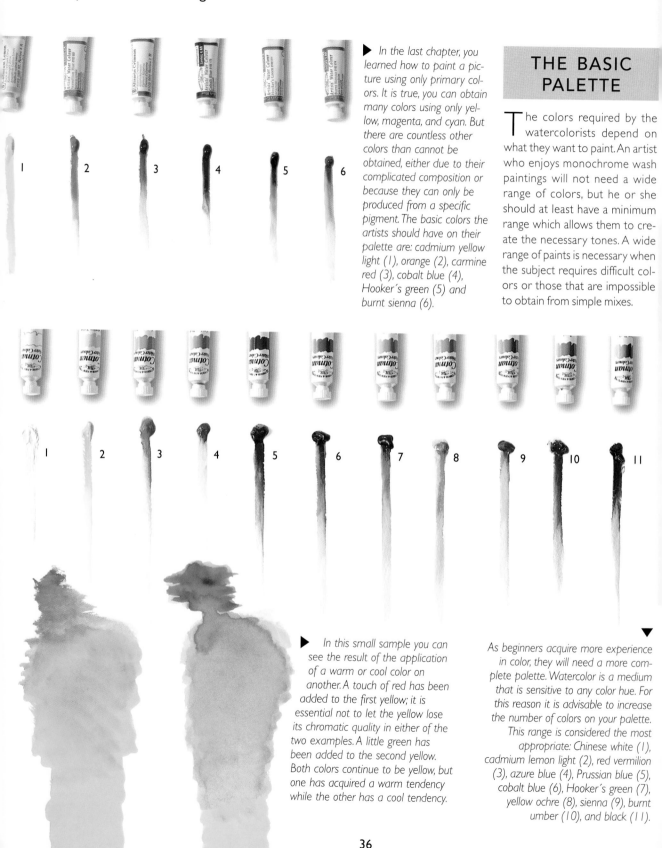

In the last chapter, you learned how to paint a picture using only primary colors. It is true, you can obtain many colors using only yellow, magenta, and cyan. But there are countless other colors than cannot be obtained, either due to their complicated composition or because they can only be produced from a specific pigment. The basic colors the artists should have on their palette are: cadmium yellow light (1), orange (2), carmine red (3), cobalt blue (4), Hooker's green (5) and burnt sienna (6).

THE BASIC PALETTE

The colors required by the watercolorists depend on what they want to paint. An artist who enjoys monochrome wash paintings will not need a wide range of colors, but he or she should at least have a minimum range which allows them to create the necessary tones. A wide range of paints is necessary when the subject requires difficult colors or those that are impossible to obtain from simple mixes.

In this small sample you can see the result of the application of a warm or cool color on another. A touch of red has been added to the first yellow; it is essential not to let the yellow lose its chromatic quality in either of the two examples. A little green has been added to the second yellow. Both colors continue to be yellow, but one has acquired a warm tendency while the other has a cool tendency.

As beginners acquire more experience in color, they will need a more complete palette. Watercolor is a medium that is sensitive to any color hue. For this reason it is advisable to increase the number of colors on your palette. This range is considered the most appropriate: Chinese white (1), cadmium lemon light (2), red vermilion (3), azure blue (4), Prussian blue (5), cobalt blue (6), Hooker's green (7), yellow ochre (8), sienna (9), burnt umber (10), and black (11).

36

Step by step
Landscape in warm range

The ranges of colors do not necessarily have to conform to those of the subject. When artists choose a certain color range, they use it to interpret the subject with the chosen color. In this exercise you are going to paint a simple landscape with a range of warm colors. Don´t rule out the possibility of using cool colors, but if they are included, they must never be predominant.

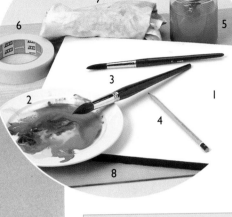

MATERIALS

Watercolor paper (1), paints (2), watercolor brush (3), pencil (4), water container (5), adhesive tape (6), rag (7), a support (8).

1. *As you gain more experience in watercolor, you will see how important the preliminary drawing is and how, without it, the watercolor paints would lack any support and guide. This subject is sketched with a pencil, although you can also use charcoal for the task. The drawing must be precise enough while not including unnecessary details.*

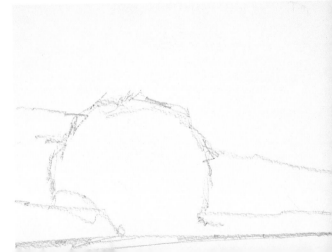

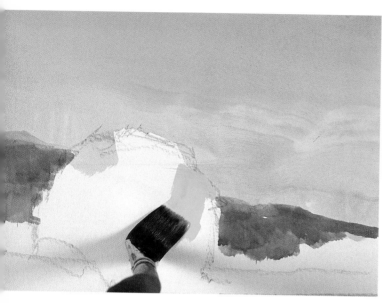

2. *First paint the entire area of the sky with a gradation, a technique explained in the topic on wash. Wet the paper, making sure not to touch the tree; and then apply the brush loaded with an orangy ochre tone in the top part. With long sweeping strokes applied from side to side, extend the color over the wet zone. Once the background has dried, paint the mountains on the horizon with sienna. Once this area has dried, the entire length of the tree is painted with cadmium yellow.*

Colors from other ranges can be included within a specific range. This serves as a complement and contrasts with the colors applied.

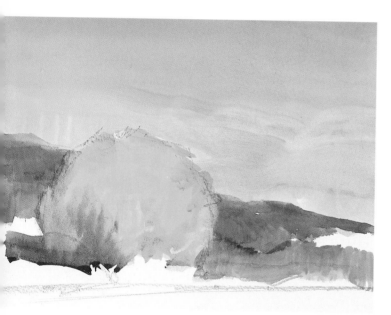

3. *A touch of green is added to the yellow on the palette, and is mixed until a slightly darker tone is obtained. Cadmium yellow is an intense color, which belongs to the warm range of colors; by adding a dash of green, the tone can be altered enough to paint several uncontrasted shadows. With a very luminous green, paint the vegetation at the edge of the road. Although this is not the definitive color, it serves as a base over which other warm colors can be applied.*

4. *With a barely damp brush loaded with a touch of very transparent sienna, apply abrupt strokes in the darker part of the tree. Continue with this work until part of the yellow base is removed. Now with magenta, sienna and a touch of blue, you obtain a very warm, violet tone which is used to paint the intermediate area. Since the underlying color is dry, the tones do not blend together. Now the green is almost entirely covered with this new warm, dark color.*

5. *A very transparent wash of sienna is applied and the white of the paper is tinted in all the lower part. This color nullifies any completely white brightness and will be the base for the other darker colors. With the violet which has just been used for the background, start to paint the shaded zone above the road. The color is the same as that used previously, but as the painted area is very bright, it does not seem so opaque. On the right-hand margin, orange is painted. This warm tone will be used as the background for the later darker colors.*

Drying of the watercolor can be speeded up with the help of a hand-held hair dryer. Do not place the tube so close that the drops of color run.

6. *With sienna mixed with umber, the darker contrasts are painted in and the umber tones in the landscape are increased. When the dark zones are painted, the highlights stand out more, due to the effect of the contrasts. The brushstrokes of the shadows lying underneath have to be wide and uniform. The brush drags the color horizontally. It must take a little bit of color with it every time it passes over this zone so that a gradation is not formed.*

7. *With a very bright orange somewhat tinted with umber, the painting of the top of the tree is continued. The new brushstrokes drag away part of the former sienna color and both are mixed on top of the paper. The trunks of the trees on the left are painted with sienna mixed with a little umber. The background should be completely dry so that the colors do not merge into one another. Observe how the color orange stays in the background. On the lower part of the road an ochre tone mixed with orange is painted. The most luminous strip is left unpainted.*

39

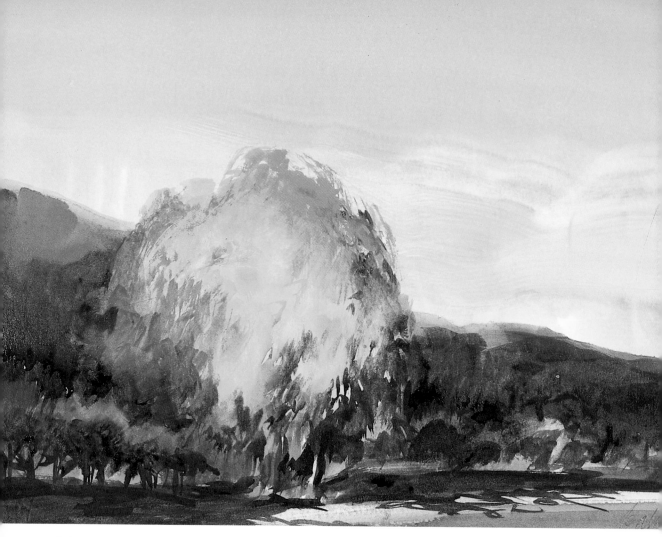

8. *It is necessary to wait for the painting to dry completely before applying the final touches. Once the background color is dry the right-hand side of the mountains are painted red, and on the left in a very dark marine blue. In the foreground the contrasts of the color of the road are made stronger with a sienna wash. With very dark violet brushstrokes a few lines are added to the base of the shadow of the trees.*

SUMMARY

Very **pure cadmium yellow** in the background as the base color to paint the tree.

Superimposition of **red** on the already dry background.

The color green with warm nuances. This color will be the base for later darker colors.

The sky has been painted with a very warm tonality in order to illuminate the whole landscape.

Blue has been used as a complementary color so as to compensate for the excess of warm colors.

A very luminous sienna wash is the brightest part of the road.

Wet on wet

THE IMPORTANCE OF PAPER AND WATER

The basis of watercolor painting is water. Water allows the paint to flow easily over the paper. In this topic you will focus upon precisely this characteristic, developing many of the artistic possibilities that this effect offers. Until now, when painting in watercolor, we have strenuously maintained that a brushstroke must be allowed to dry before applying another color or tone. In this topic, you will study the possibilities offered by applying or removing paint while the background is still wet.

▼ *The paper is highly important when working in watercolor, whether the painting is on a wet or on a dry background. Watercolor paint is transparent and so insubstantial that the papers texture remains visible. To paint on a wet background a proper paper is needed that will not buckle or wrinkle easily. Here, a test of three types of paper is made, similar in quality but differing in degrees of grain. As you can see, the brushstrokes and the degree of wetness have responded in distinctive ways.*

▼

Watercolor on a wet background allows all manner of techniques. Colors blend together and extend. With practice, these effects can be controlled. In this exercise, some of these characteristics are observed.

▶ *For this exercise, any brush can be used. The brush is dipped in watercolor paint just as before. Remove excess paint on another piece of paper or a rag. Delicate brushstrokes are made to observe the tracks of the brush. Later, with this same technique, using hardly any color, paint a tree, starting with the foliage. When all of the paint is used, load some more, again removing the excess and drawing in the trunk. With the brush practically dry, sketch in the earth. Here the brushstroke dominates, since the background is now almost completely dry.*

STRETCHING THE PAPER

Before beginning to paint with different watercolor techniques, it is helpful to learn how to stretch paper over a board. This will avoid the formation of pockets of colors, as well as assure that the wet paper does not buckle. Many artists use painter's tape or even thumb-tacks. The surest method of stretching paper is demonstrated here. The system is quite simple and practical, as you will shortly see.

2. Paper warps easily when wet, since its fibers swell. Pockets of color are formed precisely in this way. Paper deforms in an irregular manner, which produces internal tensions and contractions that usually translate into buckling and wrinkling. To avoid the formation of awkward pockets, wet the entire paper surface with plenty of water, using the sponge to smooth the water over the paper.

▲

▼ 1. To stretch paper, the only things needed are painter's tape, a drawing board, a sponge, water and, of course, the paper. Any paper can be stretched in this way, but a certain thickness is recommended so that it doesn't rip during the process.

Many artists attach the paper with thumb-tacks.

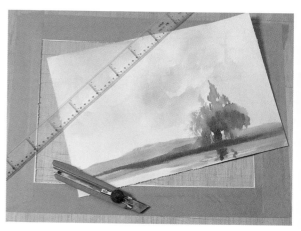

▼ 3. Wait for the paper to soak up the water. This will not take long; no more than one or two minutes. While the paper is still well, stick the four strips of painter's tape on each side of the paper so that it is fastened to the board. Wait until the paper is thoroughly dry before beginning to paint. It is not important if pockets form in the paper while it is wet. They will most certainly disappear when the paper dries, and its surface will be smooth and taut.

▼ 4. Once the painting is complete, you must wait for it to dry again. Then, a ruler and utility knife can be used to cut it away from the drawing board. To remove the painter's tape from the board, you only have to wet it again.

REMOVING COLOR FROM A WET SURFACE

Many effects are possible with watercolors. On a wet background, many changes and all types of techniques can be applied. In this exercise, you are going to develop a painting where the paint itself is not the main focus of the work, but instead the clear tones that can be made by absorbing colors with the brush. This exercise is very important for understanding the potential of gradations and as a base for opening up whites, which will be examined in Topic 7.

1. The entire background is painted in a dark tone. It doesn't necessarily have to be a gradation. The brushstrokes are vertical, covering the whole background with a uniform tone. This exercise will be carried out on a wet, but not thoroughly soaked base. If it is too wet, you will have to wait a while until it dries a little. With a dry brush, we begin to remove some of the color. When the brush passes across the wet paper surface, the hairs absorb the paint.

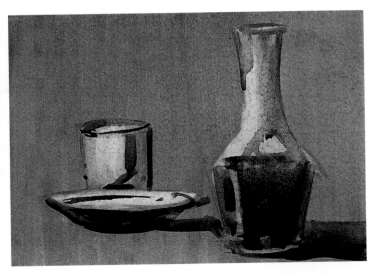

The quality of the paper has an important role in doing this example. A low quality paper would be dyed by the color and would never allow the complete absorption of the color.

3. In order to capture the brightest reflections, or, to put it another way, to obtain the whitest of whites possible, several passes with a clean and wrung-out brush must be made. For the final touches, the dark tones may be highlighted, but in this case the background must first be completely dry.

▼ *2. The pressure of the brush regulates the amount of color that is lifted off the paper. This is another way of creating gradations in tone over which another color can later be applied, or, as in this example, developing distinct planes. Each plane is an area of the painting. By drawing the brush over the paper, a sketch can be precisely drawn. The darker areas are established by accumulating some of the absorbed color at the edges of the brush.*

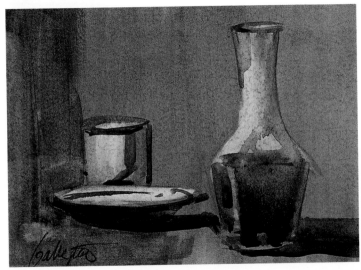

▶ **I.** *A wet shading can run and expand in various ways. Watercolor paint is extremely sensitive to any alterations in the wetness of the surface. In order to paint this area, it isn't necessary to wet the paper beforehand, but it is important that it be painted in a continuous manner to avoid possible breaks between the brushstrokes*

REDUCING THE WET COLOR

The colors that the watercolor painter must have will depend on the use to which he or she puts them. A person who enjoys painting monochromes will not need an extensive range of colors, just the minimum to allow the necessary tones to be displayed. An extensive range is necessary when the painting demands unusual colors or colors that are impossible to create with simple mixtures.

▶ **2.** *Since the background is still wet, a clean and dry brush may be moved across the paper to remove some of the color. The paper must be quite wet, but not to the extent that the paint itself runs. The procedure to remove paint is as follows: First, with a dry brush, remove all of the color that one stroke can soak up. Then, wash the brush in clean water, squeeze it out, and repeat the process. The more often a brush is passed across an area of the paper, the more the wet background becomes like the white of the paper.*

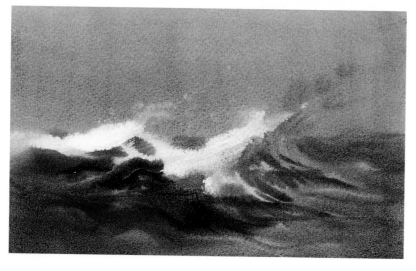

▶ **3.** *Once the necessary whites have been opened up, contrasts can be added to define the forms. This exercise is very simple but can provide various options for the work we have seen in previous sessions.*

Step by step
Landscapes. Opening up whites

In these first topics we have frequently emphasized doing landscapes, since the basic watercolor techniques practiced on this subject do not require as much precision, unlike still lifes or figure motifs. A landscape allows for a certain margin of error and subjectivity that, for other themes, would be too glaringly evident. This could, as a result, discourage the student-artist. In the following step by step process we are going to revise some of the ideas that you have studied before: the gradation and the opening up of whites.

MATERIALS

Watercolor paper (1), watercolors (2) and palette (3), watercolor brushes (4), pencil (5), water jar (6), masking tape (7), rag (8) and support (9).

1. *With a pencil, the principal areas of the landscape are drawn in, without sketching anything more than is strictly necessary. It must serve as the template for all the work to be performed in watercolor. The drawing must be plain, without shading or any other ornamentation; only the bare minimum so that you have a guide as to where the color is to be applied.*

2. In previous topics, you learned how to make color gradations. In this exercise, you will make another gradation to define the zone that corresponds to the area of the sky. Let's recap the procedure: first, we wet the area where you want the gradation. Before it dries, paint a wide horizontal band of blue along the top border of the paper. Since the background is still wet, the color tends to expand, and the brush helps this expansion along until the color is fused with the white of the paper. In the lower band of the sky, the process is repeated, only this time with a very light ochre color. Before this dries completely, a band of burnt sienna is added for the horizon line. When the lower area is dry, the objects on the ground can be painted without affecting the background.

> The paper must have the right weight and must be specifically for watercolor. Otherwise, the color will make a soggy patch on the paper surface and it will not be possible to paint.

3. The umber color is mixed with some blue to paint the band of the horizon, and a simple profile of the buildings in the background is sketched. Since the paper is still wet, this building will lightly blend with the recently painted horizon.

4. Colors that are painted in watercolor must follow an order; the lighter tones and colors are always painted first, and over these are painted the darker and more opaque colors. Watercolors can dry quickly if a hair dryer is at hand while they are applied. In this way a new color can be painted rapidly over a previously applied layer without blending or mixing the two. For the band of color that corresponds to the sea, a bright blue is applied. The areas of reflection are established by soaking up color from the paper with a dry brush, just as we did before. After this new background dries, a dark brown is painted to create the tree trunks.

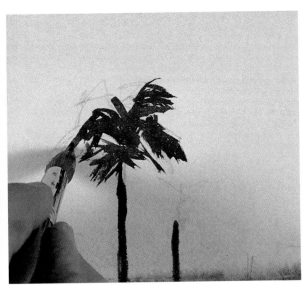

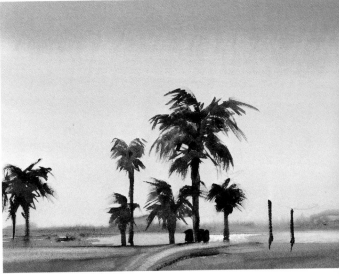

5. *With a dark green, paint the leaves of the palm-trees. Just a touch of paint is used, and work only with the tip of the brush, so that the lines can be precisely traced. It is fundamental that the drying time be respected when pure colors are painted, to ensure that they don't mix with the colors on the paper. In this example, the difference between the work performed on a wet surface (the sky) and that done over the now dry background can be perceived.*

6. *All of the treetops are now painted in the same way, including those to the left, which are painted before the tree trunks. This is done to take advantage of the color mixture. It doesn't matter if the trunks are painted later, since the sketch is still visible and the pencil lines provide us with a guide. In the area to the left, a small correction has been made over the still fresh background. The dark color has been absorbed by the brush and then repainted in an earth tone. The rest of the ground has been completed in similar tones. Now the dark bands of the railing and bench are added.*

> Watercolor paint can be removed from the paper with a clean brush. Wherever the brush touches the background, the wet paint is absorbed.

7. *Before painting the palm-tree trunks, paint the greenish tones of the sea. A dark blue is applied for a contrast with the area of the water in shadow. The long shadows of the palms are painted with a dark burnt sienna. The same color is applied to the right of the painting, slightly mixed with blue to establish the clarity of this new form. Run a dry brush across the form to remove some of the color, just as you did before, but without opening up the paper's white. Finally, paint the red of the railing.*

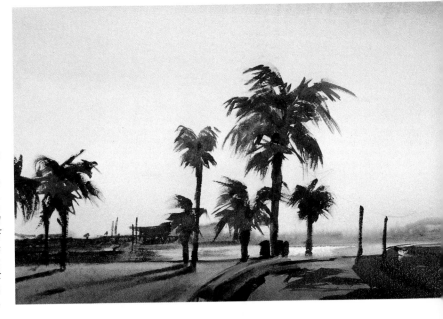

47

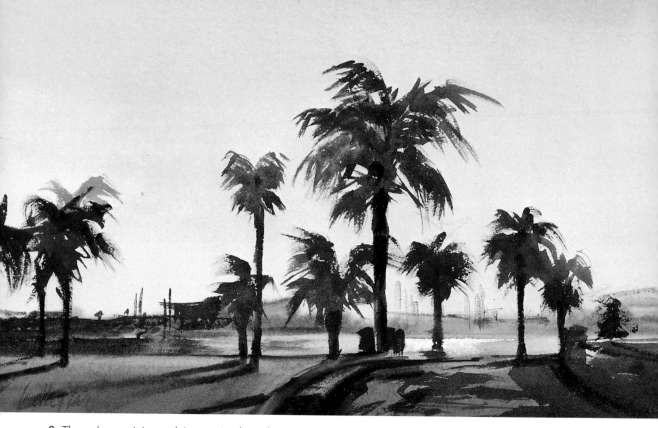

8. *The only remaining task is to paint the palm-trees with dark green mixed with burnt umber. Some palms are left bright while others are darkened. As you finish this simple exercise, you can see how you put into* *practice some basic lessons, such as correcting mistakes, working on a wet background and painting on a dry background; three techniques that we will develop in greater detail later on.*

SUMMARY

A gradation made on a wet surface. It is important to work with the support upright.

A lighter tone created by dragging the brush across the paper while the color was wet.

A correction with help from a clean and slightly damp brush. The mistakenly applied color was removed.

Superimposing of one color over another when the background was completely dry. In this way the treetops of the palms were not blended into the background.

The tone was lightened in the shadow to the right without actually removing so much paint so as to see the white of the paper.

Watercolor on dry

THE GRAIN OF THE PAPER AND THE BRUSHSTROKE

Just as with the previous technique, the brushstrokes and the grain of the paper are of great importance. To practice this technique it is necessary to have a good knowledge of the absorption qualities of the different papers, in order to select the type of paper best suited.

Here we will continue to treat one of the principal techniques of watercolor painting. Up until now, you have seen how watercolor paint blends with other paints already on the paper if they are still wet, and how to avoid this effect, you must wait until the previous layer is dry. Painting on dry has many more options than those already discussed, and in this topic you will study some of them.

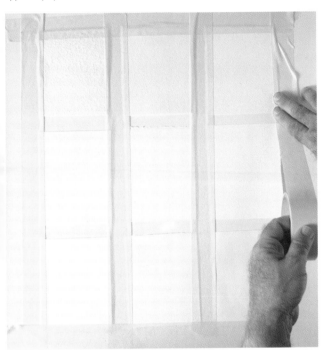

▶ *To carry out this exercise correctly, it is helpful to make up a set of different types of paper. It isn't necessary to use large pieces of paper; a small piece big enough for a single brushstroke is all that is required. The purpose of this exercise is to discover the appropriate paper for watercolor. There are many different types of paper on the market, but not all are equally recommended. The pieces of paper are placed in rows. You have already written on the back of each piece its trademark, weight and grain. The pieces of paper are joined together with painter's tape.*

A wash of any color is made, preferably an intense, bright color to contrast with the paper's whiteness. The most diffi-cult aspect of this test is to capture the same amount of paint on the brush for each stroke. You should try to make each brushstroke identical to the one before. After they are dry you will be able to see which type of paper best accepts the color (not all paper has the same degree of whiteness). You will also be able to ascertain which papers are not appropriate for watercolor painting (some allow paint to flood the paper and other papers inordinately wrinkle and buckle). The brushstroke is executed on a dry surface; in this way the degree of absorption can be noted.

◀

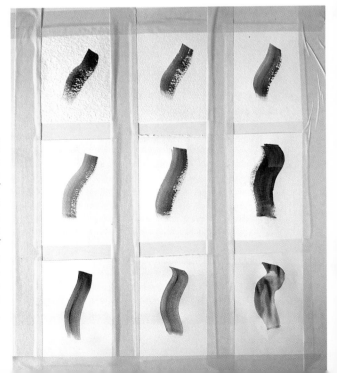

BASIC TECHNIQUES. SUPERIMPOSITION OF COLORS

One technique available to the watercolor painter is the ability to superimpose one color or tone over another. In watercolor painting, when two equal tones overlap, the overlapping area is darker. This can have many positive applications, such as changing a color or producing an illuminating effect.

Whenever two colors are superimposed, the intersection gives rise to a third color.

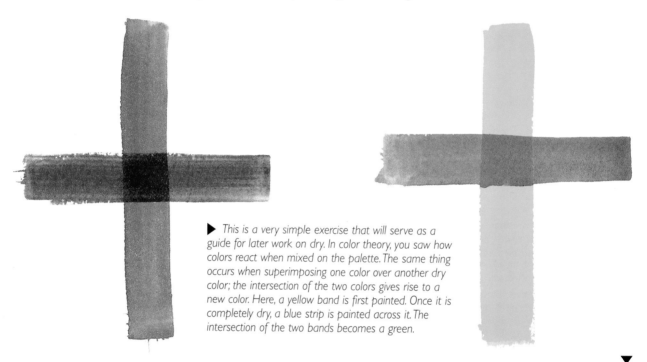

▶ *This is a very simple exercise that will serve as a guide for later work on dry. In color theory, you saw how colors react when mixed on the palette. The same thing occurs when superimposing one color over another dry color; the intersection of the two colors gives rise to a new color. Here, a yellow band is first painted. Once it is completely dry, a blue strip is painted across it. The intersection of the two bands becomes a green.*

▼

The following example is the same as the previous one, although we have varied the colors. The vertical strip is a magenta. Once dried, a horizontal band of blue is painted. The resulting intersection is the color purple.

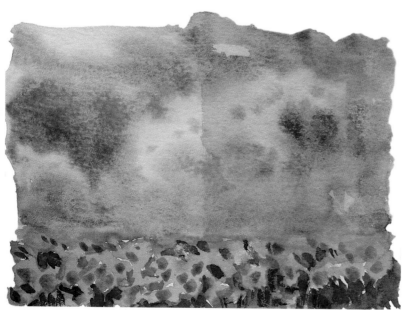

▶ *This example is very simple; it can be carried out on any sketch or, in this case, over a painting made especially for this demonstration. We have painted a landscape with a large sky and allowed it to dry completely. Meanwhile, we have prepared a transparent wash of the color ochre. With this tone half of the landscape is painted. You shouldn't make repeated passes over the background: you don't want the background to dissolve and mix with the wash! The achieved effect is quite interesting; you have added a curious illumination to the atmosphere which affects all of the lighter tones.*

1. *To perform this exercise with China White, choose a cream-colored paper. It isn't usual to use colored paper in watercolor painting, although there are times when it can be quite useful for painting certain subjects. First, you want to test the way in which the color of the paper will affect the transparency of the watercolor. Apply a transparent gray wash over the paper and let it dry. Another wash of the same color, but much darker, is added over this. Note how the color of the paper affects the lighter tone much more.*

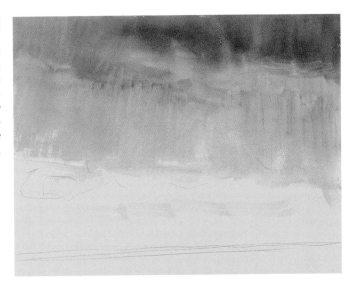

RESERVES AND CHINA WHITE

Watercolor paint is very transparent, so much so that any underlying color will alter its tone. The use of China White is one way to decrease the transparency of watercolor paint. China White is a very dense watercolor that, when mixed with other watercolors, serves to make them more opaque and pastellike. A reserve is a section of a painting left open and unpainted, so that a dark color is isolated from a lighter color; it will be left white if the paper is white. The use of China White bears no relationship to a reserve. China White allows light tones to be painted even if the paper itself is colored.

2. *Observe the difference that the darker gray tone acquires when it is mixed with China White. Some brushstrokes of China White are painted to test its opacity on the colored paper. In the lower area of the paper a triangular form is painted. Here you can see that the paint is not completely opaque since the color beneath can still be discerned. Several dabs of China White are applied with the brush. In the darker area the white points are more evident.*

3. *Some dark blue is placed on the palette alongside some China White. First, with pure dark blue paint some trees, as can be seen in this image. The brightest, or most illuminated areas of the treetops are painted with the same color, although more watered down. To paint the bottom area the blue is mixed with some of the China White until the mixture acquires the desired tone. With this somewhat lighter color the ground is painted. To finish, dab some China White over the painting again.*

▶ **1.** *The upper area of the painting is painted with an orange tone down to the foot of the mountains. The rest is left white. When this is dry, a violet tone is used to paint the mountains. If any part of the background area is not dry, the two colors will run. A medium sized brush is moistened with this violet tone mixed with sienna, squeezing out the excess color, and horizontal strokes are painted over the white foreground.*

DETAILS WITH A DRY BRUSH AND TEXTURES

Various effects can be achieved with a dry brush. A dry brushstroke on a dry background brings out the grain of the paper and can create an interplay with previously applied coats of paint. A dry brush can be used to paint over a white surface or one previously tinted with a wash.

▶ **2.** *A very dark green is used to begin filling in the lower part of the painting. When applying this color, there is no need to make the brushstrokes regular. When the color in the brush is used up, pass the brush over the upper part of the painting to bring out the relief of the paper before reloading the brush with more paint. Once the mountains are dry a new layer of the same color is superimposed. The addition of the second coat makes the mountains darker.*

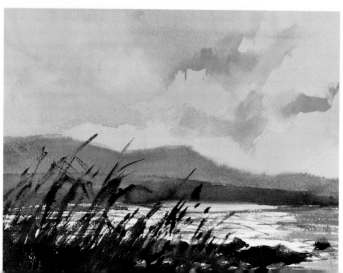

▶ **3.** *On the right, a dark gray is painted with strokes that leave small areas unpainted suggesting reflections. When the background is completely dry, a trace of greenish ochre is painted below the mountains. The brushstroke is continued until the paint runs out. Finally, when all the paint is dry, the tall grass in the foreground is added. Soft, flowing brushstrokes are made at an inclined angle to trace the stalks. The brush should not be too loaded with paint to allow broken brushstrokes.*

Step by step
Landscape with tree

The technique of using a dry brush is one of the most interesting ones that can be performed with watercolor. Naturally, it isn't something to be used at all times, since some areas of a painting will inevitably demand techniques involving blending colors or creating gradations. The exercise that follows is a landscape with a large tree in the foreground. This subject is sufficiently rich in shades and textures to allow it to perfectly demonstrate the technique of using a dry brush.

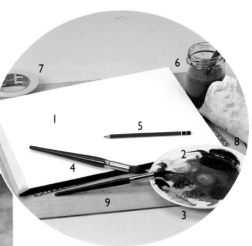

MATERIALS

Watercolor paper (1), watercolors (2), a palette or a plate (3), watercolor brushes (4), pencil (5), water jar (6), masking tape, (7) rag (8) and a support (9).

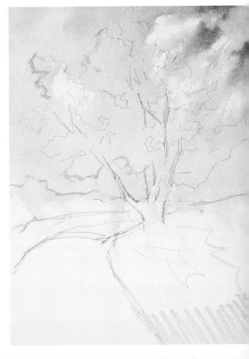

1. *The main outlines of the landscape are sketched in with varying degrees of precision. The area corresponding to the road is minimally but clearly outlined. Care is needed to draw the curve that differentiates the road from the earth and its vegetation. The tree trunk is precisely sketched and its most relevant branches are clearly shown. The area that corresponds to the higher branches is barely sketched at all to allow a free hand with the dry brush. Begin by painting the background sky with smudged blue, graduating toward white to suggest clouds.*

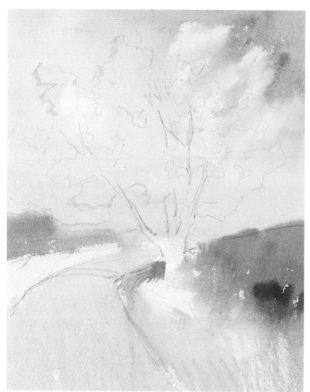

2. *A very light, ochre-colored wash is applied over a completely dry background in the area of the road. The colors are painted in areas separated by blank sections in order to prevent the colors from mixing. In this way, the lighter colors don't run into other, darker tones. Along the borders of the road, separated by a central patch for the dry areas, the green foliage of the vegetation is painted. On the right of the painting a touch of sienna is also added, which mixes with the green.*

The white area directly below the tree must be respected throughout the development of the painting. It will later be treated with a dry brush to create a bright reflection.

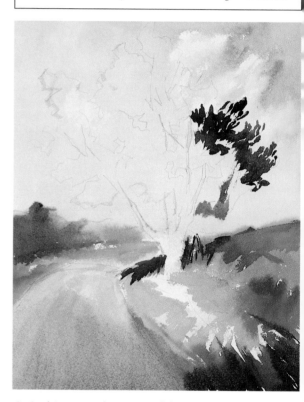

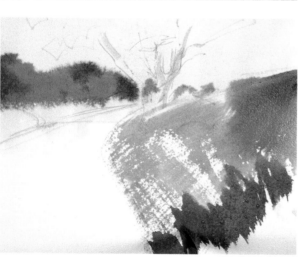

3. *The entire background is slightly darkened with a light green, including the trees in the distance on the left and the area of foliage on the right. Using a very dry brush and a yellowish green mixed with ochre, paint the area on the right of the road. The brushstrokes are long and follow the curve of the road. In the nearest foreground of vegetation, over a completely dry base, an olive tone is added. The brushstrokes here are slanted. They are not as long or as broken as those executed in the previous exercise.*

4. *At this stage, the tones of the background are strengthened. Some areas have dried completely, others are still half wet, but none of them should be so completely wet that the color and brushstrokes are uncontrollable. In the distant trees to the left the area is finished by applying dark greens among the lighter greens. To the right, a dark green has been added, delineating the tree trunk; here the background is completely dry. In the road, a long brushstroke following its curve is made, darkening its tone with a luminous wash of ochre and orange tones. Attention must be paid to the brushstrokes that define the treetop: they are short, dense and always painted on a dry background.*

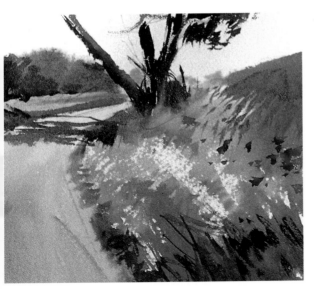

5. *Advantage is taken of the paper's texture in the area of the vegetation by using a very dry brush lightly loaded with green paint. Small brushstrokes of bright red on top of the green earth color are added to paint the poppies, some of which are allowed to run and mix with the background. With a watery mix of sienna and violet, paint the shadow of the tree on the ground. In order to properly create this shadow the background must be completely dry.*

The background must be thoroughly dry and the brushstrokes must not deposit too much paint in order to allow the texture of the paper to be seen.

6. *Run a clean wet brush across the green area on the right to blend and soften the excessively dry brush-strokes, in order to develop this area in greater detail later. To blend the colors, the red used for the poppies is mixed with green, which creates a brown color appropriate for the earth tones of wild vegetation. A clean and moist brush is repeatedly passed across the background greenery to the right until the tone lightens. The treetop continues to be worked on with the same brushstrokes used before. So that the tones do not run together, this area must be left to dry before adding new layers.*

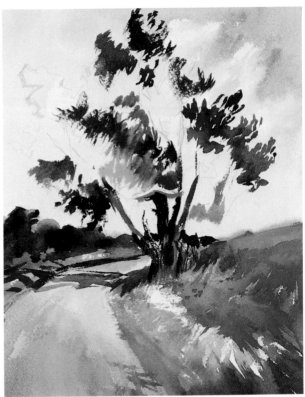

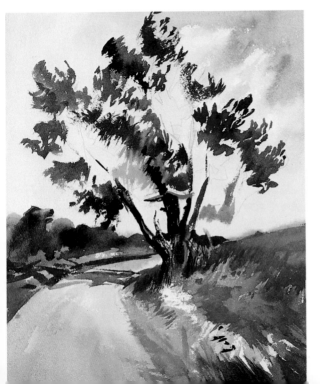

7. *Continue to work on the tree's foliage until it acquires the desired form. The green tones run from dark to light green, and include tones that are very dense and almost blue. A rusty green is painted over the completely dry green of the terrain. Under the tree, using short brushstrokes that define the ground to the left, a shadow is added that contrasts with the edge of the road. In the area to the right a tone is used that allows the underlying tones to show through.*

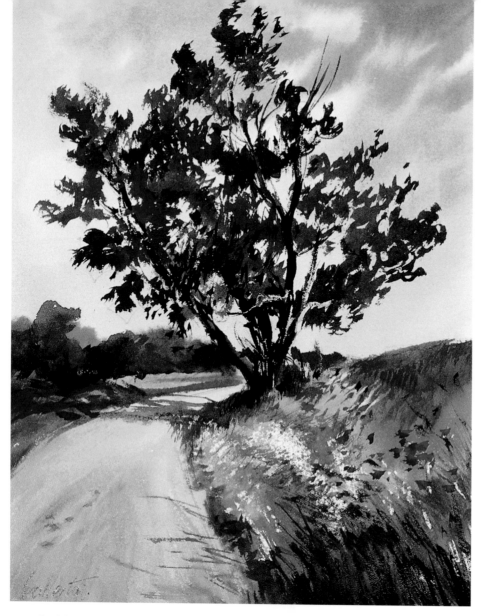

8. *The work that remains is to develop the contrasts of the countryside. The treetop is finished with a succession of short and dark brushstrokes that are superimposed on the underlying tones. The finest branches are drawn in, as is the grass in the foreground. Small hints of color are added to the road with a very light and transparent sienna color. And so this beautiful landscape, where we were able to develop the dry brush technique, is finished.*

SUMMARY

The foliage is painted on a completely dry background. Wait for the color to dry each time you intend to add another color.

This white zone is maintained as a reserve from the beginning of the painting. It is the brightest and most reflective area of the ground.

The texture of the paper is put into relief by an almost dry brush, which allows the underlying colors to show through.

The background of the sky is painted on dry, but the blending of the tones is created with a gradation of color that finishes off as the white of the paper.

The red, superimposed on the green in this area, is mixed, giving rise to an appropriate brownish earth tone.

The grass in the foreground is painted in the last stage. The brush must carry just the right amount of paint to establish the desired texture.

The combination of wet and dry techniques

THE WET BACKGROUND

The wet background allows effects of ambience, vague shadows, merging areas, gradations and the merging and blending of colors to be realised. The extent to which an added color will spread depends upon the degree of wetness of the background. Controlling this enables the painter to work with great precision in the area where the color is being applied. The wetness is controlled with absorbent paper, with a sponge, a dry brush or by the natural evaporation of the water.

It is difficult to use just the technique of painting on a wet background or just the technique of painting on a dry background in any given painting. Usually, both are used simultaneously to achieve the desired effects of each, capturing the fusion of tones on the one hand and the precision of a dry brushstroke on the other. The only problem posed, is that these two techniques demand completely different drying times between applications. If the base is wet, the newly applied paint will spread and merge. If the base is solid, the brushstrokes will appear definite and precise.

▶ I. The base is completely wetted with a sponge or brush after attaching the paper with some painter's tape to avoid swelling and wrinkling. With the paper upright and quite wet, paint a horizontal brushstroke along the upper border. (We have done all of this before, but it is important to insist on learning how to control a wash in order to understand the basic watercolor techniques). Assisted by the paper's wetness and by the brush, the color gradates toward white.

2. It is necessary to wait for the paper to dry a little. If we paint while the paper is still soaking wet the same thing will happen as in the initial gradation; the color will expand out completely. While the background is still wet, but not soaked, a darker blue is added. We can see that with a dryer base, the form of the brushstroke can be controlled much better, although the paint still swells and blends into the background around the borders of the stain.

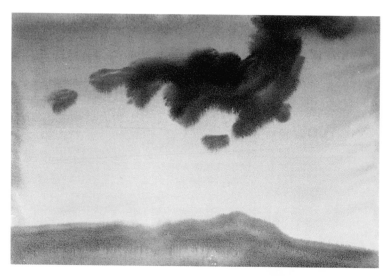

▶ 1. *In the same way as for the first coat, now almost dry, a new one is added, this time along the bottom edge. There is no reason for this to be identical to the first; this is nothing more than an exercise on drying times for various layers of paint. Up till now you have painted three different areas on the paper, each one with a specific drying time. Controlling the flow of the paint on the paper improves as the paper dries.*

DRYING TIME FOR EACH COAT

To observe the drying times for each coat of paint, continue the same exercise. In this way you will have a reference point close at hand involving the two methods that form part of this exercise. The work on wet is performed while the paint is drying, until the point comes where the work is executed on dry.

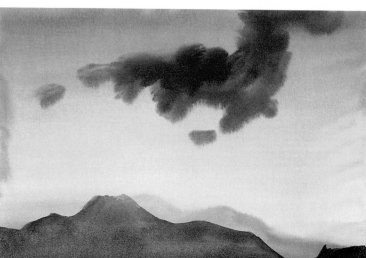

▶ 2. *The stain in the background can be varied while it is wet, even to the point of making it a gradation. Once the background mountains are dry, paint the second ridge of mountains with more definition, using a darker tone. Note that its borders are perfectly delineated and they don't blend into the mountains in the background. It is important to remember that you can't paint light tones over dark tones with watercolor paints. It must always be the other way around.*

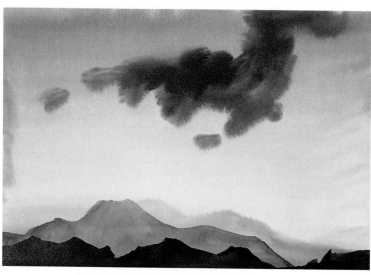

▶ 3. *Finally, to finish the study of different drying times, paint yet another overlapping ridge of mountains in the foreground. As you can see, with practice the exact definition of their form can be created but only if the background is completely dry.*

I. *The paper's color is white, which is the lightest possible tone. The whiteness can be modified by painting a uniform application, as here, where we have painted a very light ochre tone. Even though the paper has been painted completely, the transparency of the watercolor still allows the brightness of the white background to been seen through the paint, which is to say the ochre color is not opaque.*

LETTING THE BACKGROUND SHOW THROUGH

The color of the paper is the lightest tone of a watercolor painting. If it is white, the reflections will be white. If, on the other hand, the light tones are of another color, the reflections will be this chosen color. In this practical exercise you will be able to see how the background color acts and offsets the work as a whole. The brightest tones have to remain visible through the darker and denser tones.

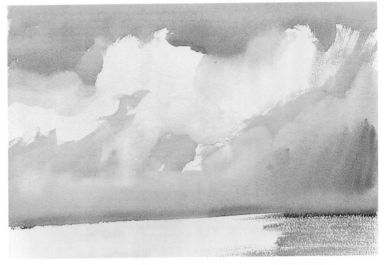

2. *The background color is left to dry almost completely. Begin to paint in the dark parts of the clouds with some sienna and outline their form. In some areas the color blends with parts of the background that had not yet totally dried. In the lower area we have made use of the dry brush technique to paint in the reflections on the water. The brush hardly retains any paint, and as it is passed over the surface, the grain of the paper's texture becomes evident. This is called letting the background show through.*

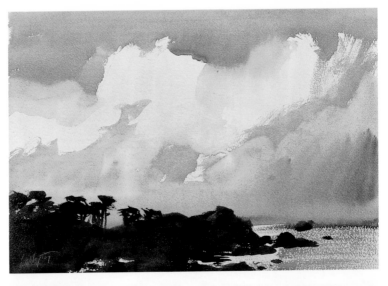

3. *We now have to let the background dry completely, since we don't want the tones to mix. With a very dark, burnt umber, paint this perfectly defined area of back lighting. Since the background is completely dry, the tones do not run and blend. At the same time, within this shading, some of the color is absorbed, lightening up the tone without losing the color's freshness.*

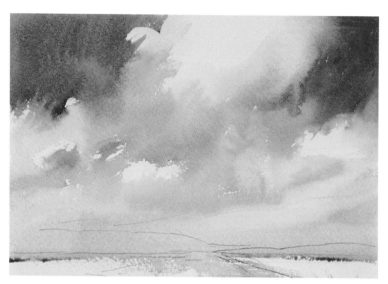

▶ 1. *The background is begun with a watery cobalt blue. The form of the clouds are outlined, leaving them perfectly etched out in the sky, as now the background is completely dry. In the area below we have used a tone that is much more transparent and bright. Just before the blue background dries completely, a transparent wash of black and yellow is prepared. Using this tone, create the dark areas of the clouds. In the areas where the two tones are in contact, they blend. In contrast, the white of the paper is dry, and is isolated so that no color seeps in.*

COMBINATION OF TECHNIQUES

O nce you control different drying times, it is possible to combine both techniques. With practice, this combination will yield astonishing results that are much more simple to create than would appear on first impression. The effect of a blend on wet can be applied next to the effect of a painting on dry to demonstrate the depth of a landscape, textures on objects, volume, etc.

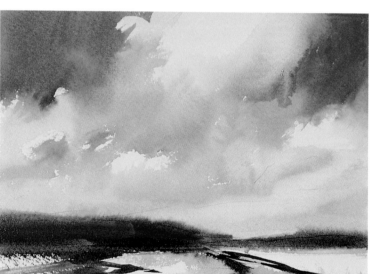

▶ 2. *We paint the area of the horizon with a very dark blue while the background is still wet. This will blend with part of the bluish color of the sky. The area below the horizon is painted with dark gray. These brushstrokes are supple and precise. They do not run or blend since the background is now totally dry.*

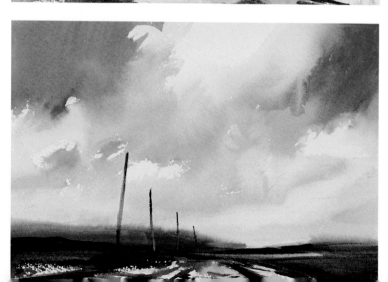

▶ 3. *We wait for the entire painting to dry. Now we can paint in detail the areas of contrast. The dry brushstrokes allow the background to be partially visible; the white color of the paper remains visible through the textured tones left by the brushstrokes, or left as reserves.*

Step by step
Figs and apples

The exercise that will now be presented is a straightforward still life comprised of two simple elements: apples and figs. Fruit is much easier to paint than symmetrical elements like a plate or a bottle, for no margin of error is allowed with these. In contrast, fruit permits a certain amount of licence when deciding their shape: it does not have to be completely homogenous. In this exercise the two principal techniques of watercolor are going to be put into practice: the necessary techniques to be able to develop any subject. Of course, in this example the difficulties have been moderated so that the enthusiast can easily take in the techniques of painting on dry or on wet.

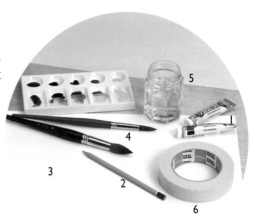

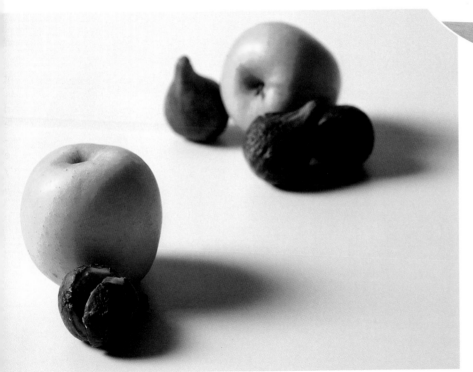

MATERIALS

*Tube colors (1),
pencil (2), medium
grain paper (3),
watercolor brushes (4),
water jar (5),
tape (6),
and support (7).*

1. *The drawing of this still life is very simple: it is based on a shape as elementary as a circle. The most complicated part of the still life is the composition of the elements on the paper. The drawing is done in a very basic way: only the outlines of the fruit are laid down. Very fine lines mark the shadows on the table.*

61

STEP BY STEP: Figs and apples

2. Start painting the apple in the background. All its surface is painted in bright yellow, leaving the highlights unpainted. The color is darkened a little on the palette with some green and the shading is painted. This color melts into the last one because the latter is still wet. The darkest part of the shadow is painted in a subtle tone of sienna. The brush is cleaned and then dragged over the right side, removing some of the fresh color. The shadow of the fig is painted with very dark carmine, which is gradated in the illuminated area.

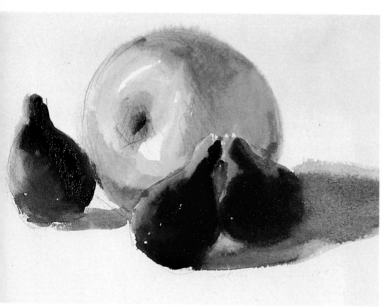

3. The figs on the right are painted in violet tones, bluer than on the left. First, the lightest tone is painted and on top of this the dark parts of the shadows. As the background is still wet from the last colors put down, these mix directly on the wet paper. The violet is watered until it is very transparent and the result is used for the shadow cast by the fruits at the back. Wait until the paint of the figs has sufficiently dried or, in spite or this new coat of paint, their shapes will dissolve into the newly applied paint.

4. The shadow area of the apple in the foreground is started in a greenish yellow. The brushstrokes outline the shape of the fig but the color does not penetrate into the latter because the background is completely dry.

When it is laborious to open up a clear space on top of a dry color a few drops of bleach can be added to the water. The white which is then opened up will be perfect.

5. *The luminous zone of the apple is painted with a very clean golden yellow, although the highlight is left white in this area. In the upper part of the shadow a dark area is painted with burnt umber and it is melted into the rest of the color insisting with the brush. When painting this shadow area, you must be very careful not to touch the yellow zone: this must be kept clean. With a very dark pure carmine paint the opening of the mature fig. Using the dirty water for brush cleaning, put down a very transparent layer on all the background. Do this only when all the previous colors are completely dry.*

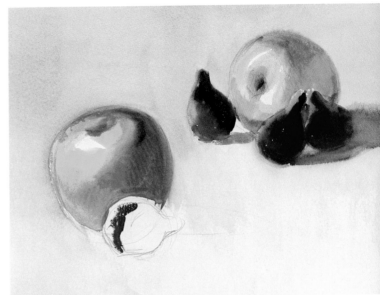

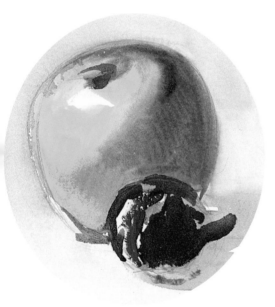

6. *Once all the background is dry, the fig in the foreground is painted with a very luminous ultramarine. The highlight zones are left white. With this same color the shadow of the fruit in the foreground on the table is also painted. On top of the luminous color of the fig, once it is almost completely dry, shade in a darker stripe, even though this leaves a lighter stretch on both sides of the cut.*

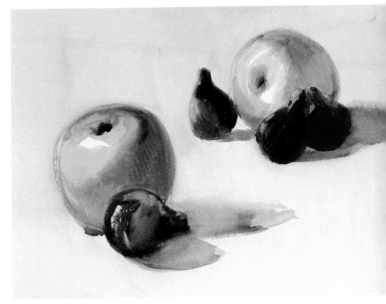

7. *Repeatedly pass a clean and wet brush over the upper part of the fig to open up a clear area. Before this area dries out, paint in an orange color that will quickly merge into the violet of the previous layer. The darker tones are obtained with a violet made by mixing dark carmine and cobalt blue. A little ultramarine can also be added. While the color is still moist, take some of it off with repeated brushstrokes. If the color has dried completely, it is still possible to open up the paper's white but you need to persist a lot more with the brush.*

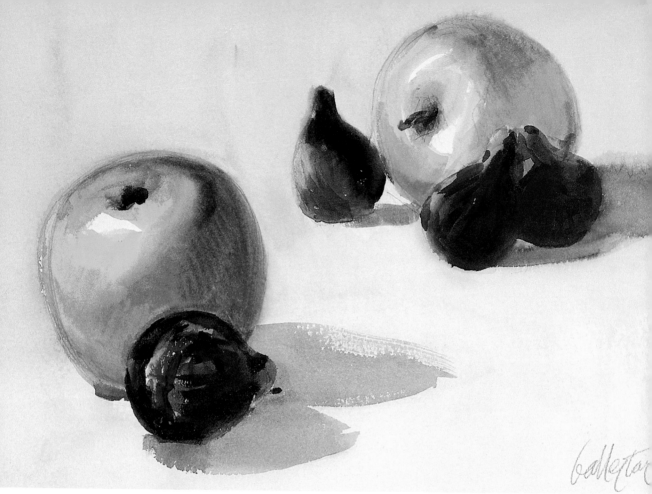

8. *Once the excess humidity is dry, paint in the most intense contrasts on the just painted fig. Using the almost dry brush, repaint the shadow on the table trying to ensure that the brush leaves its track. It is only possible to achieve this texture when the background is completely dry. With this the exercise is finished: you have practiced the two principal techniques of the watercolor. It is not difficult to do, provided that the drying time of each zone that is being painted is always respected.*

SUMMARY

When painting the apple in the foreground the dark color blends into the most luminous one. This is because the second zone has been painted while the first was still wet.

In the fig on the left the dark parts are painted once the first base color has dried.

The first color painted is the one of the apple in the background. All the other colors used on it are done while the yellow background is still moist.

The figs next to the apple in the background are not painted until the latter is completely dry.

In the background an almost transparent layer is painted. The colors do not mix because you have waited for everything to be dry before painting it.

7

Opening up whites

WHITES TO BE OPENED UP

In watercolour painting, opening means to restore to the paper the light that the color has taken away. There are different techniques to open up the white in watercolors. All of them have the same aim: take away color from the paper. Color can be removed in a number of different ways to achieve a variety of effects. On this page some very quick and simple exercises are shown. They will teach you how to resolve different problems that can occur when opening up whites in more complicated exercises.

On more than one occasion a beginner will hear someone saying that a watercolor cannot be corrected. This is not entirely true; in fact, the technical richness of this medium is such that one of the most interesting techniques that it has is precisely the opening up of white spaces. The clear or white spaces opened up in watercolors can be used for several reasons: to simply correct an area which has turned out badly, right through to the elaboration of all types of technical effects or textures.

▶ 1. A square area is painted in any color. This exercise is done while the color is still wet. A dry sponge is used in the same way as cotton wool and is pressed against the middle of the colored area. When the sponge is removed you can see how it has absorbed a part of the fresh color and has left the impression of its texture on the paper.

2. Another area similar to the previous one is painted and the sponge is dampened slightly before being pressed against the paint. The sponge is wrung out completely to eliminate the excess of water. When pressed against the still damp paint the sponge absorbs the color.

▶ 3. A third similar area is painted and once again the sponge is dampened and the excess water is squeezed out. The damp sponge is passed over the still wet surface, pressing and dragging at the same time. The result is more whiteness than that obtained by simply pressing.

4. The final test is done with a brush. A square area is painted and while it is still wet the brush is passed over it repeatedly. After every stroke, it is washed and blotted. The result is an opening up of white much more controlled than those obtained with the sponge.

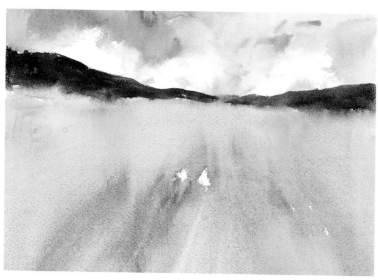

▶ 1. *The upper part is painted with a very gestural, expressive, brushstroke in a blue wash mixed with a little burnt umber to create the dark tones of the sky; some parts are left unpainted and remain completely white. Once the sky is completely dry, the mountains in the background are painted with burnt umber mixed with blue. Once the mountains are dry, a overall wash of all the ground area is carried out: it is painted ochre. On top of this, while it is still wet, brushstrokes of sienna are added. The brushstrokes are long and indicate the perspective of the earth.*

CLEANING UP A WET AREA

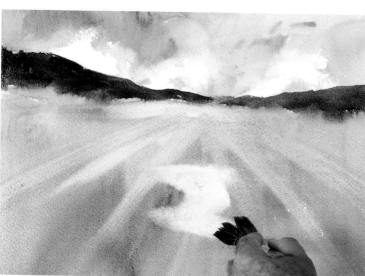

While dealing with previous subjects different ways of opening up whites have been carried out as, for example, in doing skies, but this option is much richer in possibilities. The white of the paper is much more responsive while the color is damp: it gives up more color. When a white space is opened up in a damp color, it is unlikely that the white of the paper returns to its original splendour, unless the paper is top quality. The whiteness of the space depends on the quality of the paper. A first-class paper allows white spaces to be opened up in all the scale of tones, even going as far as the perfect white.

▶ 2. *While the earth is still wet, different whites can be opened up with the aid of a clean and dry brush. First of all, the brush is run across the center of the horizon and long lines are opened up that indicate the perspective of the landscape. As the paper is still wet and as the brush is not used insistently, the whites opened up are not as pure as that of the paper. A much bigger white space is opened up exactly in the middle of the terrain. This area is made much whiter than the other spaces. To achieve a cleaner white the brush has to be passed over numerous times, washing it out and blotting it for each stroke.*

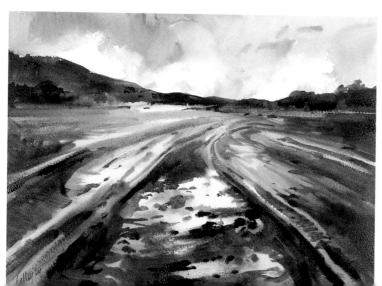

▶ 3. *It is not necessary to obtain such a fine finish; this is simply a practical exercise to show the opening up of former white spaces. Once the earth wash has dried out almost completely, the darker tones can be painted: they allow the whites and other tones to be more clearly made out.*

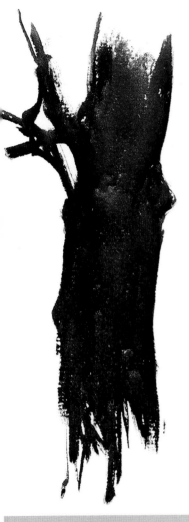

▶ **1.** *Paint the trunk of the tree with a very dark burnt umber. The density of the colors in tubes permits darker tones to be obtained than with colors in tablets. As can be seen, almost all of the brightness of the paper has been blocked out. This shape is not difficult to do, especially as it needs not be identical to that in the picture. To continue practicing, it is necessary to let the color dry completely; this can be speeded up by using a hair-dryer.*

2. *Once the paint is completely dry, take a round, quite thick brush, wet it and drain it to get rid of the excess water, and start doing vertical brushstrokes over the dry color. After several brushstrokes the dry paint begins to soften up and impregnates the brush. When the brush starts to fill up, it is washed and rinsed before repeating the opening up of white spaces. The more you insist with the brush over a certain area, the whiter the result will be.*

◀

CLEANING UP A DRY AREA

O n more than one occasion the watercolorist will observe that in an area which the artist considered to be finished, it becomes necessary to open up a white or clear space which has a tone similar to that of the paper. In the same way that it is possible to soften the dry color in palette, it is possible to do the same on the paper. The two techniques that are explained on this page, and the next, will be fundamental in order to master the numerous technical effects explained throughout the rest of the lessons.

▶ **3.** *Some lines are left very white, others are hardly suggested. Thus the aim is to become sensitive to the touch of the wet brush on the dry paint. In later chapters this technique will be used again to elaborate very varied textures.*

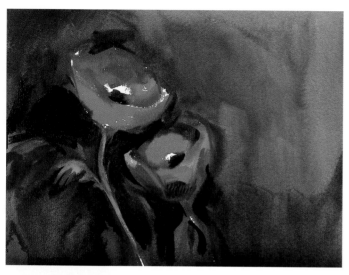

▶ 1. *This exercise can seem extensive, but it never fails to follow it in practice. You can learn how to open up clear or white spaces in a particular way. Doing this type of exercise will in the future permit the student to correct compositions which contain mistakes, or even to add new elements in complicated or very dark areas. First, the flowers have been painted red; the elaboration is very simple. Then the stems, and, finally, a very dark blue background have all been added. Before doing this, the painting must dry completely.*

REDOING ELEMENTS

It is possible that after painting a picture, once it is completely dry, one finds that it is necessary to paint an additional element. If the background or the elements of the picture are very bright there is no great problem because it is always possible to paint a dark color on a lighter one. However, if it is the other way round and the background is dark, it is necessary to clean the area and to lighten it before painting in the brighter color.

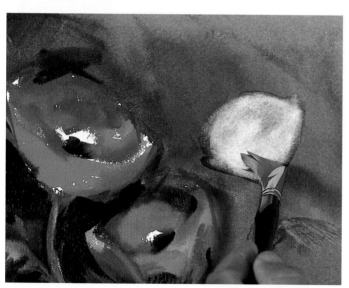

▶ 2. *In the same way that on the last page vertical lines were opened up to draw the whites out of the bark of the tree, here a wet flat brush is used to soften and clean the shape of a new flower. This time it is crucial to be insistent with the clean and dry brush, as now you are aiming at as bright a white as possible. It is in this kind of work that the quality of the paper takes on an important role: a good quality paper permits a neat piece of work, while it is possible that one of low quality cannot be cleaned adequately.*

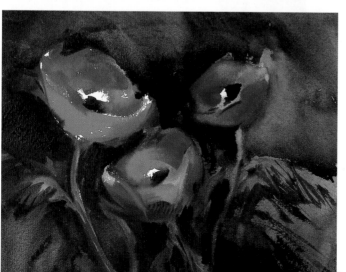

▶ 3. *When the background around the flower has been completely cleaned, it can be painted with the necessary colors. The colors can be bright in relation with the white that has been obtained from the paper.*

Step by step
A white vase

White is one of the most important colors in watercolor technique. Although it is usually present in every watercolor, this color does not exist physically as a paint. White in watercolor is the paper. The watercolorist, when painting eliminates with the color part of the brightness of the paper. In this exercise we are going to practice with the white color of the background, marking it off with very dark colors. Moreover, we will study various aspects throughout the lesson, such as how to reopen clear tones by absorbing the color.

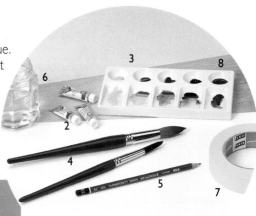

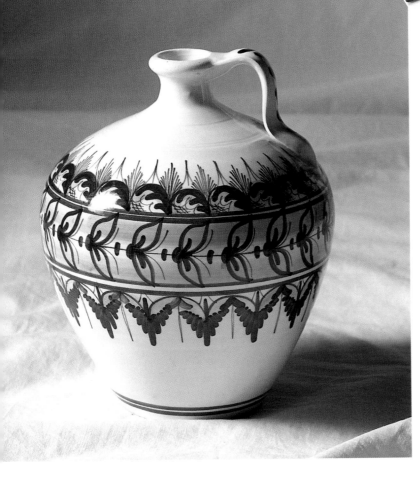

MATERIALS
Watercolor paper (1), watercolors (2), palette (3), watercolor brushes (4), pencil (5), jar of water (6), tape (7) and support (8).

1. *Before starting to paint, it is important to establish clearly which areas will be occupied by the highlights. The sketch of the vase will visibly separate its outline from the background. In this exercise it is important that the dark areas are markedly distinguished in the drawing, for it is the dark tones that will contrast with the lighter tones and colors.*

69

STEP BY STEP: A white vase

2. *The background is painted with dark sienna, burnt umber and blue wash. The shape of the vase is perfectly delineated by the dark color. Now it seems as if the area of the vase is painted white. When the background is painted, take care with the profile of the drawing so as not to penetrate the area reserved for clear colors.*

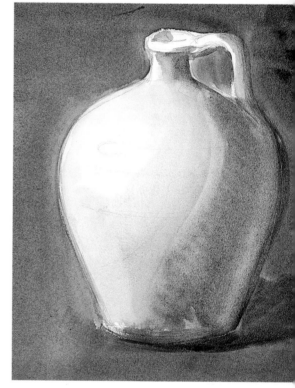

4. *While the tone of the shadow is still wet, merge all of the area of shadow with supple brush strokes with a wide brush. To darken the color of the palette, you need only add a little more color. To get the grey tones of the vase a mixture of blue and burnt umber can be used. A good merge between the color and the white can be achieved with a brush dampened in water: this takes prominence away from the contours of the shadow.*

3. *Once the background is dry, the interior of the vase is painted with a very clear wash, almost transparent. This tone is applied from the right with very inclined brushstrokes. Once again the area of light on the left of the vase is left in negative. Before this tone is dry, in the same way that the highlights were opened in the first part of this chapter, a luminous area is opened up on the right with a wet and clean brush. It is not necessary to insist too much with the brush if you do not want to open a perfect highlight.*

5. *With a grey layer somewhat thicker than the previous one, rapidly stroke, the shadow area with the brush, just as you did before. On the right side a thick, long brushstroke is made with a wet brush, but without hardly removing any paint. In this way the right edge of the vase is restored. When the background wash is completely dry, the frieze is drawn in a very clear blue, and on top of this a new blue tone, but this time much darker.*

> While the color is still wet, it can easily be manipulated with a clean, dry brush.

6. *With the brush only moderately loaded, the frieze of the vase is now finished off. The background is now repainted with a mixture of sienna and a little, but much darker blue. The outline of the shape of the vase is painted with care. Notice in the picture that, by the background being painted in a darker tone, the shape of the vase on the left has been changed.*

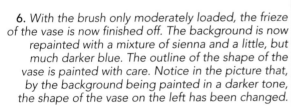

7. *Notice how a small error in the center of the vase has been corrected: this highlight has been opened up with the clean, wet brush, making small, repetitive strokes across the area in such a way that the surrounding blue merges. Now is the time to start correcting the left side of the vase. First, try to retouch it by modifying it with the dark exterior tone, but this will fall short of the result sought after. This curve will have to be redone by opening up the tone from the interior of the shape.*

8. Start giving a new shape to the left side of the vase with a clean, wet brush. These strokes have to be very gentle. Continue until the shape takes on the desired curve. Once the correction of the shape has been realized by dragging the color, allow the area to dry and finish off the decoration of the ceramic. When the vase´s decoration has finished drying, make some dark brush strokes in the shadow area. Lastly, lay down an almost transparent yellow layer. Despite this latest addition of color, the most luminous highlights have already been reserved.

SUMMARY

White area reserved from the beginning. The brightness of the inside of the vase has remained intact since the start of the picture.

Highlight opened up by dragging strokes of a clean, wet brush.

The righthand zone of the shadow has been painted by the brush, but not so much as to open up a highlight.

On the left of the shadow the shape of the vase has been redone by repeatedly dragging the brush across the dark background tone.

8 Highlights and reserves

THE MANUAL RESERVE

The manual reserve is made by hand, impeding color or dampness from penetrating into an area destined for a white or clear color. When doing a manual reserve, it is necessary to be especially careful not to penetrate the reserved area. To achieve this, one of the best ways to make this type of reserve is through a correct initial drawing. The line of the pencil lead must not be crossed either by the color or by the brush.

In the last topic we studied how to open up highlights by removing color from the paper, which can be done for a number of reasons. This topic is also going to deal with white, but in a different way. One question is the treatment of white when it is an opening up of an area with a color tone already on the paper, and another, very different, when it is a white area in negative, reserved, from the beginning. The reserve can be done manually, by leaving out color in a certain area, or by using masking fluid. This is a product which is applied with a brush and temporarily makes the area it covers impermeable.

▶ 2. *On the light tones, darker ones can be painted. Providing that the initial tone has dried completely, you can do new reserves that show a different unpainted tonality. The most luminous highlights must remain intact unless the tone requires a little retouching.*

▼ 1. *Before laying any color down, it is necessary to do a detailed drawing that shows the principal shapes and highlights that must be reserved in negative as perfect whites. One recurrent error of many beginners is to start to paint before having finished the preliminary sketch. The drawing must always provide fundamental technical support for the watercolor. After doing the drawing you can start to paint, first with the lightest tones that isolate the bright areas: these highlights must not be touched by color.*

3. *After several layers, different brightness can be highlighted, all of them based on more or less recent reserves. The most luminous areas correspond to reserves left during the first layer. As darker layers have been put down, clearer reserves have been made on top of previous layers.*

73

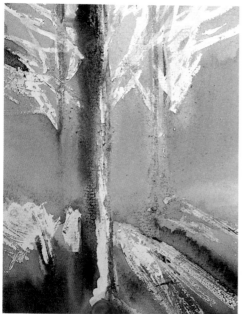

THE MECHANICAL RESERVE

Despite such a spectacular name, this mechanical reserve is the mere laying down of a blocker that prevents a certain part of the paper from being painted. A mechanical reserve can be made in different ways, the most practical for the watercolorist is to use masking fluid. This material is a liquid paste that is applied with a brush. Once it is dry it makes the area covered impermeable. When the watercolor is completely dry the mask is taken off by simply rubbing gently with the finger, and a clear white space becomes visible.

▶ **2.** *Before applying the masking fluid, the previous wash has to be completely dry. The masking fluid is applied with a brush. In this case a yellow variety is being used but it also comes in gray. The masking fluid has a non-white color to distinguish it from the paper underneath. The brush does not have to be dipped completely in the pot, only the hairs. As soon as the application is finished, the brush must be washed with running water to avoid the hairs becoming brittle.*

▼ **1.** *This exercise is very simple. You will practice the use of the masking fluid. Some very sketchy trunks are painted in sienna. It is not necessary to go into details, only the general lines that situate the principal shape and a few branches.*

▶ **3.** *The masking fluid dries very quickly. You can paint on it in any color or tonality knowing that the masking fluid will prevent the watercolor from penetrating. First allow the colors of the picture to dry and then take off the masking fluid. It will have become an elastic film which is easy to take off by simply rubbing it off with one of your fingers. When the masking fluid has been removed the protected area is revealed white.*

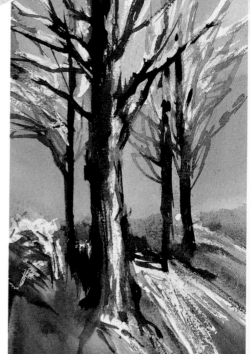

◀
4. *Here you can see the effects achieved with masking fluid.*

WASHES AND RESERVES, WHITE TEMPERA

The reserves can be made in many different ways, but they always aim at isolating a part of the paper which will be used for a highlight, a luminous area. Sometimes the color of the paper is not exactly white, which makes it harder to use this color for the maximum luminosity in the wash unless a medium is introduced into the painting that is not a watercolor technique: white tempera. Different to the China white used in previous chapters, the white tempera is completely opaque and allows perfect whites to be achieved in part of the picture. White tempera is used, above all, to obtain reliefs on colored paper. In this simple exercise a comparison is made between work done on colored paper and work done on white paper.

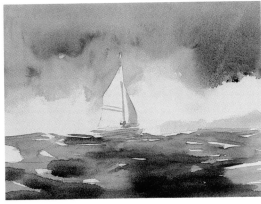

▼ 1. *To do this exercise it is necessary to have both white and colored watercolor paper. Both papers are held to the board with tape. The paper on the left is a cream color while that on the right is completely white. Obviously, on colored paper it is not possible to paint whites since in watercolor whites are achieved by reserving. By using white tempera, a similar effect can be obtained on both papers.*

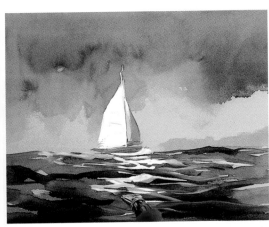

▶ 2. *To compensate for the lack of whites on the colored paper, white tempera is used. This means that the picture becomes more dynamic and incorporates light effects. Nevertheless, some areas are left in negative so that the background color comes through the darker areas of the blue.*

3. *Compare the treatments that have been carried out on each of the two papers. You can see that white tempera can be used to greater effect on colored paper. This technique is not very normal in watercolor painting but it is always convenient to know it.* ◀

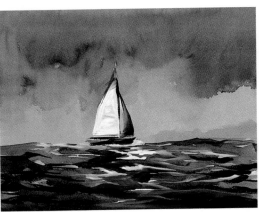

Topic 8: Highlights and reserves

SUPERIMPOSING LAYERS AND PROGRESSIVE RESERVES

When a layer is superimposed on another already dry layer, the result produced is the sum of the two tones or colors used. This has been seen throughout various topics.

This same effect can be used to make reserved areas. In this topic we have studied the use of masking fluid to obtain perfect whites. If masking fluid is applied to a surface already painted

and dried so that certain areas are protected, or reserved, when the masking fluid is peeled off, the new tone or color will include a reserve of the initial color. At the same time the zones that are reserved for whites can be painted in light tones that hardly effect the colors around them.

▼ 1. The first reserve is going to be carried out with masking fluid. To begin the process a drawing is made to sketch the shape of the reserve. With a medium brush dipped in the masking fluid the areas that are to remain white in the first phase of the layers are protected.

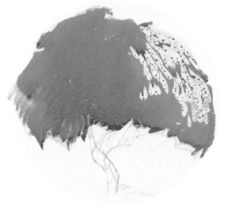

▼ 2. Once the masking fluid is dry, a uniform color can be painted. As before, the color does not penetrate in the area protected with the masking fluid. The mask is much more secure than the manual reserve, although it does require a much slower and laborious process. Masking fluid is especially suitable for small details and areas that are difficult to protect by hand.

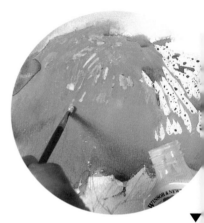

3. On the dry color, before peeling back the masking fluid, a few more reserve strokes are made. This time the color that is reserved is the green tone that was employed initially.

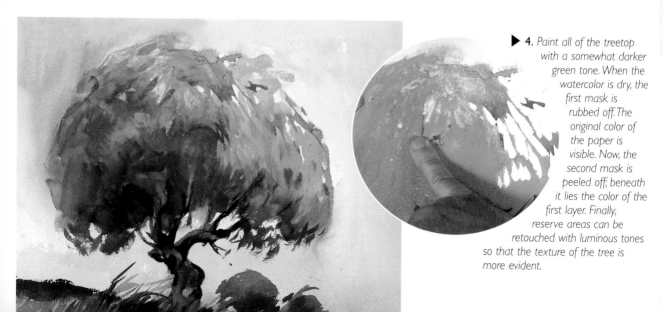

▶ 4. Paint all of the treetop with a somewhat darker green tone. When the watercolor is dry, the first mask is rubbed off. The original color of the paper is visible. Now, the second mask is peeled off; beneath it lies the color of the first layer. Finally, reserve areas can be retouched with luminous tones so that the texture of the tree is more evident.

Step by step
A mountain landscape

In this chapter you will look at different ways of reserving spaces. We have chosen a snowy landscape to do an exercise with a large reserve. Here the space reserved will be the snow-covered mountain. In this part of the picture, successive reserves are going to be applied. In all of them the white of the paper is the most important consideration.

To do this landscape it is not necessary to use masking fluid because it is vast and has no small details or fine lines that need to be protected.

MATERIALS

Watercolor paper (1), watercolors (2), palette (3), watercolor brushes (4), pencil (5), jar of water (6), tape (7), and support (8).

1. *One of the reasons why a landscape is recommended to someone who wants to learn to paint watercolors is because it requires less precision in the drawing than still lifes or figures. It is easier to draw lines that represent a mountain than, for example the oval that describes a plate in perspective. This drawing is very simple, although it is necessary to sketch in the areas that will contain the darkest tones of the mountains. In this way the white reserve can be executed with great precision.*

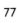

STEP BY STEP: A mountain landscape

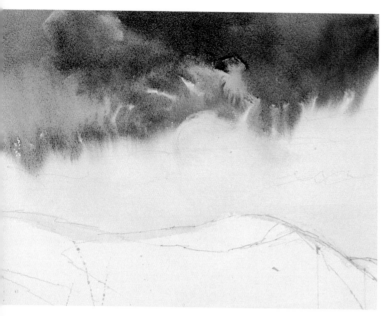

2. In order to reserve all the white areas of the mountains from the wash that is going to be applied to the paper, the sky is first dampened with a clean brush. The mountain area is left untouched. The moistness of the water will act as a reserve of the white of the paper because the color will spread only over the previously dampened areas. Start applying different intensities of color from the top: cobalt blue and a dash of ochre to get green tones.

> Manually reserved areas keep intact the white highlights.

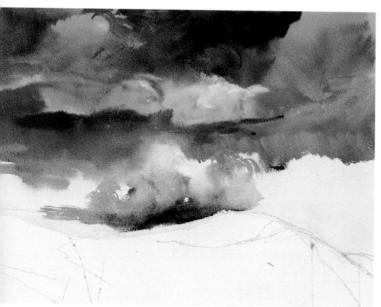

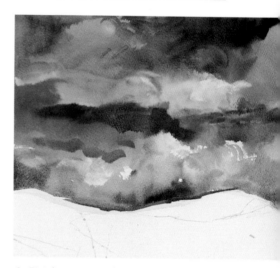

3. On top of the previous color, once dry, a very pure ultramarine blue is painted. The initial color becomes the first reserve area as the blue now isolates spaces that a moment ago were occupied by the first grayish tonality. In the lower one, the blue outlines and reserves what will be the clouds that crown the mountain. To maintain the reserve of the mountains, the sky that outlines them is once again wetted with a brush and clean water. Now, the clouds on the horizon are painted without there being any danger that they penetrate into the white zone.

4. Finish painting the lower clouds while the mountains are still wet. Here use cobalt blue with some burnt umber to give a leaden hue to the clouds. All this area is not painted in a uniform manner, instead different intensities of wash are applied to get darker and lighter tones. The most luminous areas of the clouds have to be reserved while the darker ones are being painted. The importance of the ultramarine blue reserved while doing the clouds can now be appreciated. This is also the case with the white mountain reserved by the clouds on the horizon.

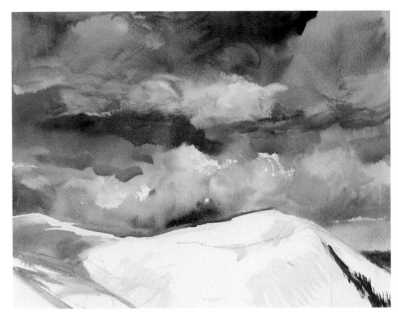

5. *Start the painting of the shading of the mountain in an ultramarine blue mixed with little cerulean blue. This color is painted with precision using very watered-down paint and respecting the previously sketched-in area. The blue color must not touch the clouds, instead leave a fine white line between them. This white strip is also considered part of the reserved area.*

6. *Once the shadow area on the left of the mountain has been painted, add other tones in a mix of cobalt blue and little ochre. An almost transparent wash is used to paint the most luminous shadow tones of the mountain. The background must be dry in order to keep as a reserve the brightest white. On the right, the painting of the trees is started using a mixture of dark green, blue and a little sienna. Use short and vertical, rather dark, brushstrokes on the upper area to maintain some space so that the white of the background shows through.*

7. *The right-hand side of the picture is completed with numerous brushstrokes over the dry background to paint this forest area. It is important to leave in reserve the delicate area where the white of the paper can be seen through the trees. In spite of all the details, the treatment given to this zone is very gestural: the dark color of the trees is painted with a rapid brushstroke in which the start and the end of the movement become especially important. To avoid strokes that are oversized, the brush must not be too loaded with paint. Finally, trees spread over the mountain are indicated with supple, small brushstrokes.*

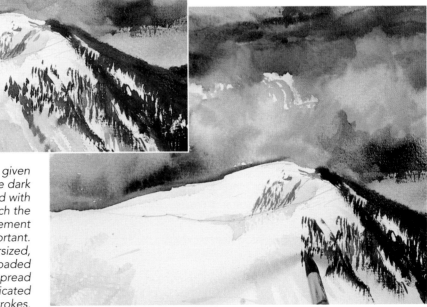

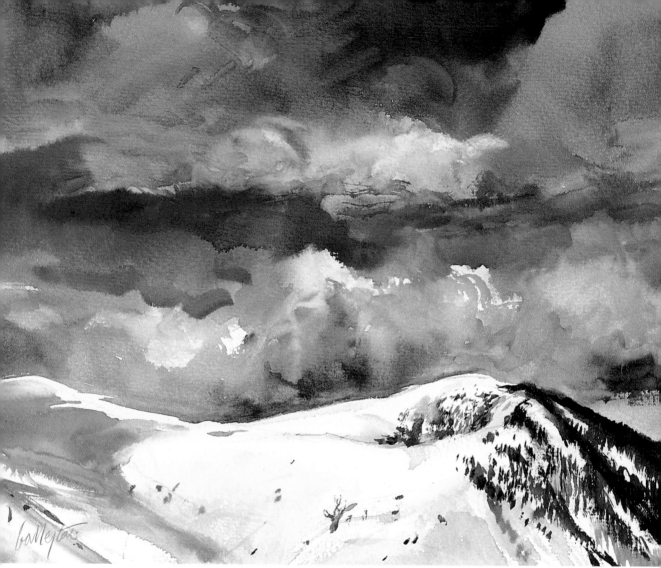

8. *The final touches are given to the dark area of the forest with a mixture in which burnt umber and dark green predominate. The space on the left is completed with an ultramarine blue wash. All these are the final details of a picture in which the white reserve has played the leading role.*

SUMMARY

The ultramarine blue of the sky in turn reserves the first wash of grayish colors.

The grays of the mountains were drawn from the beginning of the picture. In this way the white reserve can be done much more precisely.

The zone of grays on the left receives a final touch of very luminous color.

The purest white is that of the paper.

The forest area allows the color of the paper to come through as it has been worked when dry.

The small details of the trees spread out over the mountain are painted when the picture is almost finished.

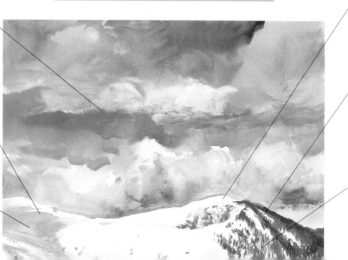

Special techniques

SPECIAL MATERIALS

There are many techniques that normally can be used to alter the surface of a watercolor. One of the most usual tools in the studio of a watercolorist is the hair dryer. This can speed up the water evaporation from the paper. Another tool that can modify the surface of the paper is sandpaper.

The watercolor is very sensitive to any alteration that is produced on its surface. This quality is an advantage when the techniques that provoke such changes are known. When using watercolors, accidents often happen, like a scratch on the paper, scraping with the brush or many other incidents. This topic will deal with these effects as a part of the normal possibilities for the watercolor technique.

▶ 1. The dark color is painted in the usual way. In this exercise we are going to do some textures with sandpaper on a painting of rocks. The colors used for the rocks can be very dark.

▲ 2. Some techniques are done when the color is completely dry. To accelerate the drying of the color and to be able to work on the the dark mass, the paper is dried with an electric dryer. If the paper is too wet it is wiser not to get very close with the dryer so that the color does not run or the drying is irregular on the surface.

3. Rub the surface of the rocks with a medium-grain sandpaper. This action causes the upper layer of the paper to be taken off and the dry color with it. It is not necessary to press too hard. Some areas can be left untouched: just rub where you want to texture the surface.

▲

4. You can then repaint on the retextured surface with very transparent washes or with dark colors without completely covering up the resurfaced area.

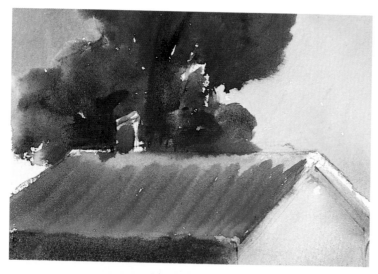

▶ 1. *The effects that can be achieved with watercolor can be realized on a completely dry surface, or on fresh paint. When the paint is wet it is possible to achieve more varied results, for it is not just a question of getting rid of the paint. Depending on the type of paper, the painting can be scored with grooves that do not completely take off the superficial layer. Here the experiment will be done with fresh paint.*

SCRATCH THE PAPER WITH THE TIP OF THE BRUSH

At the opposite end to the hairs, that is to say the tip of the handle, there is another very practical tool which offers many possibilities. Different tasks can be done with the sharp point of the brush, especially when the watercolor is moist. Some brushes have a sharp tip, and others have a blunt one. Some watercolor brushs even have a beveled tip, specially designed to scrape the paint.

▶ 2. *While the painted surface is still moist, start with the tip of the brush. You can see the effect in the photo. Do not press too hard: the smallest indentation is enough to mark the paper. Stroking like this will not achieve pure whites. In the indentation made on the paper, more color is accumulated than on the rest of the surface, unless you insist several times with the brush. In this case pass the brush over each stroke. By so doing, instead of building up more color, part of it is taken away, and this makes the result a clearer and finer tone.*

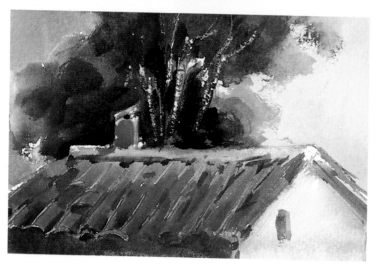

▶ 3. *When the tip of the brush is pressed hard over the still moist background it is possible to open up whites like those among the trees. To make these type of marks not all brushes will do. Some of them have a tip that is too blunt. If it is necessary to make indentations that remove some of the paper a sharp toothpick can be used.*

A KNIFE AND TURPENTINE

A knife or a cutter can scrape the paper with great precision. As these tools are so sharp, they must not be used on wet paper as as it could scrape to the point of tearing. The cutter is a more practical tool than the knife for it can be handled with the precision of a pencil. Moreover, another technique that produces interesting effects on the watercolor is the use of turpentine; the mixing on the paper of a brush loaded with turpentine with another loaded with water produces an unusual texture that is worth experimenting with.

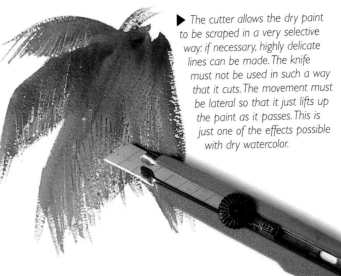

▶ The cutter allows the dry paint to be scraped in a very selective way: if necessary, highly delicate lines can be made. The knife must not be used in such a way that it cuts. The movement must be lateral so that it just lifts up the paint as it passes. This is just one of the effects possible with dry watercolor.

1. This little exercise demonstrates the combination of the technique of watercolor with turpentine and the opening of whites with the cutter. As with all the exercises in this book, it is a good idea for the learner to put it into practice: it is the only way to understand how the technique works. All work in watercolor is initiated with a drawing. Once the main motif is finished, the paintwork can be be started. A brush is dipped into turpentine and some areas of the background are covered. On top of this you paint with a dark color. The turpentine gives the watercolor a very textured appearance.

2. Once the background has been painted, the figure is outlined perfectly. A dark green color is used to paint the leaves of the plant. In some areas quite a lot of turpentine is applied and in others none at all. In the areas with turpentine the color penetrates with more intensity.

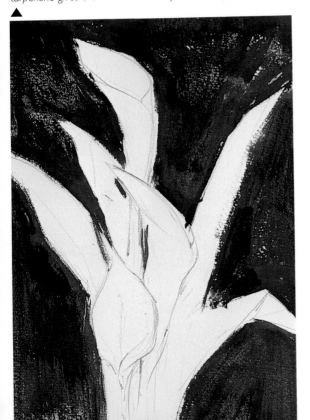

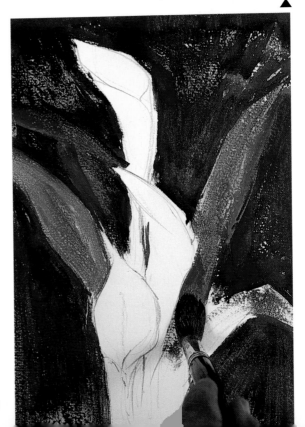

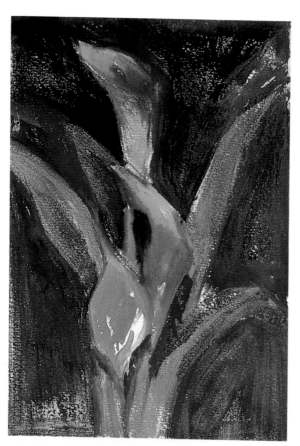

▶ 1. *In spite of using these special techniques the watercolorist must always keep in mind the principal techniques: that is to say if you do not want tones or colors to mix you have to wait for the previous layer to dry. Once the green leaves have dried, the red central flowers can be painted. In this area turpentine is not used. However, it is used on the upper flower in which ochre, sienna and red are present.*

COMBINING TECHNIQUES

The special techniques do not have to be used constantly in watercolors. In general, it is better to use these effects as very defining notes in any work. All the techniques of watercolor must be combined intelligently so that the painting is not cluttered up with special effects.

3. *Finally, once the necessary scrapes have been done, repaint with darker tones to outline the forms or to include layers through which the background of the paper can be made out.*

▲

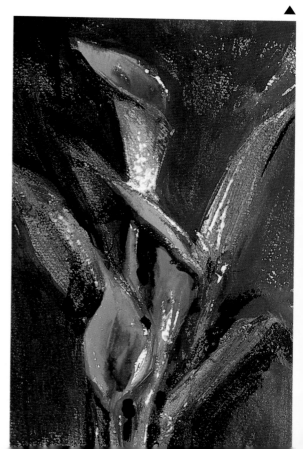

▼ 2. *When all the painting is completely dry, the cutter is used to open up new textures and to lift up the white of the paper. The long strokes produce white lines, while, if little scrapes are made close together, very textured white areas are achieved, as can be observed in the upper flower.*

Step by step
A boat on the sea

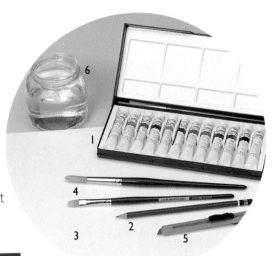

In the following exercise a theme that combines the principal techniques of watercolor is going to be dealt with: the color wash and the brushstroke superimposed on dry. In the exercise not too many texture effects are going to be done, only those that are vital, like scraping with the cutter or with the end of the brush. Here the subject is a marina with a boat. It is not difficult to do if you pay close attention to the steps detailed below.

MATERIALS

Watercolors (1), pencil (2), watercolor paper (3), watercolor brushes (4), cutter (5), and jar of water (6).

1. *A subject like this does not need great drawing skills, but it is necessary to know at least how to sketch the form of a boat with the essential lines. After these first lines you can start to paint the first color.*

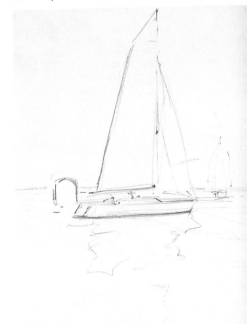

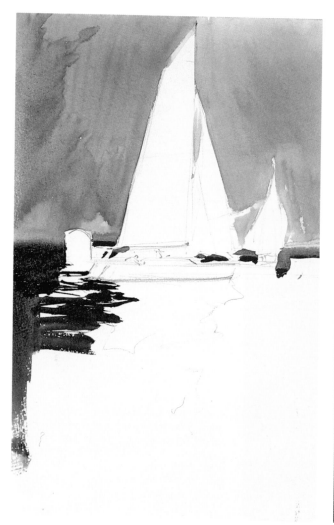

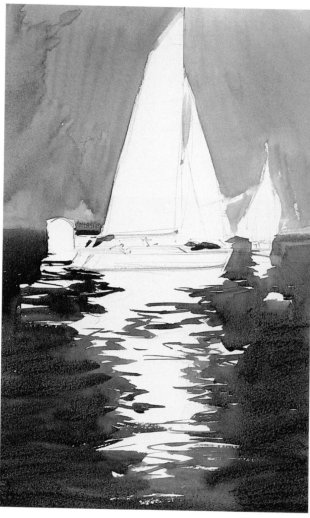

2. A first wash is made over the background with transparent blue, outlining the form of the boat with the brush. It is useful to remember that in watercolor the white is always the white of the paper, so whenever this color is needed, a zone has to be reserved. The color of the sea is begun with dark blue. In the same way that the white of the sail has been reserved so too are the highlights in the sea.

3. In this step the complete outlining of the shape of the boat is finished in the principal tones of blue. Pay attention to how the whites in the water are reserved. The brush is used to draw the dark zones of the reflections with horizontal brushstrokes. In some areas within the reserve these brushstrokes have a very mannered look.

> The most luminous areas must always remain white. This means that later grey tones can be added as nuances of the white colors.

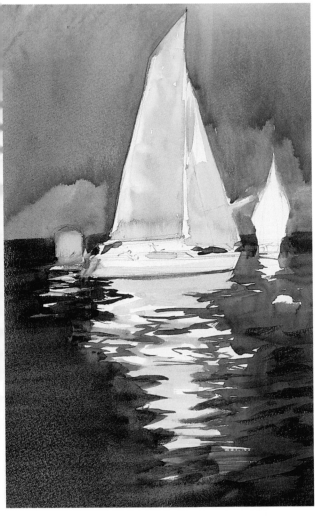

4. *The background is made darker by recovering it with a new blue wash; this allows a break to be made with respect to the first layer of color which is already dry. The work on the sea is developed with the same very dark blue with which the area was initiated. As new layers are superimposed on top of former ones a darker tone is achieved which represents the waves of the sea. Wait until all the color is dry and then paint, the sail and the hull of the boat in grey, and the white reflection in the water. The buoy is painted yellow, and a red waterline is added to the boat.*

5. *Before the grey tone of the sails is completely dry, the back of the brush is used to trace the lines of their structure. The color quickly falls into these little "furrows" and they become saturated. With the same grey color used on the boat the darkest zones of the hull and of the sea reflections are modeled. Now that the sea color is completely dry the shadows can be painted in with irregular horizontal brushstrokes.*

6. *The cutter is used to begin the outlining of the brightness in the sea. It is not necessary to scrape too much: passing over a few times to lift little scrapes will be enough so that the brightness shows up perfectly.*

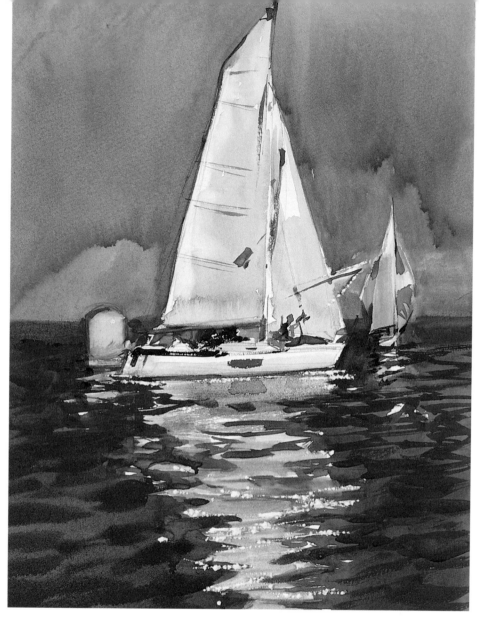

7. *Using the knife finishes off this work in which different techniques, related to the moistness of the color on the paper and the work on the texture, done with the knife or with the almost dry brush, have been combined. It has been demonstrated that the light effects produced by the scrapes on the paper are striking. To maintain interest it is necessary not to overdo the use of this technique.*

It is important to work on heavy grained paper. These effects cannot be done on thin paper.

SUMMARY

The first layers have the role of completely outlining the form of the boat against the backdrop.

The brightness of the sea is obtained with the trails left by the brushstrokes on the white of the paper.

To do the sails the back of the brush is used.

The textured zone has been opened with a knife, making soft lines.

Value and modeling

LIGHT AREAS, HIGHLIGHTS

To place the highlights on any object it is important to know the direction from which the principal light comes. Light falls on an object and runs over the shape; depending on its intensity it will provoke shadows or highlights of varying luminosity.

The valuation consists in the correct gradation of the tones to achieve a scaled effect of grays on the surface. A valuation is nothing more than classification of the possible tones that can be obtained from a color. In previous chapters the different techniques of the watercolor have been studied. If in a scale of tones the differences between one tone and another are made finer until a point is reached when it is impossible to appreciate the difference, an effect of modeling is achieved. Starting from the basis of this explanation the volume of an object can be painted according to the light that falls on it. In the exercises that we are going to do in this chapter ideas that we have learnt before will be applied. It is fundamental to pay a lot of attention to the images and to the explanation.

▶ 1. As already stated, the drawing is the basis of all watercolor work. It is crucial not to forget this before starting any work with the paint. This preliminary drawing should always be as clean and neat as possible: the lines must only indicate the fundamental shapes of what is going to be painted. The jug is drawn and the shape of the shadow is also defined. So that the effect of the light can be observed more closely, the background is painted with ochre.

▶ 2. Wait until the background is dry. Afterwards, use a blue color mixed with ochre for the shadow zone of the jug. All of the process that is now going to be explained must be carried out in one go, before the color that has been painted onto the paper can dry out.

3. The brush is dampened with clean water, it is drained and then it is run along the edge of the still fresh brushstroke. The wet brushstroke with the color has to follow the shape of the jug. It is dipped in water, drained, and run along the edge of the gradated area again. In this way you obtain a gradated area which fits the shape perfectly.

▲

▶ 1. *Just as in the last exercise, a ceramic jug is taken as the reference. Here the light is frontal and therefore the most luminous point is in front of the viewer. The shape is drawn carefully and any unnecessary lines are rubbed out. The area that surrounds the shape is painted in a yellowish orange so as to emphasize the shape.*

ALWAYS DARK ON LIGHT

The process of watercolor painting has a premise that must always be respected: the lighter colors must always be reserved, the dark colors outline the highlights and light areas cannot be painted over dark tones. That the color white is only contained in the color of the paper and that it is the darker colors which isolate it and make it stand out are important factors to bear in mind. The subject of the color white in watercolors has been dealt with previously. In this simple exercise a valuation is going to be realized using the color sienna. The color white will play a role through the gradation of the tones.

3. *Quickly, without allowing the color to dry, the brush is dipped in clean water and drained off. Several brushstrokes are made following the shape of the jug. The color is gradated and valued toward the centre of the figure. The dark color remains on the edges of the shape. When the color is almost dry, make several brushstrokes on the right-hand side of the shadow: the color comes out a little and provokes an effect of volume. This technique will be constantly used in all the spherical shapes painted with watercolors.* ▲

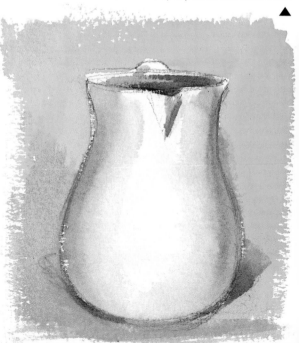

▼ 2. *This time, to do a variation on what we did in the last chapter the white background of the jug is dampened before applying the darker color. The brush is dipped in sienna and both sides are painted in the same way. The color tends to spread out over the damp zone. On the spout of the jug the shadow is painted with very fine brushstrokes.*

MERGING COLORS AND TONES

To get the volume right it is necessary to control the merging of the tones. The level of moistness of the color will be a deciding factor in controlling the merging of the colors properly. It is necessary to wait for a prudent period of time so that the modeling of one color onto another can be achieved by gently caressing with the brush. In this exercise the subject is an apple, but the technique is valid for any other object or color.

1. To do these exercises of valuation and modeling, subjects that are straightforward to do have been chosen. In general, it is always easier to paint an object that does not require perfect symmetry like an apple. After having drawn the fruit, paint all the surface of it with a very luminous yellowish green. As you paint, the most luminous area is left in reserve. As said before, the painting must be done from light tones to dark, that is to say, first a very transparent color and then the center of the fruit is painted, but in a darker tone.

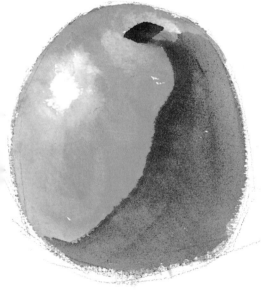

> To open up highlights any brush can be used, but it is always better if it has many hairs that allow a good tip to be obtained. Sable hairs are the best.

▼ **2.** *When the first color laid down has dried, all the shadow zone is painted in a dark green. The color does not have to be applied wet because the valuation must not be done by merging with the previous tone, but by gradation of the last color. In the picture, you can appreciate the direction that has been given to the brushstrokes. First, the brushstrokes define the contour of the shadow. These brushstrokes are then stretched to the right with a soft inclination and in a straight line. Lastly, on the right side the clean and drained brush is passed over again, following the shape of the apple.*

3. While the color is still fresh the paint is brushed to the right of the apple in a soft gradation of the background. If necessary, you can paint a little more of dark green in the central area, but not in the part where the tone is gradated because otherwise you would not be able to do valuation work with the color. To finish the modeling, before the color dries completely, stroke the clean and semi-wet brush along the profile of the shadow so as to soften the abrupt edge.

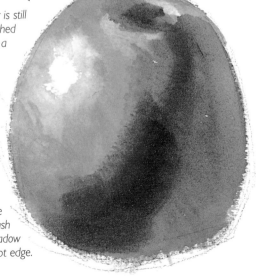

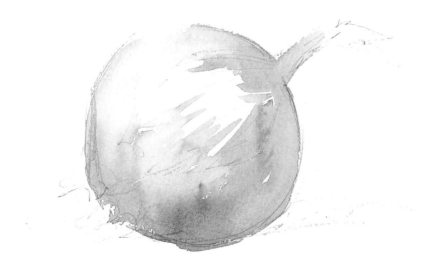

▶ **1.** *After drawing the shape of this onion, the color is applied onto the completely dry background so that the principal highlight can be placed at the same time. The brightness is created with long drawn out, supple strokes. The valuation has to be done while the color is still wet. On top of the first very luminous wash, a few small brushstrokes of carmine are made in the lower part. The color quickly merges into the contours but adds a certain volume.*

VOLUME AND FINISH

O n the previous page we studied how it is possible to achieve the volume effect thanks to modeling the valuation. Sometimes, the object depicted requires a better finish than that obtained by values and tones. To obtain this finish it is necessary to combine the techniques studied up till now. First of all, work is done on the values and white reserves and later the texture is added to the dry background.

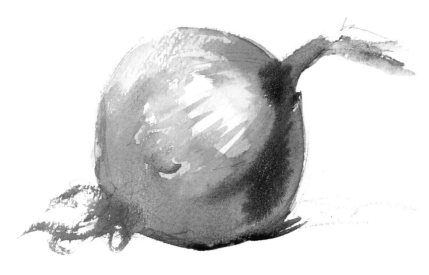

▶ **2.** *The application of color is begun on the right side of the onion, keeping the brightness intact. The background is still wet and the violet sienna color that is painted now must not be too watery so that it can maintain its density. The brushstrokes merge on their own in the curves, while spreading to the limit of the wet background.*

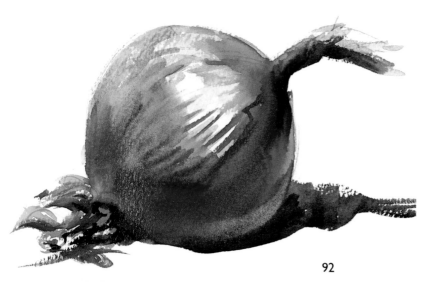

▶ **3.** *Until now work has been done on the wet background; the work of valuation not being very different from that done in the rest of the chapter. To paint on the texture it is necessary to let the background dry. The painting of the texture of the skin is begun with a violet color obtained from sienna, a little carmine and blue. Long and supple brush strokes are made in the highlights. An area of shadows is also made, merging the colors. Finally, as has been done in previous examples, with a clean, wet brush the highlight on the contour in the shadow zone is opened.*

Still life of fruits

The color, the brightness, the highlight or the texture can all be varied but essentially the process of valuation and modeling of the shapes is always the same. Getting striking results is a question of study, and above all of a lot of practice. Now we are going to put into practice the notions that have been learned in this lesson. It will be necessary to pay attention to the drying times of each area. Sometimes the work will be done on the wet background, and at other times it will be realized when it is dry. A model with a variety of colors and textures has been sought out so that different solutions to tone valuation questions can be worked on.

MATERIALS

Watercolor paper (1), watercolors and palette (2), water-color brushes (3), jar of water (4), and support (5).

1. *The work is begun with a very plain sketch of the shapes that you want to represent. As can be seen, it is not very complicated but this drawing has to be done neatly and with precision. Do not start painting until it is complete.*

93

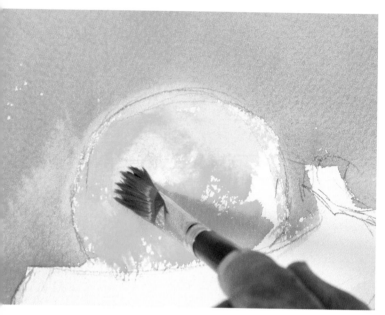

2. *As was done in the first exercises on this subject, isolate the principal elements of the picture by completely painting the background. In this way the shape is outlined and the white of the paper is perfectly marked out. A broken tone of green, sienna and ochre is used to paint the background. To increase the luminosity of the white, the tone that surrounds the shape of the fruits is darker than the rest. Once the background is dry you can start to paint the orange. Pay attention to the highlight: the color tone is densest in the shadow area.*

To correctly model the tones and colors, the work must be done before these are completely dry.

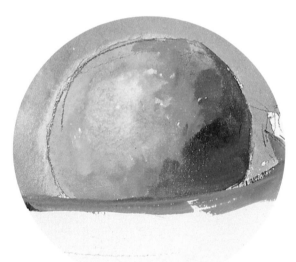

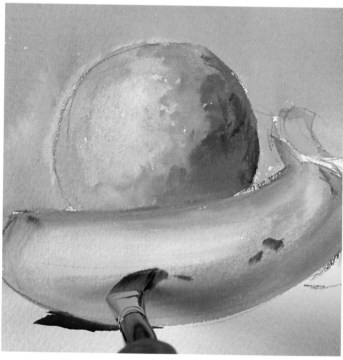

3. *The valuation of the orange is done with progressive tones of the same color, always conserving the same highlight as a reference for the volume. To do the valuation around the shadow, luminous green, orange and some sienna are mixed in the palette. A curvature that follows its shape is painted on orange. Where the highlight meets the shadow, brushstrokes tinted with red are made. Once the orange is dry, the painting of the banana is initiated with long brushstrokes in luminous green; follow its shape.*

4. *Be very careful of the valuation of the tones of the banana. Before the green of the first brushstrokes are completely dry, the banana skin is begun with golden yellow. The direction of the brushstrokes has to follow the shape of the banana and pull the green until it is softly merged into its contour. In the lower part the valuation is realized with some sienna and orange. Lastly, in the most luminous part of the banana the clean, wet brush is passed over until some of the color is drawn out.*

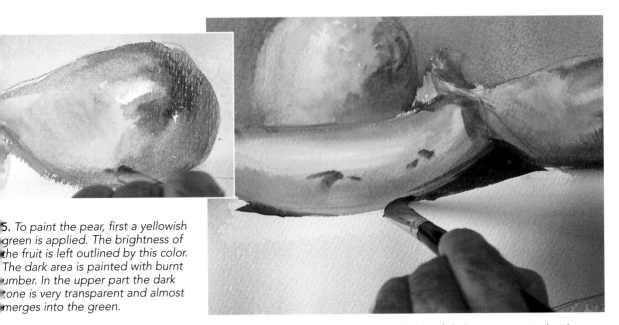

5. *To paint the pear, first a yellowish green is applied. The brightness of the fruit is left outlined by this color. The dark area is painted with burnt umber. In the upper part the dark tone is very transparent and almost merges into the green.*

The color of the paper gives luminosity to the paint. The dark tones do not allow reflections from the paper. These tones must only be used in the darkest area.

6. *A little of dark green is mixed with some water, not too much, to darken the pear. The brushstroke must follow its shape, pulling and merging with the shadow color. In the lower part of the pear, to increase the modeling effect, the clean, wet brush opens up the typical brightness. Once the pear is dry a final transparent layer of green shadow is is painted in the highlight area. On the tablecloth, the shadow is painted in very dark burnt umber.*

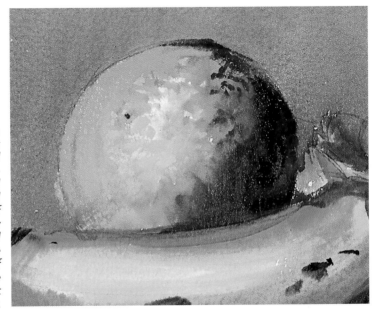

7. *So far we have done the complete modeling of the three pieces of fruit but the contrasts are not accentuated enough. If the contrasts of the shadows are increased, the highlights will stand out more and the volume will be more accentuated. The finish of the orange is begun with a very dense cadmium orange and small brush strokes to make the texture more noticeable. The upper part of the shadow is painted with a mixture of violet and carmine which as it descends turns into burnt umber.*

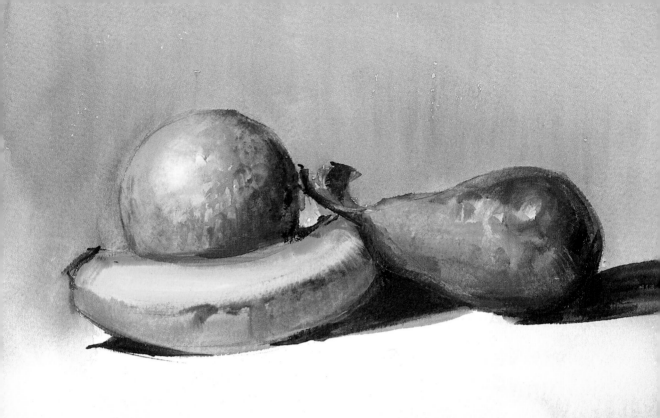

8. *The painting of the orange is rounded off by merging the dark colors that have just been painted into the background with successive brushstrokes. On the pear the shadow is painted with burnt umber and soft brush strokes are made on the limits of the green until the tones are integrated. On the right of the pear shadow, on the dry background, long, wet brushstrokes open up a soft area of light. Lastly, to darken the banana, the lower part is slightly dampened so that the shadow color expands gently. Thus this watercolor with valuation is finished: the shadows and the white of the paper have played the leading roles.*

SUMMARY

The background is painted first so as to emphasize the shape and light of the fruits.

The brightness of the orange is left reserved from the beginning.

The green color of the banana is softly merged into the yellow tone.

The highlight above the banana is opened with a clean, wet brush.

The contrasts on the orange increase the volume effect.

The green of the pear is done in two phases: the first to approximate the tone, the second with a darker green, dragging and forming the tone of the shadow.

On the banana the darkest plane is painted once the lower one has dried. Firstly, the zone is wetted so that the shadow color merges in.

Still Life

PREPARING THE MODEL

In this topic we are going to develop important concepts related to the technique and practice of the still life. To do a faithful still life it is first necessary for the set up to be correct for it forms part of the composition itself.

Still life is traditionally the pictorial genre that generates the most interest. It can be practiced from the moment you start with watercolors. It is important that the enthusiast covers all of the topics so that the creative capabilities which most suit the artist can be developed. Doing landscapes can involve concepts that leave aside questions related to the still life. For example, the proportions or precision in the form of a landscape are not always paramount. Conversely, in a still life these questions are indispensable.

▶ *The still life is one of the subject which keeps the majority of painters the busiest. To elaborate a still life, the model has to be prepared with care and the possible composition techniques have to be thought out.*

The phase before painting a still life can be as simple or as complicated as the artist wishes. It is always wise to invest a certain amount of time in the preparation, especially if you do not want the still life to be run-of-the-mill, but attractive for the unity of its forms and colors.

▲

The tools to arrange the flowers are diverse. Scissors, water atomizer, wire and synthetic cork to fix the bunch. The pot to hold the flowers is also important for the picture depends to a great extent on the objects that make up the composition. The model must be laid out so that it offers the image sought after before painting. If a flower is too droopy a piece of wire can be thread into the stem so that it is held upright as desired.

▶ Piling up or placing the objects too close togther prevents a correct composition. A lack of space compresses the objects and makes the whole set-up heavy on the eyes. The space around the collection of objects also forms part of the painting. Grouping the objects too close spoils the harmony of the composition.

THE STILL LIFE MODEL

When preparing the still life, some key points have to be borne in mind, like, for example, the composition of the model that will be used as a reference. The grouping of the elements of the still life is a fundamental question that has to be considered whenever two or more objects are in use. Here we will explain a few practical concepts about the location of the different elements as well as the relationships that are established according to the distances between them.

▶ When the objects are spread out too much the whole composition breaks down completely. The distance between the objects of the still life marks a visual rhythm and helps to establish the basic lines of the composition. Therefore, avoid dispersing the objects that make up a still life too much.

▶ Grouping the objects correctly before painting is not difficult but it requires attention and a sense of composition. When the objects are placed for the still life you have to stand back to coolly observe the whole. The corrections that are made to the model must always be made from where you are going to paint. To obtain an adequate layout for a still life, a harmonious and balanced composition is called for, without excessive bunching nor too much dispersion.

TYPES OF STILL LIFE

It is possible to find inspiration for a still life anywhere, it is just a question of looking around you to realize that the majority of objects that surround us can be part of a composition. Up until now we have seen numerous still lifes with classic elements, such as apples, bottles, and flowers, but you do not have to draw the line here. Even the most everyday objects can be used as a model worthy of being painted.

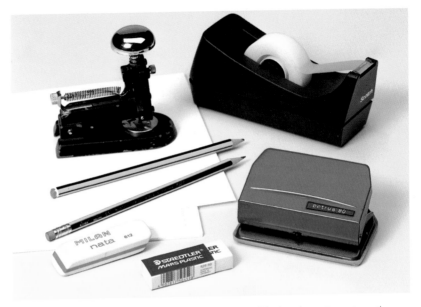

A flower shop can be an ideal place to practice. Another alternative is a public park where a flower bed can be the subject. Photographs are also a good source, enabling you to work at home or in the studio.

▲ *Before beginning to paint any still life it is indispensable that the artist prepare the subject that is going to be painted. It is necessary to have available the things that are going to be the part of the still life: flowers, fruit, pots, or a combination of objects which offer an adequate composition for the picture. With the necessary material spread out on a table you can begin to set up the still life according to make a balanced composition. This collection of desk items is an example.*

PLACING AND SHADING

As we have explained, before starting to paint it is necessary to bear in mind a series of matters related to the model, among others the placing of the different elements of the still life. Once they are adequately laid out you can start to work on the model. This little try-out aims to initiate the enthusiast a step further in the still life. By painting these flowers we are trying to convey the idea that even the smallest detail needs preparation. We are going to practice with the following example: set up this floral still life, studying the elements that compose it. It can be painted as shown below.

▶ *Drawing is necessary for the completion of every still life. It starts out from a simple structure, just the general forms that become more detailed and gain body as the lines find their exact place on the paper. It is much more straightforward to do a picture with a good structure, with the objects fitted, rather than just starting out freehand with nothing to guide the painting. From a scheme already conceived, it is easy to finish the forms and the color. The whites of the flowers are perfectly outlined by the darker tones.*

▶ *Painting any watercolor has to go from the general idea to the details, from light to dark. General toning brings the smaller forms closer as it outlines them without going into details. When the whole idea has been completely sketched in, the forms are corrected and the smallest forms are defined with fuller shading. The drying of the different layers must be respected if you want to avoid the colors mixing.*

▶ *The colors have to be applied progressively, always from light to dark. The most luminous tones are enclosed by the darker tones and in this way the forms can be made firmer. Finally, the small details and the layers that give nuances to the white are painted in.*

ILLUMINATION

▲
Illumination is one of the important factors of a still life. Observe how the same still life in the two pictures above completely changes with the light. Both versions are correct but they are radically different.

Step by step
Still Life

The still life that has been chosen for this model has a great variety of warm colors. Also, it can be seen that some elements like the pumpkin or the fruits have decidedly cold zones. These will help to compensate the overall excess of warm colors. Great care has been taken to prepare the model: a harmony has been sought between the different elements, trying not to put them either too close or too far apart. Composition is one of the principal factors in the realization of a still life. It starts with the preparation of the model.

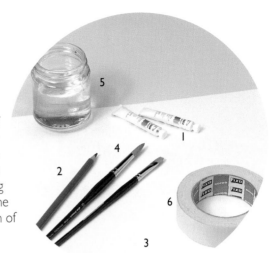

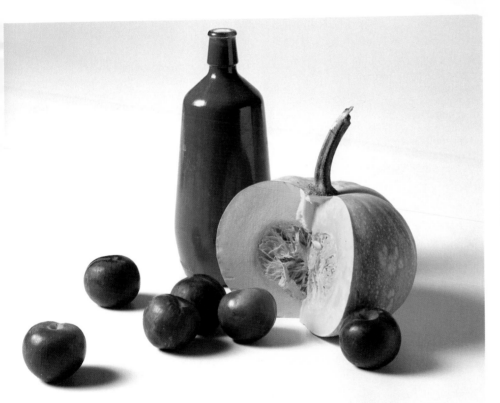

MATERIALS

Tube colors (1), pencil (2), medium grain paper (3), watercolor brushes (4), jar of water (5) and tape (6).

1. *Start doing a rough sketch without rubbing out the double lines and trying to respect the correct proportion between the elements. The shadows are also put in, placing each one carefully to avoid any error in the painting which is started with an ample yellow wash. The background is not painted completely: the areas that will contain very luminous highlights are left in white. The color is not painted with the same intensity in all the areas: lower down the tone is intensified and the rest is much more luminous. The inside of the pumpkin is painted in a quite pure orange tone. On the left side the tone is darkened with a dash of blue.*

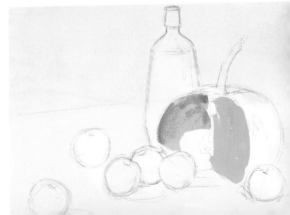

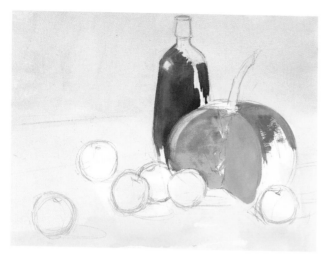

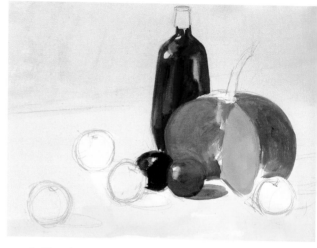

2. Now you are painting with the warm part of the chromatic range, although blues and greens are used to cool it down and to darken the shadows. This is how the dark areas on the outside of the pumpkin are approached. The bottle is started in a dark red lightly mixed with sienna. The space reserved for the highlights in the crystal is left blank. This first color of the bottle is going to be the base of other darker colors.

3. The dark parts of the bottle are painted after adding burnt umber to the red of the palette. The previous layer is showing through this new darker color as a highlight. Also, a new reserve is left so that the red of the background can be seen. Where the pumpkin is cut it is painted with long strokes loaded with red tones. The part in the center is painted with a very intense red and the dark part is tinged with burnt umber. The outside is painted in a clear green, the brushstrokes merging with the orange colors. The plums are a carmine red, except for one which is a dark violet blue.

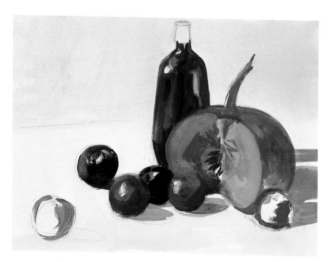

4. The remaining plums are depicted in a variety of warm tones, in red, carmine and yellow. The shadows are painted with a little burnt umber added to the mix, leaving the brightest points unpainted. The darker fruit is colored with cobalt blue and dark carmine added into the mix.

5. Use supple strokes to paint the center of the pumpkin in reds and browns. The shadows of each one of the elements of the still life vary in tonality according to the color of the object that projects them: purplish for the plums and slightly gray for the pumpkin.

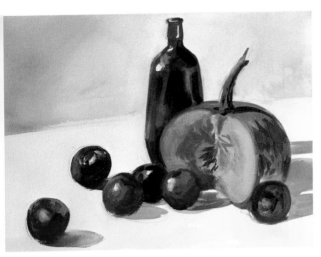

6. Finish painting the plums, perfectly placing the colors to show the highlights and shadows. Various blue nuances, or purplish tinges, when in contact with the warm colors, round off the tones of the fruit. The projected shadows are also painted: they vary in tone according to the colors that surround them. The nearest shadow to the pumpkin is darker than the others. The highlight of the bottle strongly contrasts with the very dark purplish mix, although the most luminous parts of the glass are not too bright.

7. The outside of the pumpkin is painted in a green mix with a dash of carmine, creating an olive tone that contrasts with the bright green and the low orange area.

8. Note carefully the delicate variations in this step with respect to the last. The definition of the volume of the two plums on the left is concluded. Although the contrasts of the shadows of the plums are cold, the purplish tone produced from the carmine mix gives it a warm nuance.

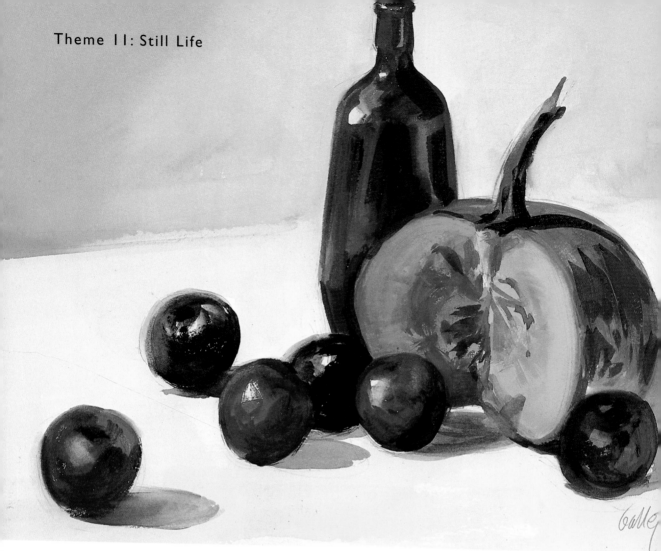

9. To finalize, warm tones that contrast with the different textures are used for the interior of the pumpkin. The chromatic ranges that have been used harmonize with the colors of the composition. This exercise has practiced the composition of warm colors but without excluding greens or blues.

SUMMARY

The initial sketch must organize and carefully compose the objects of the still life.

The dark areas of the plums come from the superimposition of blues and carmines.

The highlights are left clear from the outset.

The planes of the pumpkin are in two tones, one darker than the other.

The shadows that are thrown form part of the composition of this still life. Each shadow has distinct nuances from the others.

Figure

DRAWING AS THE BASE FOR PROPORTION

As we have seen, all the elements of nature can be synthesized from others which are simpler. To illustrate this we are going to look at the construction of a hand. This is one of the most complicated parts of the body to paint: however, as you will be able to see, with a good drawing the proportions and the fundamental anatomical forms can be perfectly shown.

The figure is one of the greatest challenges that a watercolorist can take on, not only because of the subject itself, but also for what can be done with the watercolor techniques. With other pictorial themes a watercolor can have some limitations. However, with figure exactly the opposite occurs. This subject requires a lot of rigor, starting of course with the initial drawing. Although this book is about watercolor, it is important to bear in mind that the outline of the drawing is the base of the color. Therefore, when doing the drawing it is necessary to constantly keep in mind the painting process.

▶ *The initial sketch has the task of laying out the most elementary and simple outlines before filling them in with color. These outlines have to be expressed in very straightforward lines and at the same time they have to fit. To draw this hand observe the interior spaces, the inclination of each one of the lines and the distance between them. The advantage of starting with such a simple sketch is that the corrections to the outlines are also very easy.*

◀

Having done the initial sketch, and having accepted it as valid, the drawing is concluded in an approximate way, but without leaving any line that could induce error in the painting. Before starting to paint, the drawing, although simple, has to be perfectly finished. In this case the hand is finished in a very elementary but effective way: it is enough to fill in the dark area that surrounds it and then the medium tone that reveals the form of the knuckles. Finally, the fingers are not painted completely: they are just hinted at by their shadows.

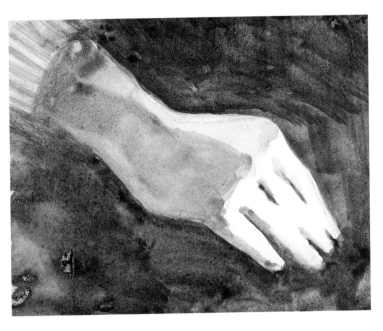

THE PLAN OF THE FIGURE

The figure must be planned in detail, like the hand, but apart from the possibility that these geometric shapes offer, it can be constructed from a well-studied internal structure. In general, the figure moves on several axes which, according to how they move, change the pose of the figure; these axes are shown by the lines of the shoulders, the spinal column and the hips

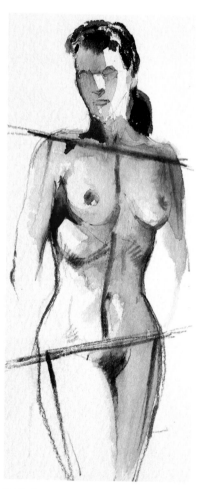

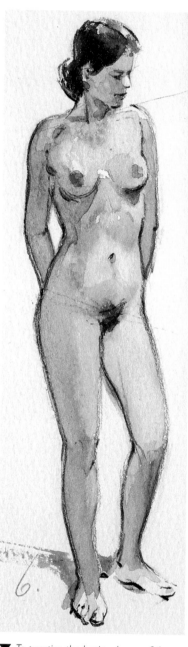

▼ 1. The upper line will be used to show the position of the shoulders. In the central zone the spinal column is represented with a vertical line. The line of the hips, just like the shoulders, will be inclined so that the legs are in a natural pose. Starting from the hip line, the proportions of the legs are sketched with straight lines and the joints are defined.

▼ 2. Building on the previous sketch the drawing of the figure is constructed. As you can appreciate, a lot of practice is needed to constuct the figure, but the system of fitting it together using axes allows a well proportioned development and the security that the drawing is reliable.

▼ To practice the basic scheme of the figure try to find the internal lines of this already finished figure. In the first place, set the axes of the shoulders and of the hip, then the spinal column, and finally, do the sketch of the arms and legs.

THE VOLUME OF THE FIGURE

When you have learned to construct the figure correctly, the next step is to give shape to the drawing. This is done with color and the various light effects that are carried out on the paper. Just like the other themes that can be painted with watercolor, a certain amount of light is projected on to every figure. This means that some areas can be represented with light and others with shadows. The light areas always have to be those reserved by the darker tones. It is precisely this effect that produces the volume. The parts of the figure most exposed to the light will have to be outlined by the shadow, which will always adapt to the anatomy. Here are two exercises.

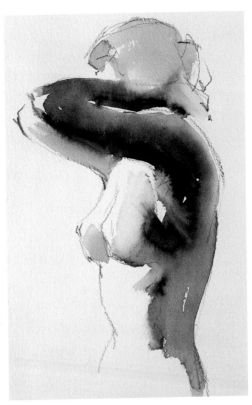

1. Once the figure is defined and the drawing is refined, the painting of the volume is started by placing the shadows and the light areas. When starting out with the volume procede with caution for it must be suggested by the points of maximum luminosity. In this example the most luminous parts are perfectly marked out by the darker zones. Likewise, in these shadows medium tones are also painted in. It is sufficient to absorb part of the color with a clean, dry brush while it is still moist on the paper. Or otherwise wash the area with a clean, wet brush if the color has dried completely.

▼ *First, the drawing must be constructed as correctly as possible. Starting from the dark areas the densest shadow tones are established. These, in turn, are the backdrop to the highlights. Lastly, the background is darkened and the shadows are merged with the most illuminated areas.*

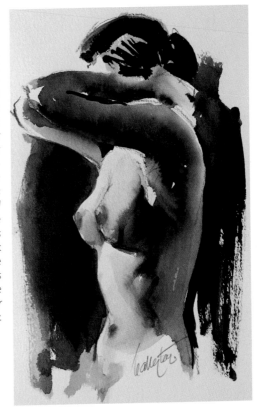

2. The volume is finished off with medium tones that pull some of the darker tones towards the lighter ones, and then they are blended by repeatedly passing the brush over the most luminous parts. To put the final touches to the contrast of the body of the figure, all that has to be done is to paint a dark background. In this way the shadow tones are perceived as having more volume due to the contrast, while the clearer tones gain luminosity.

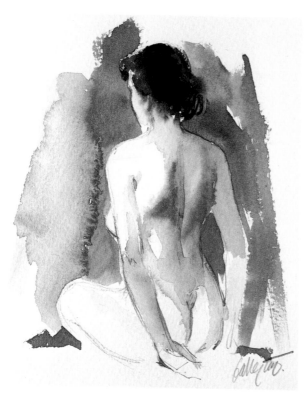

TECHNIQUES OF SYNTHESIS

The synthesis should be the principal recourse of the water-colorist. Synthesis means the process by which the representation of the objects is reduced to the most basic elements. In general, when painting without experience there is a tendency to fall into the trap of cluttering with excessive details. As experience is acquired, unnecessary factors are eliminated. Here we are going to study the synthesis process in the figure and how economizing on techniques can give much more expression to the overall effect of the picture. To paint well you have to know what is important and what is superfluous.

▶ *Paint this figure following these steps: first sketch the general lines within a triangular form, omitting any detail. Draw the lines that reveal the shoulders and the spinal column. Finish off the drawing of the body with only essential elements. As you can observe, the fingers are not drawn and the legs are hardly outlined. However, the figure is completely defined. With a very quick shading, the forms that make the highlights stand out are finished off.*

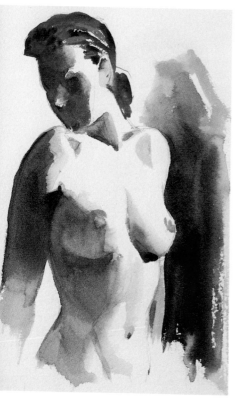

▶ *1. The dark parts of this figure define perfectly the principal points of light and allow the form to be modeled. On one hand they integrate the shadow into the illuminated area, and on the other they open up small highlights in the volume of the breasts. To achieve the maximum contrast all the side that is in contact with the illuminated zone is darkened.*

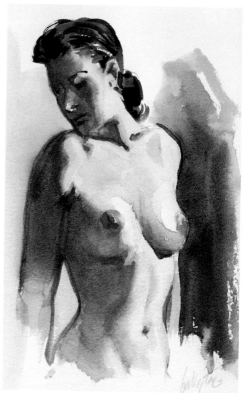

◀ *2. By being very economical with techniques, it is possible to paint figures of a fairly advanced technical level, despite doing away with unimportant details. Instead, the light points and the modeling of the shadows have given definition and volume to the figure.*

Step by step
Female back

In this exercise the aim is not to do an excessively complicated painting. If one studies the approach to the principal volumes, starting with their shadows, it will turn out to be very easy.

On top of the picture which will be used as a model, a graph has been superimposed so that it is easier to sketch the principal planes. The lines "a" and "b" correspond repectively to the lines of the shoulders and hips. Starting from these two lines a trapezoid is done on one side, and on the other a triangle and a square.

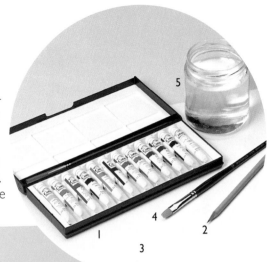

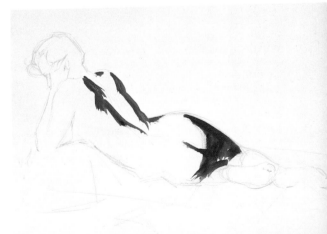

MATERIALS

Tube colors (1), pencil (2), watercolor paper (3), watercolor brush (4), water jar (5).

1. *Starting from the simple geometric shapes drawn on the model, outline the figure. The back fits into a trapezoid, the pelvic zone from the waist to the hip fits into a square, and the legs and feet into a triangle. From these forms it is easy to define the basic anatomy of the model. The drawing must be perfectly finished before starting to paint. Once it is done, start painting the dark areas with burnt umber.*

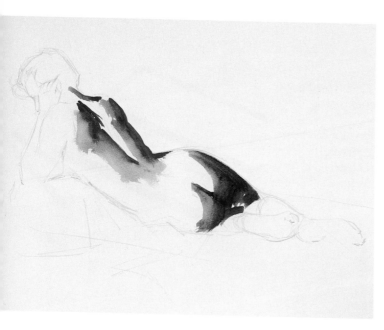

2. *With wet, clean brushstrokes color is dragged from the back in a soft gradation, reserving the strip of the spinal column. The process is continued with the shadow of the legs which defines the round shape of the buttocks and frames the shadow of the hip.*

Sometimes it is difficult to imagine the result of a color on another, above all when it is a question of several layers. This is why it is always recommended to have available papers of the same quality as the one being used in the definite work so that you can do color blending tests and check the final result.

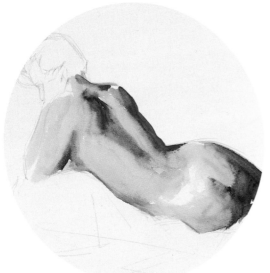

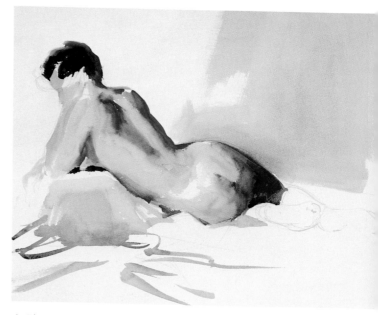

3. The color of the flesh is obtained with an orange transparent layer. When the paper is wet, the sienna tone that is added to the side of the body blends in easily and suggests the volume. A very faint purple tone is added in the armpit zone. The form of the buttocks is modeled with almost dry color: the burnt umber is blended by successive brushstrokes. A very transparent greenish yellow layer is added which mixes with the previous coats of color.

4. The contrast of the armpit is increased and the hair is painted with a burnt umber and cobalt blue tone. The color of the skin is obtained from the illumination of the space that surrounds the figure. A transparent wash of burnt umber and blue is prepared with which to paint the background of the picture in a somewhat irregular way. The bluish hue is intensified around the hip.

5. When superimposing tones or planes, synthesis or summary should be the main objective of the water-colorist. A lot can be expressed by well-placed shadows and by omitting unnecessary details. Therefore, to paint the hand the fingers are not drawn. This part is resolved with the dark shadows that surround the illuminated area. The back of the hand is contrasted with a slightly bluish burnt umber. The fingers are defined by the hair and by the shadow of the face.

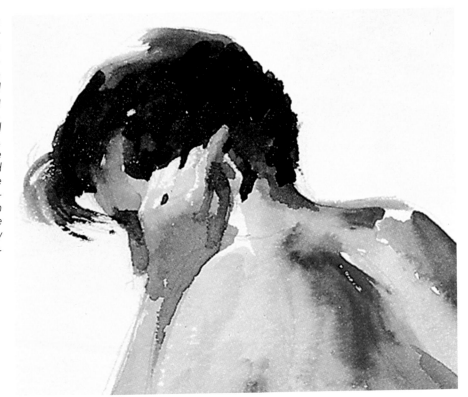

A general layer can be painted at the end of the session with the dirty water in the jar. This technique is widely used because this water has a highly transparent broken tone. If this layer is painted, the colors underneath must be completely dry, and you must not insist too much so as not to soften them again.

6. To paint the feet the contrast of the shadow of the legs is intensified and the most luminous areas are defined: the right calf muscle and the soles of the feet. The latter are painted with a very clear burnt umber wash and a dash of blue. The brightest parts are left white. This is the best way to give relief to the highlights of the skin.

7. *The contrasts of the soles of the feet are intensified with small brushstrokes that outline the highlights of the toes. The tone painted before must be completely dry so that the colors do not mix. The brush is wetted and drained off prior to gently brushing the shadow of the* legs *so that they have depth. Finally, the inside of the leg is contrasted and the buttock is defined. Pay attention to the modeling of the buttocks: the brushstroke must be curved and must blend the colors without destroying the shadow as it softly superimposes the tones.*

SUMMARY

The fingers are not drawn in. They are defined only by the hair and by the shadow of the face.

The color of the back is dragged with the wet brush in a gradation, leaving the strip that defines the spinal column.

The figure is outlined by drawing simple geometric shapes into which the model fits.

On the buttocks the brushstrokes must be curved and blend into the colors without destroying the shadows.

The soles of the feet are painted with a very clear wash of burnt umber and blue; the most luminous parts are left white.

13

Quick sketches

SKETCH OF THE LANDSCAPE

O ne of the sketches that is held in high esteem by the
enthusiasts is the painting of landscapes, because of the
freedom and endless possibilities of adapting the subject to their
own tastes and aptitudes.

**The quick sketch is one of the best
exercises that the watercolorist can
develop. Continuously practicing it,
one learns rapidly and intuitively
the techniques of watercolor. Doing a
sketch requires a great effort by the
painter because speed and an ability
to synthesize come into play. The
details are left aside so as to give priority
to the shadows and to the light areas.
A sketch can be done in any place.
All that is necessary is paper, a
brush and some watercolor paints.**

▶ 1. *Clouds change their shape very quickly,
this obliges the artist to work fast. By practicing
the strokes proposed here, you will acquire skill
in rapidly solving problems of color mixes and of
the opening up of whites.*

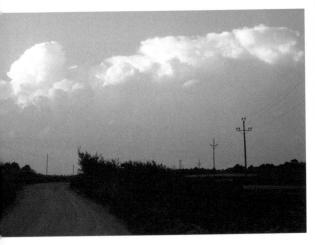

▼ 2. *A line is drawn that defines the limit of the clouds against the
sky. A second line situates the horizon. Starting from this sketch, the
form of the dirt road is indicated. Wet the brush with clean water
and outline the shape of the clouds, without moving into the sky
area. Finally the blue of the sky is painted. As the clouds are some-
what wet, part of the color merges at the edges. This way the
exremely sharp definition of the line is broken.*

▼ 3. *A cold gray is obtained with a cobalt blue and sienna wash:
this is for the contrast of the clouds. The shadows of the horizon
are painted. The path is painted with carmine mixed with violet
and sienna. With a clean, wet brush a clear space is opened up
in the upper part of the path and in the mud in the foreground.
The sketch is concluded with contrasts of dark green for the
bushes on the left.*

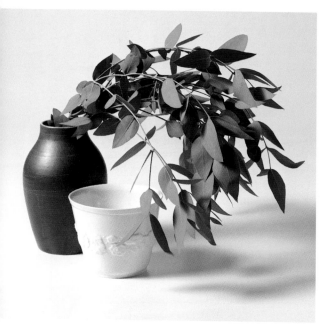

STILL LIFE SKETCHES

Most everyday objects allow the artist to do sketches immediately. Doing an exercise starting from elements in the home or garden enables the watercolorist to practice models and perfect geometric forms, like pots, vases, flower beds and other simpler, but not less attractive, shapes, such as flowers, leaves and other still life elements.

▶ 1. *Any object in the house can be used to do a quick sketch, but there are advantages in choosing selectively. Here a sketch of a still life is proposed. Despite the elements appearing simple, it is much more difficult to draw and paint a geometrically perfectly defined object than a landscape or clouds. In this study special attention must be paid to the highlights and the contrasts among the objects.*

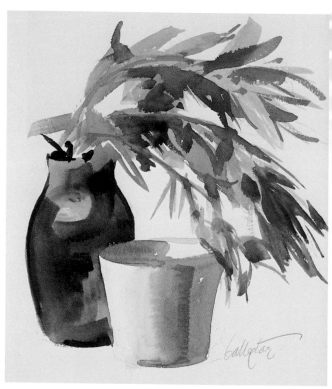

▼ 2. *The sketch is made with a few strokes: precision is not necessary. The pencil need only indicate the principal lines. First the vase is painted with a transparent wash of burnt umber slightly tinted with blue. The flat brush is used to shade all the vase, while the flower pot is outlined and profiled. On this clear tone repaint a darker tone, leaving the highlight unpainted. With a greenish, grayish tone the shadow of the flower pot is painted.*

▼ 3. *The flower pot is finished with the green used before. This stroke on top of the previous tone produces a dark cut. With the clean, wet brush merge the left side of this shadow in a vertical zigzag. Using the same color with which the vase was painted, the form of its left-hand side is now profiled. The leaves are painted with a wide variety of superimposed tones. The darkest are put in once the lightest have dried.*

FIGURE SKETCHES

A figure sketch is more dramatic than a still life one. It brings into play a higher number of more complicated recourses both for shadows and color. The figure not only demands much attention when drawing the outlines, so as to respect the proportions, but also when the skin tones are painted and the same with the clothing. Pay close attention to the simplicity with which the shadows that synthesize the lights are resolved.

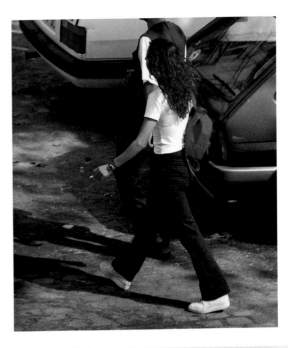

◀

1. The street is the best place to do movement sketches. Here a girl walking has been chosen. Special care has to be taken with the movement and position of the legs and of the arms. It is advisable to do the sketch looking at the real thing, but you can always resort to a photo.

▶ *2. After observing for some moments the person who is going to be the subject of the sketch, do a quick pencil outline of the principal lines. When the model is moving, the initial sketch is more important because it is certain that when the painting is started she will have disappeared from view. If you study this just started sketch, you will see that the main points of interest are the form of the head, the curve of the back, the knees and the base of the feet.*

◀

3. The trousers are finished with the dark blue tone used to paint the dark area. The hair is painted with the original burnt umber, darker on top and mixed with an orange tone at the back. The rucksack is painted in two stages: first with a very transparent red, and afterwards with the same tone somewhat more opaque in the shadow zone. Finally, the small details that define the eyes, the mouth and the gray zone of the shirt are put in.

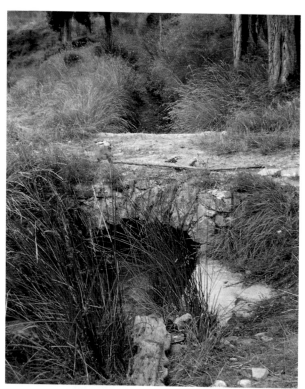

NATURE SKETCHES

As has been observed at the beginning of the chapter, sketches of nature are always freer than more demanding themes like still lifes or figures.

It is important when doing these sketches to reinterpret nature and to improve it as much as possible, varying the too perfect vertical, or horizontal, elements, such as the plane of a bridge or the verticality of trees. Do not hesitate to adapt the sketch to your interests, for at times the model is not always the subject of artistic expression.

▶ **1.** *If you contemplate a woodland area, like the one shown in the illustration, it could seem that it is a complicated subject because of the quantity of details that appear everywhere. One has to learn to see and to appreciate the impact of the image in just one look. Here, you can see a very symmetrical composition with a bridge dividing it across the middle.*

▶ **2.** *Here only the lines that demarcate the arch of the bridge and the river bed, almost hidden by the grass, are drawn. With a great proportion of yellow mixed non-uniformly with green and ochre all the surface of the picture is covered, but for the part below the arch. With a very luminous green the upper shadows are painted: it does not matter if it mixes with the background color. The trees in the upper part are painted with a fairly transparent dark green. The trunks on the right are outlined with a small touch of burnt umber on the dark green. The bridge is suggested with a burnt sienna wash. The area under the arch is painted with quite opaque, dark green.*

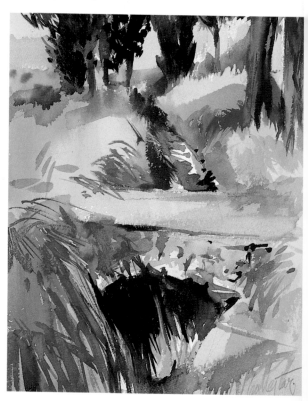

3. *Once the preliminary sketch is finished, paint the contrasts that make the terrain and the vegetation recognizable. The trees in the background are painted with small, supple brushstrokes that allow the light tones to be seen. Finally, paint the undergrowth with supple, gestural strokes in bile green, dark green and bright green.*

Step by step
Figure sketch

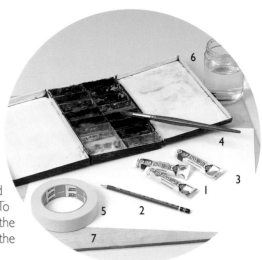

This exercise is very interesting for any watercolor enthusiast, and therefore not just a sample exercise. It goes further and aims at showing what a fast sketch is: fresh and spontaneous; something a beginning watercolorist should always practice.

The painter must respond rapidly to any movement, however complicated it may be. The only way to master each subject skillfully is through practice. To do a quick sketch we have opted for a dressed figure. As can be noticed, the pose involves no difficulty, but pay attention to the initial structure and the immediate solution of the light areas.

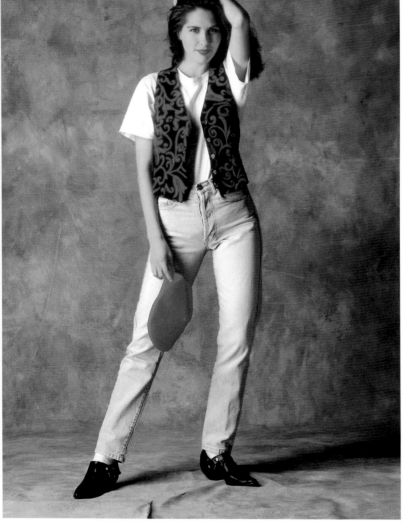

MATERIALS

Tube colors (1), pencil (2), medium grain paper (3), watercolor brush (4), tape (5), water jar (6), and support (7).

1. If a lot of attention must always be paid to the subject, this is even more so with the figure. Before starting to draw you must try and comprehend the internal structure of the figure, and how the proportions of every part of the anatomy relate to the volume of the clothes on the body.

STEP BY STEP: Figure sketch

2. *Throughout this topic, different sketching processes were studied and the synthesis of complex forms using the least number of possible elements in their development were shown. If the examples of the topic have been followed, you will have observed how the forms that require the most details are resolved by taking advantage of the highlights. The face is painted with the same color throughout, although the left side is done with a light wash, this will be the most complicated area. Leave unpainted the highlights in the hair. The latter is to be painted with a mixture of red and blue, complemented with burnt sienna. The skin is painted with a very vivid yellowish orange and the highlights are left open. The raised arm is painted in an intenser skin color. Once the color is dry, the shadow areas of the face are painted with sienna.*

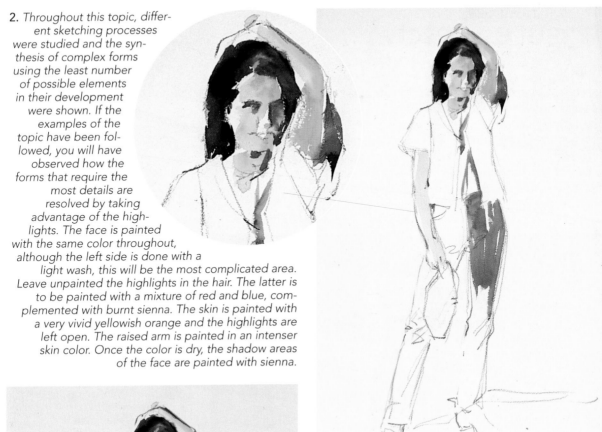

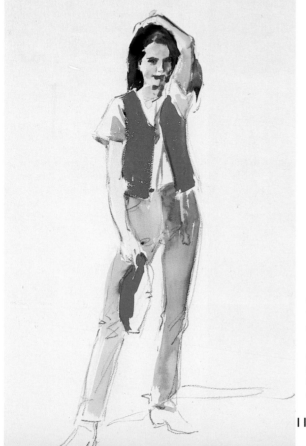

3. *The figure is sketched with rapid strokes. Observe the proportion between the different elements of the body and how the principal lines relate to each other. Not one detail is drawn, and the lines that mark off the volumes are corrected as you go along. Once the drawing is completed it can be painted. In this case it is done in a chromatic order that allows continuous work in different parts of the body. The relaxed arm is painted with a very transparent wash.*

4. *It is the highlights that permit the volumes of the face to be suggested, and the change of tones denotes the different situations of the planes. With a vivid red the lips are drawn. The waistcoat is rapidly painted and the highlighted area of the beret. With purplish blue you paint the rear leg, taking color away from the thigh to suggest volume. The leg in front is painted in the same color as the other, but in a much more transparent tone.*

5. *In this detail you can see the evolution of the study of the face and the upper part of the torso. The work is very quick and excessive details are absent. The pattern of the shirt is resolved with a few dark strokess that leave the same background color as part of the graphic effect.*

Care must be taken working with the folds and highlights of the clothes. These indicate the joints of the shoulders and the knees.

6. *Once the principal shading of the figure planes have been decided upon, start painting the contrast of the shapes and volume, working from the shadowed areas. In the study there is no modeling of the colors, only valuation of the different tones on top of the dry background. Each original tone receives a color of its own range, superimposed, to suggest the volume. The arm holding the beret is rounded off with some brush strokes of sienna, giving it shading. On the darkest leg the shadow is painted and the folds of the trousers are added with blue strokes.*

7. *In the same way that the folds of the trousers have been painted on the left leg, now the same is done on the right. The original blue color is the base of the darker tone that is applied now. On the left leg the tone tends toward violet. The right leg is painted with a much purer, but highly luminous, blue. The shoes, with the highlights left open, are painted black.*

119

8. *Take off part of the orange color next to the thumb and paint in a new very transparent layer of the same color on the arm. All that remains to be done is the shadow cast on the floor. Thus the sketch of a dressed figure is concluded. The importance of waiting for the paint to dry has been seen, even in quick sketches when superimposing tones without them mixing, and how the synthesis of color reinforces the original drawing, starting from reserving the most luminous highlights.*

SUMMARY

The features of the face are very sketchy, but perfectly define every area.

The t-shirt stays white in the brightest parts.

The color of the waist-coat is done in two stages: first the base and then the dark shadows.

On the face the tones are put in around the highlights that are reserved.

The initial scheme is made in pencil, quickly and concisely.

The trousers are done in various stages. The folds are painted at the end.

14 Techniques for landscapes

WATERCOLOR ON DRY AND WET BACKGROUNDS

Trees can have many shapes, but they are easily represented with a simple combination of shadowing. A watercolor must always be painted from light to dark. After outlining the area where the trees must go, a light green wash is applied, and then the contrasts are put in.

When the surface is wet the paint spreads. On a dry surface, on the contrary, the brushstroke can be controlled. The two techniques facilitate the realization of all kinds of landscapes, although what is important is to use the correct technique in the right time and place. If the two techniques are used together with a certain ability this can pay dividends for the landscape painted, or trees, reflexions or atmosphere in the background of the picture.

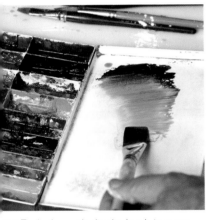

▼ To do the wash, dip the brush in water and load it well before touching a little color with the tip on the palette. Then pull it across the surface, exercising some pressure so that the water is released. Move the color in the water to dissolve it and make a homogenous mix.

▼ Drain the brush; there must not be too much water. Use the wash to color the area destined to be the top of the tree. The brushstroke has to be uniform and cover all the area.

▼ When the lightest color of the tree is almost dry the middle part is shadowed with a tone somewhat darker than the original. This is done with supple brushstrokes. The middle tones allow the highlights to be isolated. Finally, with very dark brushstrokes, the shadows are painted over the dry background.

▶ If you want to paint a far-off group of trees the process is similar to the one explained at the beginning: the shades of the first tone have to be together. The medium tones isolate the light points. Finally, darker strokes over the dry background paint in the shadow areas.

TREES IN THE DISTANCE

In general, the backgrounds of landscapes, like the sky or the water, are painted on wet paper. On this surface, tone gradations and merging of colors can be done which show well the luminosity and atmosphere of the landscape. Once the background tone has dried, different effects are realized to paint trees and reflexions.

▶ **1.** *Before doing anything, the paper must be fixed with tape to the support board. When the paper is wetted it can easily buckle. Fastened by its four corners it will remain tense and tight. The paper is dampened with a sponge, in this way you avoid soaked areas appearing on the surface. On the wet paper, starting from the top, a blue wash is applied. The brush spreads the color from above in strokes that cover all the paper. The further down you go, the less color is spread.*

3. *On a dry background it is possible to do clean and precise strokes. The brush is dipped in the watercolor, which can be watery or denser, before adding new tones or painting trees. One simple way to solve the problem of the foreground is as shown in the picture below: in front of the background some branches are painted in with few strokes and the leaves are depicted with supple strokes.*

▲

▶ **2.** *As many gradations as necessary can be done. The background can be used as a base for any other color. Be careful not to darken the background too much as the transparency and luminosity of the paper would be lost. Wherever a highlight or a lighter color is going to be placed, this area must be left unpainted. On top of the previous background, once dry, a dark gradation is painted. Turn the wood support around so that horizontal brushstrokes can be painted more easily. When you paint on a vertical support the watercolor tends to run down. To avoid dripping, use the brush to pick up excess water and to spread it.*

WHITE IN THE SKY

As has been studied from the beginning of this book, watercolor is very transparent, to such an extent that the white of the paper comes through the color of the paint. Clouds in the sky stand out for their whiteness. They can be shown in various ways, but what is important is to leave the cloud area white.

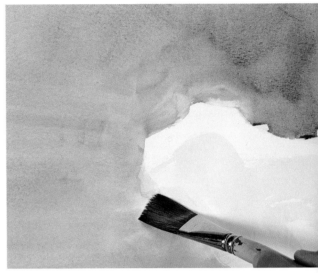

▼ 2. *The base of the background color, once dry, allows the sky to be painted, for the blue is darker than the first wash. Thick cloud areas will be left untouched. The blue of the sky can be done homogenously.*

▼ 1. *When different intensities of white are desired, it is sufficient to apply at the very beginning an almost transparent wash and to leave the most luminous areas unpainted. If you want to harmonize the white so that there are no breaks in the application, the background must be wetted with a sponge or with an almost dry wide brush. Where you do not wet the paper the color of it will remain intact. The aim is to make the color very transparent, just to the point that it slightly alters the color white.*

Wet zones are soaked up better with brushes that retain a lot of water, that have a dense tuft and natural hair. To spread color in defined areas, or to do fine white lines, a sable hair brush can be used. Its tip is pointed and makes easier the opening up of small details, while the hairs permit more water to be absorbed.

3. *Leaving aside the reserves that are not painted, while the color is still wet, part of it is absorbed with a clean, dry brush. The more times the brush is dragged over the surface, the more water is removed. After every stroke it must be washed and dried with a cloth. Once the white areas have been opened up on the paper, a new blue wash is used to outline the shape of the clouds. On this background new clouds can be started. These new clouds will always be more spongy than those outlined with the brush.*

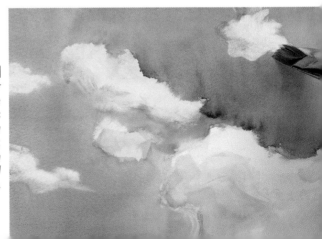

REFLECTIONS ON THE WATER

To get a good result, it is necessary to bear in mind that the reflections painted in watercolors depend fundamentally on two things: the background of the composition and the dark color that is used for the reflection.

Earlier we have seen how a gradation can be created. It is important that the background of the reflection is a gradation done previously. The shimmers have to be done on a completely dry background so that the paint does not run.

▼

1. *Throughout this chapter we have studied the majority of the techniques necessary to paint a river landscape: gradation in the background, trees and vegetation in the distance and the sky. The zone of the water always has to be painted somewhat darker than the sky. The brushstrokes have to be long and continuous so as not to make breaks in the superimposition.*

▶ 2. *Once the trees and shore have been painted, in the area where the water is painted, make some horizontal brushstrokes with the color used for the trees. In the area near to the shore, the mass of color is much darker and denser. With the color of the trees, the shimmer zone is darkened a little. As the reflection is reduced it is painted in zigzag and with very thin brushstrokes.*

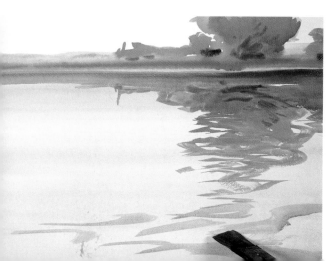

▶ 3. *To finish the reflections, once the background is totally dry, their contrasts are indicated in a darker tone than at the beginning. The darkest brushstrokes have a space between each one so that the background color can show through.*

> When the paper is touched with the fingers or rubbed with an eraser it is possible that it becomes greasy. The wash does not hold to an oily surface. To get round this problem the paper is sprinkled with talcum powder. When it is taken off you can paint with the certainty that the color will flow correctly.

Step by step
A landscape with reflections on the water

To become a skilled landscapist takes years of practice. However, starting from a few basic notions it is possible to paint acceptable landscapes. In this topic we have studied some of the most common elements of landscapes, the majority of which, like creating skies and trees in the distance, can be applied in general landscapes. Painting reflections is, naturally, part of river scenes and sea views. In this step-by-step exercise, a landscape that can seem to be complicated at first sight has been chosen. Really, it is not so difficult. All the techniques used are explained in detail in the chapter.

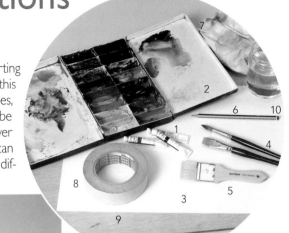

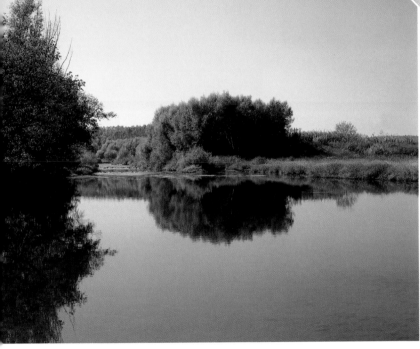

MATERIALS

Tube watercolors (1), palette box (2), medium-grained watercolor paper (3), watercolor brushes (4), flat brush (5), pencil (6), cloth (7), tape (8), board to hold the paper (9), and jar of water (10).

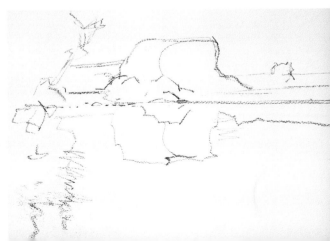

1. *The principal shapes are drawn with very precise strokes. First the line is drawn that separates the water and the vegetation. Above this line the principal volume of the trees is sketched. In the water zone the same drawing is made, but upside down as if it were seen in a mirror. On the left-hand side the basic outline of the vegetation is sketched in.*

STEP BY STEP: A landscape with reflections on the water

2. *As was seen in the theoretical part, the background is created with gradations and merging colors with long, horizontal brushstrokes. First of all, the paper is dampened. In the lower sky a very light yellow tone is painted. Before it dries, a blue gradation is painted in the upper part. In the intermediate part a somewhat darker blue tone is applied. The lower part is realized with a mixture of ochre, sienna and green.*

> When working with techniques that combine wet and dry paint a hair dryer can be used to quickly dry the paper. Do not get too close with the drier because droplets can form in the wash.

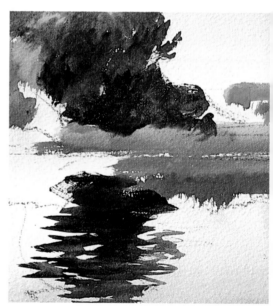

3. *When the background is totally dry, you can rest assured that painting on top will not mean that the colors merge with each other. As was seen at the outset of the topic, the trees are painted in several phases. First, a clear wash is applied in a uniform manner and then the background of the trees is painted. After, in a medium tone some areas are shaded with vertical brushstrokes. The river bank is painted with dry pasture, using a mixture of ochre and luminous green, in long brushstrokes. Above the line of the river bank an extended orange stroke is drawn.*

4. *Following the process explained in the technical section, the reflection in the water will now be painted. The wash that was done at the beginning presents a soft gradation into the white of the paper, which coincides with the lightest part of the bank. Starting from the shore, long brushstrokes are applied with very dark green. In the upper part of the reflections these brushstrokes almost touch. The further down the paper you go, the finer and more spaced out the strokes become.*

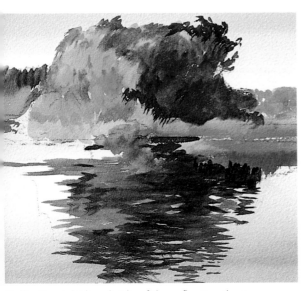

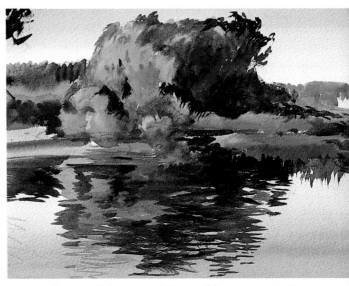

5. On the right-hand side of the reflection the tones are painted darker, the lighter greens are on the left. In this area mix in a more luminous bile green. Use long, fine, horizontal brushstrokes repeatedly on the dark part of the reflection, and sweep several times across the darkest color of it. In this way the two tones are mixed together, although the first has dried. Once the light part of the reflection has been painted, the lines of the lower part are laid down in a somewhat darker tone. Notice that the part of the reflection which is illuminated coincides with the illuminated part of the trees.

6. On top of the green foilage of the trees, paint in new brushstrokes that help to make its shape clearer. Blue is introduced into the first row of trees on the left, while the trees in the background are painted with vertical brushstrokes of dark green. Continue with the zone of the reflection. Just as there are two different planes for the trees, the same is the case for the reflection. The principal part of the reflection is finished in the same luminous tone as the trees. Once dry, the reflection of the background trees is painted in quite dark green and with horizontal brushstrokes. Do as was explained in the technical part: on top of the blue sky paint supple strokes that form the branches.

The reflection on the water must be similar in size to the trees that make it; for they are at the water's edge. If they were further away the reflection would be smaller.

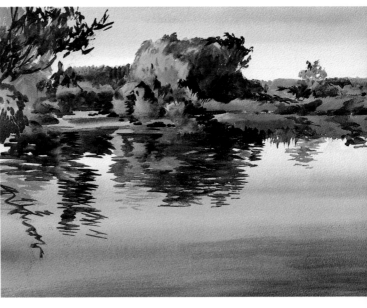

7. In the forest area on the left, paint in shading vertically in an orange yellow, somewhat sullied by green. On the right-hand side paint the luminous green tree, and around it paint some dark shading to give depth to the background. Also, in the river bank area paint a dark-toned strip that separates the greenery and the water. The reflection of the bush is painted with a few strokes of the same color.

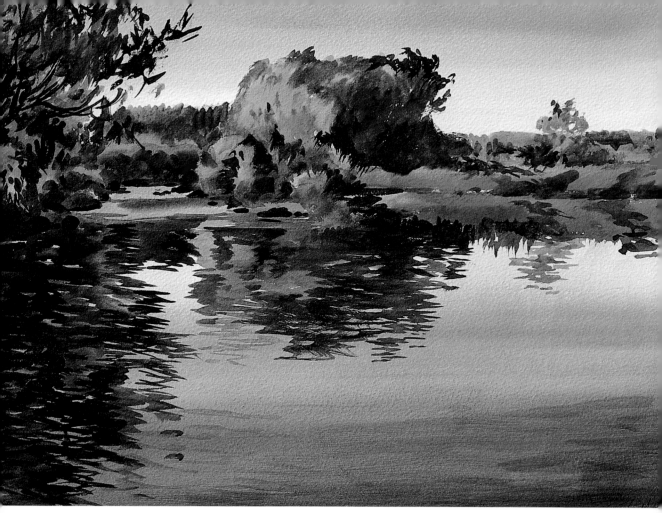

8. *The reflection area on the left is finished off with numerous sweeping strokes. Blue and green are used in such a way that they do not blot out the luminous tones of yellow that are the base. As you move away from the reflection of the upper part, space the brushstrokes out* more. *Apply brushstrokes to the greenery in this area until the background is almost totally covered. Finally, in the near foreground finish the water with several very long brushstrokes in blue that merge into the brownish grey background.*

SUMMARY

The medium tones of the trees have been intermixed with dark touches so that the volume can be perceived.

On the dry background lines and small shadows have been painted for **the branches and leaves.**

The reflections have been painted with fine horizontal brushstrokes. As you near the end of the reflection, the strokes become more widely spaced.

A quite dark, dense green has been used to paint **the trees** over a luminous tone.

The background has been done using very clear gradations in water on wet paper. Use a flat brush with long, horizontal brushstrokes.

When the color is dry several tones can be used that will mix well with this one. You have to be insistent with the brush; dampened in a dark tone. The clean, wet brush used over time can open up **luminous highlights.**

15 Mountain landscape

STRUCTURE OF THE LANDSCAPE

The first step is to plan the basic structure of the landscape. To start off, a good sketch must always be made. Only when the drawing has been done can color used. In this example, the color that is going to be used in the sky is bluish gray. To get this color in the palette, mix a dark purple with a dash of black. Starting from this mix you can obtain all the gradations possible.

The mountain landscape is without doubt one of the most interesting subjects that can be done in watercolor. It stands apart from other subjects, like the figure and still life, for it does not require a great deal of rigor in its proportions, and this permits more liberty in the treatment of the technique. However, it still can not be said that it is easy. With a little practice works can be done similar to that shown here. Above all, the enthusiast must learn to alternate the techniques on dry and onto wet.

▶ 1. The upper part of the picture is painted with a dense color in an ample wash that leaves some areas clearer and more luminous. The terrain is painted with a variety of very bright green and yellow tones to show the contrast with the sky.

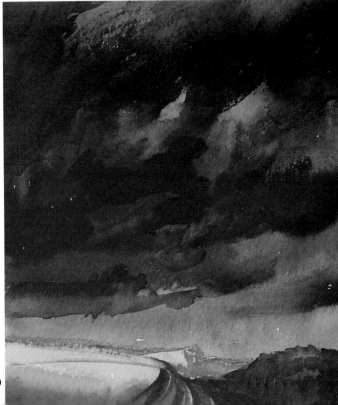

2. The lower areas are painted with brighter tones than the higher ones. With the wet brush stretch this tone until the sky is completely covered. In the intermediate area much darker tones are painted, without letting them blend into the background. Finally, the darkest colors are painted with tones that come close to black. Dark tones are also painted in the lower part and the furthest plane is left strongly illuminated and contrasting with the background of the sky.

THE FIRST SHADINGS

Before starting to paint, it is necessary to do the drawing of the landscape. The clouds do not always have to be drawn; sometimes they are painted directly, above all, when the forms are abstract or they are done starting from gradations. In the mountain landscape, the terrain requires more attention than the clouds, as the forms are very complicated, and spaces have to be reserved for light tones or luminous whites. The first shadings, as is usual in any watercolor work, must always reserve the clearest, and most luminous, zones.

▶ 1. *The first color that is painted is very luminous, an almost transparent wash. The aim of this shading is to break the white of the paper so that the clouds stand out from the clearest parts of the mountain landscape, where the snow will show pure whites. This wash will be the base of the dark color that will paint the upper area: a lead gray that will cross the picture and blend into the background wash.*

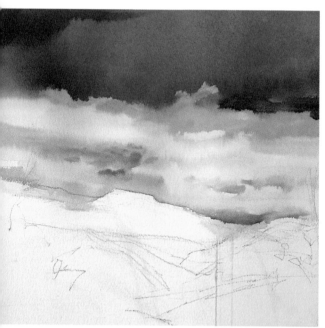

▼ 2. *The most luminous zones are gradually surrounded, little by little, by the darkest. When the background is dry, a very luminous gray wash is painted below the upper dark area. The color is watered down in the palette until it is transparent and a little blue is added before painting the clear grays of the clouds. Before it dries, paint the blues of the sky.*

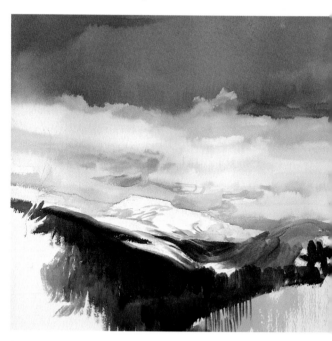

▼ 3. *After the first shadings in the sky, paint the brightest mountains in the background on the right and leave reserved the lightest areas. Here, the white of the snow will stand out against the blue of the sky. In the far mountains, the contrast on the snow is painted with small, almost transparent green stains. The foreground is shaded with very dark brown.*

DARK TONES AND CONTRASTS

When the most transparent colors and tones have been painted the first contrasts outline the most luminous zones. It is now that the dark tones and densest contrasts have to be applied. In this way the most luminous reserves take on the brightness and presence necessary from the start.

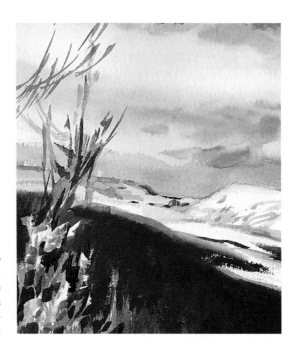

◀

4. Having set out the initial tones and the most luminous zones, intensify the contrasts to do the same for the white reserve in the tree on the left. These dark shadings should be painted with care, in such a way that the white of the paper appears to be painted. With very fine brushstrokes the shape of both sides of the branches is outlined. Afterwards, the background is painted with small strokes in very dark tones.

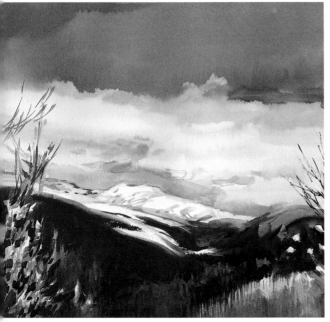

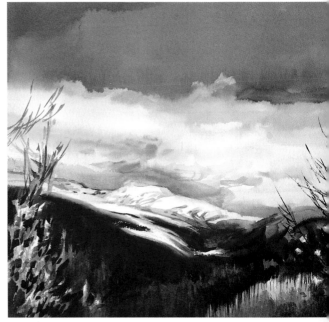

▼ *5. The tree on the right is done in the same way as the one on the left, but with a much lighter gray. On the mountains in the background, certain areas are darkened with a blue tone. The blue of the background is now seen as snow in shadow. The blues of the lower part of the sky are redone. Give a profile to the form of the mountains, which are now strongly illuminated by the contrasts.*

▼ *6. With different tones of an earth color, the dark areas of the foreground are painted and the white branches of the tree on the right are defined. This can be the final touch to this beautiful mountain landscape in which the key role has been give to white as a counterweight to the dark contrasts of the earth and the clouds.*

Topic 15: Mountain landscape

When painting outdoors, it is best to choose those hours when nature reveals itself in all its splendor. With a little luck one can be present during those marvelous moments when the sky takes on an almost unreal hue. These moments have to be used to the full. In this exercise one of these skies charged with light and color will be painted.

▶ 1. *To begin, the form of the landscape has to be drawn to establish the horizon line that separates the sky from the earth. The mountains are also sketched as in this picture they are the most distant elements. The irregularities in the terrain help to mark the differences between the planes, for the proportions vary according to the distance. Starting from the top, the sky is painted in a violet wash, transparent in the highest zone and somewhat denser in the lower part. Before it dries, it is painted with an orange color. Violet and orange blend giving each other power. Wherever you want to do a well defined brushstroke, the background must be dry.*

▼ 2. *On top of the orange, the zone that remained white is painted with yellow ochre. Where there is contact between the two colors a mix is produced due to their moistness, although they do not completely blend because the first color was already nearly dry. However, in the central area, which was the last to be painted, it blends completely with the ochre. Beneath this color-loaded sky, the painting of the landscape is begun in a very dark violet color.*

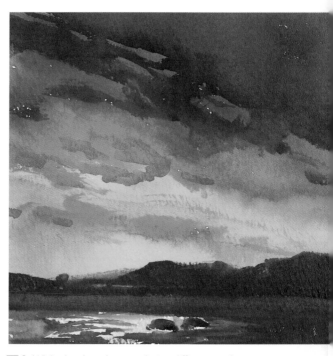

▼ 3. *While the sky colors are drying, different touches are made to model the clouds. The violet is contrasted until it is rather dark. This color gives an edge to the clouds and to some clear parts on the upper right side. With cadmium red some traces of light are painted in the sky. The earth is finished off with very dark colors, thus strongly contrasting with the sky. Some areas are left completely open to represent the brightness on the surface of the water.*

Step by step
Mountain landscape

The watercolor is completely transparent, its colors must be superimposed on top of one another according to their opacity, in such a way that the most luminous zones are reserved by the darkest. The opening of whites allows the luminosity to be restored to a previously darkened zone. This technique, added to the reserve, facilitates all types of textures on the terrain. The mountain landscape means that multiple techniques which make evident the transparency and different textures are necessary, both on dry and wet backgrounds in order to blend the tones. This is not a very complicated exercise. However, it demands that the enthusiast pays a great deal of attention to the definition in each area of the image.

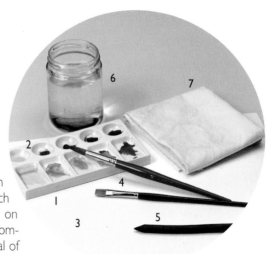

MATERIALS

Watercolors (1), palette (2), medium grain 250g paper (3), watercolor brushes (4), charcoal (5), water jar (6), cloth (7).

1. *The first lines must be very concise, without any type of decoration or shadow. To draw with a stroke that can be corrected without problems charcoal is normally used. It is much more easily erased than pencil. Any mistake can be wiped out, hardly leaving any trace.*

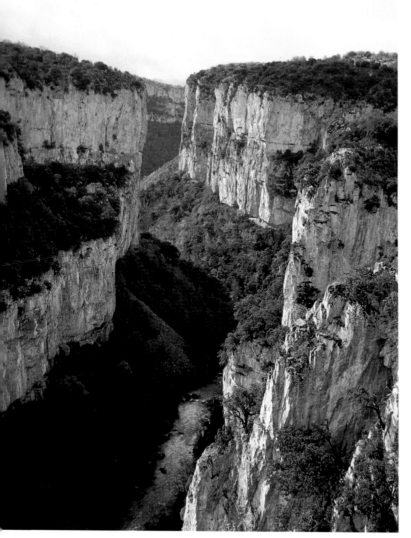

STEP BY STEP: Mountain landscape

2. *The painting is started on wet paper. To do this, it is necessary, first, to wet the surface of the paper with a brush loaded with clean water, and to spread the dampness over all the surface. When you are working on wet, it is very important that the paper is placed in a vertical position so that the color slides downwards into the moist areas. Before the background is dry, paint the walls of the cliff ochre and the vegetation of the upper area green.*

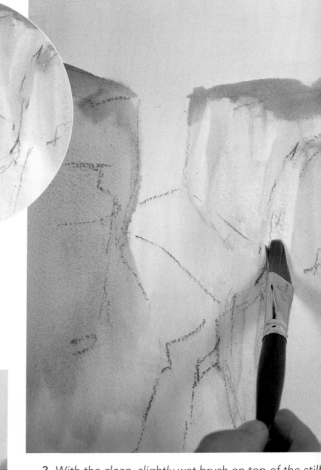

3. *With the clean, slightly wet brush on top of the still fresh background, make the first openings of white. The brush is passed in vertical strokes over the walls of the cliff until the first clear zones are obtained. Every time the opening of a clear space is done, the brush must be cleaned and drained before restarting. If the underlying color is too wet, the recently opened area will be stained by color. This is why a lot of attention has to be paid to the drying time of each color.*

4. *Once the most luminous whites have been opened, the surface of the paper has to be completely dry before putting on new layers, so as to avoid the mixing of colors. When the background is dry, dark colors can be painted in the upper cliff area. First, blue tones are put in, and then on top of these the brush is passed to open up clear spaces. Pay attention to the colors of the palette: two green tones are used, one clearer and more luminous for the background of the ravine, and another darker one for the shadows.*

5. The river is painted in very transparent cobalt blue. However, be careful: the reserve must be left for the highlights.

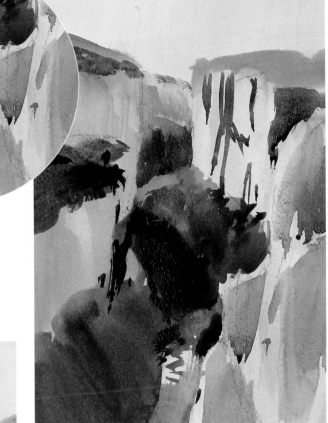

On top of the wet background it is easy to open whites. Just passing the clean brush and draining it off repeatedly is sufficient.

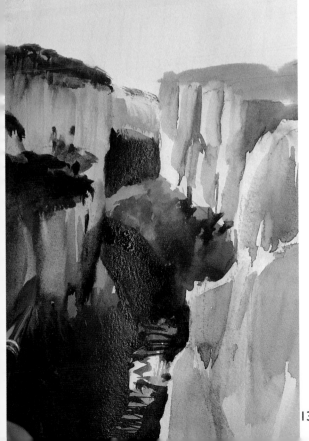

6. The colors used to paint any mountain landscape can be as varied as you wish. Depending on the distance and the texture, the colors that are painted in the mountain can include any tone or mix. Here, for example, violet is mixed with cobalt blue to paint the rocky background wall on the right. This tone is then watered down and the dark rocky portions of the nearest cliff are painted.

7. In the river, beneath a dense thick blue layer, glimpses can be seen of the former tones next to the white of the paper. The greenery on the left contrasts with the dense, dark greens. The painting of the left wall is started with a green mixed with ochre. The background is now completely dry so a transparent layer, sufficiently tinted to change the color tone, can be painted. Before this new layer is completely dry, the brush is drained and new clear spaces are opened up with the brush. Persist until very luminous lines are achieved.

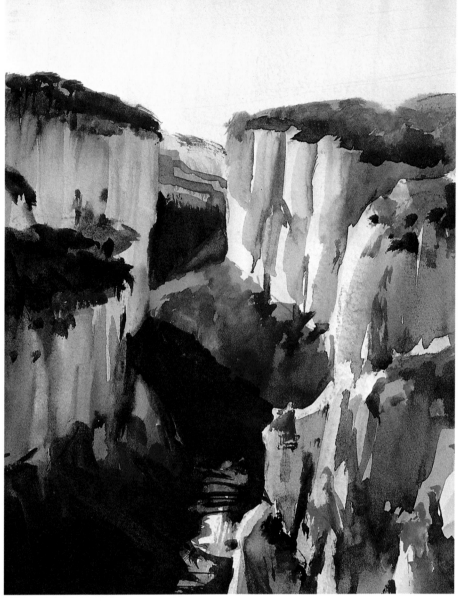

8. *Once the last clear spaces have been opened up on the paper, the densest contrasts are painted on the rock walls. In some areas ochre is used. Before continuing, allow it to dry to avoid the color running. Then paint a dark blue, very controlled wash without insisting on top of the lower layer, thus avoiding softening or spoiling the color. All that remains is to open up new, very luminous whites with a clean, wet brush in some portions of the rock face.*

SUMMARY

In the upper area of the ravine, the greenery is painted, allowing it to merge a little with the color of the walls.

To paint the dark zone that define the rocks the background has to be completely dry.

The background of the ravine is painted on wet.

On top of the rock faces, clear spaces are opened up with a clean, slightly wet brush.

The last white openings on the right side of the rocks help to increase the strength of the tone contrast.

16 Texture of the skin

THE COLOR OF THE SKIN

The color composition of the skin is obtained with different colors, tones and reflections. While the skin is young, it reflects the light uniformly and with precise highlights. In contrast, the texture of mature skin no longer reflects light uniformly but intensifies the texture and the shadows cast by the wrinkles over the features of the face.

The painting of the skin is an advanced value related study. Carnation, the color of the skin, is one of the most complicated challenges in watercolor. The examples that are dealt with on these pages are accomplished works. In this topic we will offer the fundamental techniques to solve one of the most common problems related to the figure and portrait: the skin and its texture.

▶ 1. *In this illustration, the shadow is only a small tonal difference with respect to the light zones. In contrast, in the light areas sufficient highlights have to be opened up so that the carnation reflects the light. The texture of the skin is begun by painting the carnation but reserving the most luminous area. The tone applied to reserve the brightest areas of the figure is a highly transparent carmine Naples yellow, and a little ocher, although it does not exactly have to be so. What is important is that the carnation has warm and very transparent tones.*

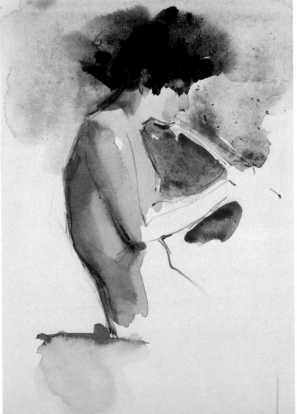

2. *The very clear tones can be painted by brushing the colors over the dry background, cutting out the highlights. In some areas, a blue layer can be painted to suggest a finer and more transparent skin, or the highlight absorbed with the clean brush. If the paint is dry, repeatedly passing the brush will enable whites or clear spaces to be opened up, perfectly outlined. Here, the texture of the skin has been done by blending two tones of different colors. The shadow is painted by blending the tones in the areas where it touches the tone below. This blending must be minimal and very controlled.*

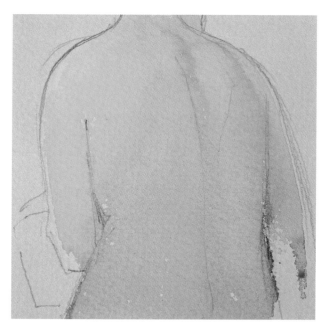

TEXTURE OF THE SKIN

B esides being able to represent the texture of young skin, it is important to master modeling if one wants to give a correct texture to the skin tones of any figure. In this process we will study in detail each one of the steps that must be followed. This exercise shows one of the many possibilities that can be be developed in watercolor.

> Paper is very important in watercolor technique if the work is being constantly corrected.

▶ 1. *The first layer will be the base for all the texture of the carnation skin tones. This base color will allow all the later applications to act like a filter, modifying the original colors according to the opacity with which they are painted.*

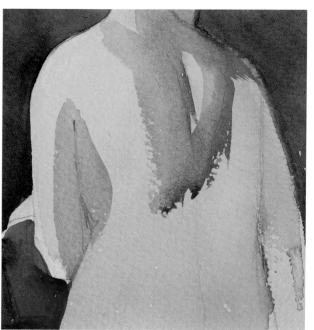

▼ 2. *The background is darkened and the principal shadows are painted. The colors used are the following: sienna on the back and burnt umber on the arm. This step and the next must be realized before the color dries on the paper so that the tones blend. It is important to control the moistness of the paper to avoid unnecessary wetness.*

▼ 3. *Shading is spread with the wet brush, somewhat insistently, to blend it into the background. The areas reserved on the skin are the shiniest areas. This is an important question to bear in mind in all carnation work. The highlights must be reserved from the start so that they do not have to be opened up later. Finally, the shadows are softened by sweeping the wet brush over them. The sharpest contrasts are defined with a soft profile. In this way the figures are outlined and the texture of the skin acquires the brightness and volume necessary.*

FEATURES OF THE FACE

B esides being able to represent the texture of young skin, it is important to master modeling if one wants to give a correct texture to the carnation of any figure. We will study in detail each one of the steps that must be followed. This exercise shows one of the many possibilities that can be developed in watercolor.

◀

1. The drawing must be as perfect as possible, correcting any possible errors. Each part of the face is drawn with the maximum precision, bearing in mind the proportion between the features. In this work the planes are very defined. The background is painted in a dark tone to put the face into context. First, an almost transparent layer of sienna is painted over all the face.

▼ *2. It is necessary to respect the drying times between the layers, both when you want to blend two tones, or when you want to superimpose them. The forehead is painted in orange mixed with a little sienna. The wrinkled area is left blank: to do it, the background has to be dry. As the color descends down the face carmine is added. The reserves of the wrinkles on the forehead are made, painting around them in an orange tone.*

▼ *3. The wrinkles of the forehead and the nasal septum, reserved beforehand, are given a yellowish layer. When the colors underneath are dry, they are retouched with a wet brush to merge the tone of the furrows and to define the forms of the shadows. When the brush is passed over the zone to be blended, the fusion of the tone on the background is controlled. Adding new tones could take part of the background away (on the nose septum). New tones are superimposed on the background to intensify the contrast (on the forehead wrinkles).*

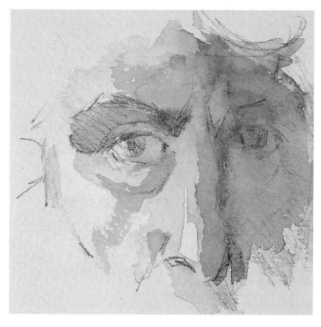

HIGHLIGHTS AND SHADOWS

The highlights on the skin depend on its tension and the amount of light that falls on it. Some areas tend to shine more than others, above all if the skin is smooth or slightly greasy like on the nose or forehead. The highlights of the skin have to be reserved from the start so that the dark areas can be put in once the first layers are dry. With the first color intervention, the light and shadow tones can be established in a luminous way.

▶ 1. At the beginning the luminous areas of the face are reserved. The background wash is resolved with two different tones to separate the light planes. When the drawing is complete, the light area is painted with a very luminous yellow ocher tone. The maximum highlight area remains reserved. The most intense point of light is on the nose. A dark layer is painted in the shadow zone. In this way, the highlight appears even brighter, making the reserved zone appear much more luminous.

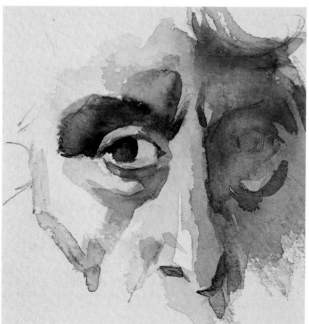

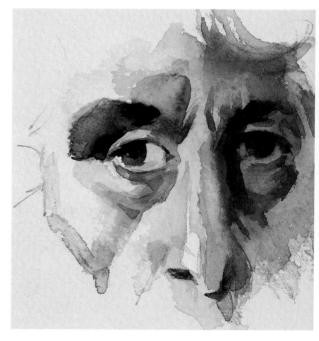

▼ 2. Increasing the shadows of one area of the face produces a contrast with the adjacent lighter areas. To balance the luminosity of the skin, a strong contrast is painted with sienna in the upper part of the eyebrow. This gives depth to the eye. Watering this color slightly, the shadow of the nose is gently darkened. Its highlights now appear more luminous. On the forehead, a brushstroke of very transparent red gives a more realistic look to the skin texture.

▼ 3. The final contrasts define completely the texture of the skin. These contrasts are obtained with a very pure sienna which is used to profile the darkest zones of the face. As can be seen, the highlights of the skin have not been touched since the start, despite the numerous layers that border on them.

Step by step
Portrait of an old man

The texture of the skin, its carnations, and the reflections of light on the face are learnt with continuous practice, in which the possibility of copying famous artists should not be ruled out. If, moreover, as in this case, a model is available, and a record of the steps which the artist followed, it is guaranteed that you will learn. The model chosen is an elderly person, portrayed against the light. His face, his features, the skin texture and the way the light falls on the model make this a perfect example for this exercise.

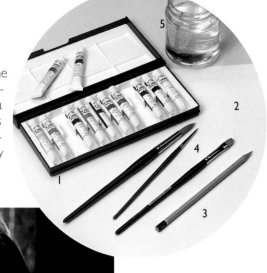

MATERIALS

Watercolors (1), stucco watercolor paper (2), pencil (3), watercolor brushes (4), and water jar (5).

1. The first step requires that the watercolorist makes a great effort to do the drawing well. If it is too difficult to do, he or she can resort to tracing. In this exercise a simple outline is not enough: it is advisable to take the drawing further so that when color comes in, it is integrated into a perfectly defined structure. The features must be sharply defined and the light areas and the most prominent wrinkles schematized with neat lines, without either grays or fuzziness.

2. *Starting from the perfectly constructed drawing of the head, the skin base is painted. The base color is elaborated in the palette with orange, ochre, and sienna. You have to paint over the dry background sufficiently rapidly so that the tones do not separate when drying. All the face is painted without creating sharp tone changes. The principal highlights are left reserved. The hair is painted with lines of Payne's gray.*

When a portrait is realized, it is necessary that the first rough drawing is sufficiently complete and contains all the elements that precisely define the features of the face, thus allowing easier future development. It is vital that the finished portrait has a good likeness to the model.

3. *Before the base color is completely dry, the first contrasts are painted with burnt sienna. This intensification of the shadow is only done in the darkest areas of the face. The skin base is fundamental to proceed with the successive colors. With the color used to darken the nose, the wrinkle of the eyebrows, the chin and the upper lip are precisely painted. Due to the effect of the simultaneous contrasts, when putting in the dark spots, the highlights gain intensity.*

4. *Allow the background to dry completely. Now you can paint on it without the colors mixing. The right side of the face is darkened with a very luminous gray wash. This phase is extremely delicate: start on the forehead, reserving the highlights. At the same time that the gray area is painted, the lit up part is profiled, outlining the upper part of the eyebrow and cheekbone. The wrinkles of the forehead are depicted with soft, quick brushstrokes of the same color. The wrinkles of the chin and of the face are painted once the gray background is dry. Hence the colors will not mix.*

5. *The background must be dry before starting the work on the texture of the skin. As we are using heavy paper, it is possible to do mergings and washes on top of previous layers without the quality suffering. The dark shadows of the skin are intensified with burnt sienna, and the profile of the shadow is reinforced around the eyebrow zone, in the eye and on the cheekbone. The shadows that suggest the wrinkles are gone over again until they expand and blend. The shadow of the cheekbone is done in a triangular shape that merges around the mouth.*

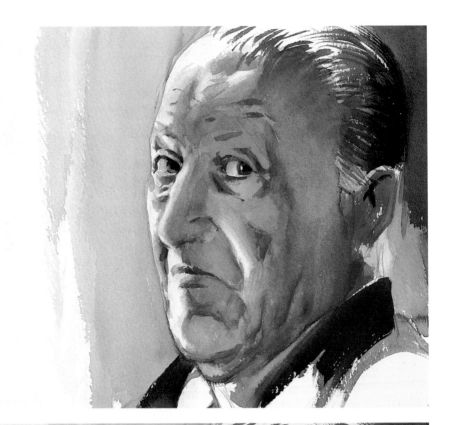

6. *Mix wash of burnt sienna and umber and use the resulting color to contrast the principal wrinkles of the face, leaving in reserve the brightest parts. The orange color that was used at the start shows through all over the face in the transparencies of the different colors. This base color is covered in some zones by the wash, in others it remains intact. The principal highlights have been reserved since the beginning of the portrait. All the right side of the face and the shadow of the lips are darkened. In this way the volume of the face is accentuated. The wrinkles of the forehead are depicted with fine brush strokes.*

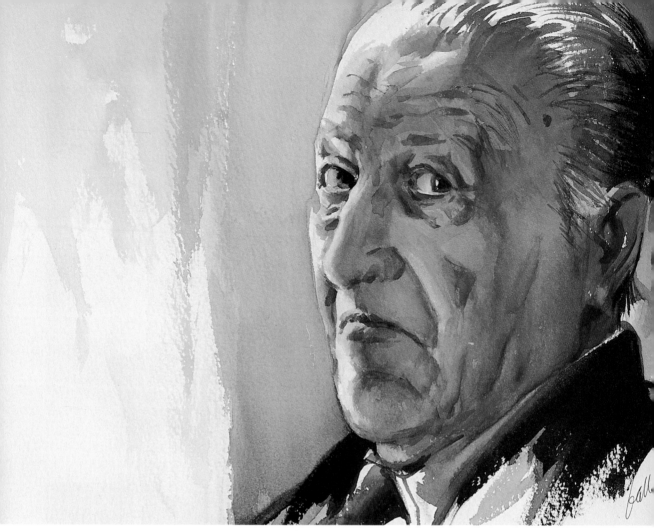

7. *The ear is painted: it is defined by its own shadow. The wrinkles of the forehead are darkened, thus increasing their volume. The background color remains as the luminous part of the wrinkles. The right eyebrow is darkened with rapid and spontaneous brushstrokes. Very watery carmine and a little* sienna complete the form of the lower lip. All that still has to be done is a very transparent layer over the background, and then this painstaking piece on the texture of the skin is finished. Although it has been a complex work, many concepts have come into play. They will be useful later.*

SUMMARY

The dark part of the shadow is transparent and outlines the face. On top of the right paper, the tones can be fused over the completely dry background.

The drawing is perfectly defined before the color is approached. The skin does not have a unique color, it depends on the many colors that surround it.

The first color application is an orange wash that is the base of later colors.

The color of the clothes in a portrait does not have to be true to the reality. They can be toned according to the needs of the image and to make the face stand out.

Animals

BASIC STRUCTURE AND THE DRAWING

The first thing that the painter must resolve before painting any animal is the study of its anatomy. A simple sketch with a pencil or charcoal will suffice, but you cannot jump this preparatory stage. By studying each of the parts of the animal you can develop the shadows and other volumes before starting painting with watercolors.

Painting animals with watercolor is a complex subject although, once the necessary practice is acquired, this barrier becomes a motivation for any artist who wants to improve. The watercolorist must always practice drawing, whatever the subject that is being developed. For the motifs that require an anatomical study the drawing is more a necessity than a support, as it can be for a landscape. Proportions, measurements, shadows, and highlights must be studied before painting. Painting animals will, doubtlessly, be one of the subjects that most rapidly attracts the attention of the enthusiast. Therefore, pay close attention to the following pages.

▶ *The structure of any animal can be synthesized in the preparatory work with straightforward geometric shapes. These shapes can be done for any model. For example, in this sketch of a horse the lines of its form have been drawn. Once this is done, the sketch is divided to show where the legs start. This dividing up will help substantially with the proportioning of the animal, for these very elemental lines aid the understanding of any shape, however complicated it may be.*

◀

Try to copy these drawings starting from the sketched outlines. Next, do the internal structure, and finally unify the lines to place the contrasts. A good way to comprehend this is the tracing of the sketch with tracing paper. Then transfer it to the drawing paper and work until the form of the animal is completed. It is helpful to do this exercise both with these sketches and with any photo of animals.

COLORING THE DRAWING

When the drawing is completely defined, you can start to add color. The best way to learn is with practice. Here we will show already finished works that can be used as a reference to be borne in mind for later works. The techniques that have been used for these examples are the same as those used for landscapes and still lifes in previous subjects, only the way the stroke is applied changes.

▼ This dog, in spite of its complexity, has a very simple structure. If you look closely, you will see that its shape is fitted inside an almost perfect oval. The legs are hidden, which makes its initial drawing even more straightforward. Once the drawing is taken care of, the first layer of color must be very faint. The brightest grays, which outline the pure whites of the paper, are painted. The head of the dog is defined with dark sienna and burnt umber tones, once the initial layer has dried.

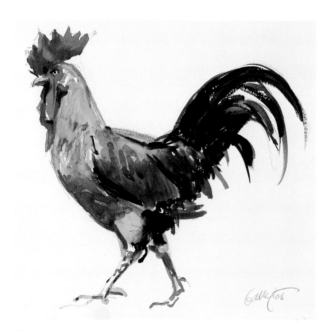

Observe in the superimposed scheme how easy it is to structure the anatomy of this bird. It is only a circle for the body and a triangle for the neck and head. Once the drawing is complete, the painting process is started with a very luminous, ocher and umber wash for the lightest tones of the breast. The first washes do not give texture to the feathers. These are painted with very supple strokes. Pay attention to the whites that remain reserved. ▼

▼ As you can see, the pose of this cock is different from the other. However, the method used does not change at all. In this illustration it can be seen how the red brushstrokes of the wing are superimposed on the initial orange wash.

TEXTURE OF THE SKIN

O nce you have learned to outline the form of different animals, it is recommended to practice an exercise that will be useful in the future. It consists of painting the head of a dog. In this exercise, the texture of the fur or of the skin is one of the most important elements, once you have understood the basic structure of the animal. Here it is important to bear in mind the way reserves are continually made.

1. Do not start painting until the drawing is perfectly defined. Watercolor is based on transparency and the corrections have to be minimal. First the background is wetted with a brush dipped in clean water. When wetting the background of the paper, the shape of the head is outlined so that the color does not penetrate inside it. The wetness of the paper ensures that the color expands.

▼ *2. While the background is still wet, the first applications of color can be made: they merge into the colors already on the paper. As the background dries, more precise tones and brush-strokes can be laid down. The painting of the eye is started with sienna and very clear gray for the fur. The dry tones allow whites to be reserved.*

▼ *3. The most luminous highlights on the fur are left unpainted so that the white of the paper is always seen. Next to these completely white parts, on the dry background, the ear and the forehead of the dog are painted with an orange wash, the color drained out of an almost dry brushstroke.*

147

AREAS OF COLOR, LIGHT, AND SHADOW

Painting animals sometimes calls upon all the technical skill of the artist because of the complexity of the process, although the success of a great work often lies in simplicity. The synthesis of the forms, the combination of every single feature will result in a vigorous study, full of realism. Here a simple exercise is proposed with a parakeet. Pay attention to the reserves, to the color, and to the light areas.

▶ **1.** *In the first place, close attention must be paid to the initial sketch of the anatomy of the bird. The drawing is straightforward and based on two correctly placed curves. If you look closely at the illustration, you can see that the body is ovoid, and the head is an almost perfect circle. Once the initial sketch is done, finish off the lines that define the anatomy of the bird.*

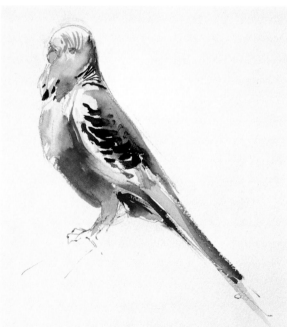

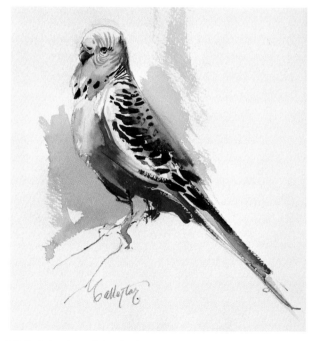

▼ **2.** *The pure whites must be reserved from the start. The principal color is blue. It is used in a transparent tone which permits each one of the light or shadow zones to be placed. This is where the initial drawing becomes essential: it would be impossible to establish the white reserves without it. The dark shadow tones are painted on top of the most luminous colors. The brush-strokes on the head and wing are done on the dry background.*

▼ **3.** *Only when all the shadows on the parakeets have been done can the contrasts that finish the painting be applied. Here the shadows are defined by intensifying the tones used. Observe the blue under the tail. Lastly, the final details allow different parts of the bird to be contrasted. In this exercise, the background is darkened to better bring out the brightness of the white areas of the bird.*

Step by step
A pair of parakeets

The simplest animals to draw and paint are birds. This is due to their rounded and tapering shape, and absence of a complicated structure. To paint birds it is not necessary to go too far: you may find a good model at home, or in any pet shop, photos in books or magazines, or in the zoo. The models used in this exercise have been photographed in an animal shop. The aid of a photo is one of the most widely used, especially when you must paint fidgety animals.

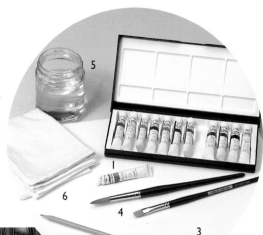

MATERIALS

Tube colors (1), pencil (2), watercolor paper (3), watercolor brushes (4), water jar (5), and a rag (6).

1. *As has been studied throughout all the topic, before starting to paint, it is necessary to do a drawing as perfect as possible: perfect in the synthesis of lines and forms. The brushstrokes must guide the color exactly so that the different areas cannot be confused. Start by drawing the parakeet on the left. Each bird is placed, starting from an almost oval form. The back is corrected with a straight line and the head, beak and eyes are put in.*

STEP BY STEP: A pair of parakeets

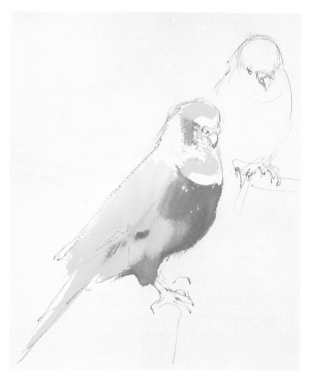

2. Once the first parakeet has been drawn, the second is done. The other also has an oval form, with an almost circular head. Such a simple shape allows rapid and pleasant work, for the corrections needed are minimal. Once the drawing is done, the painting of the bird on the left is started: first, with a golden yellow reserving the brightest zone of the breast. In this highlight, cutting across the line of the breast, a very luminous green is painted, merging the tone at the same time that the form of the body is modeled. The darkest part of the parakeet is painted with a dash of umber. As the background is still damp, the colors blend easily.

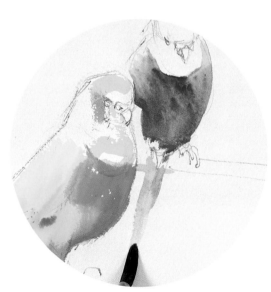

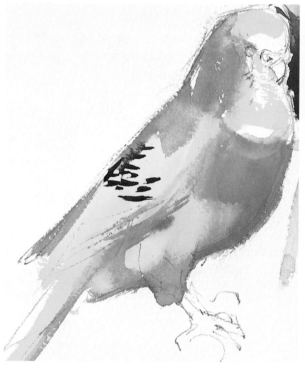

3. While the color of the first parakeet is drying, start to paint the one on the right. The wet parts of the paper must not be touched, otherwise the colors will mix. For this bird, a cobalt blue mixed with ultramarine in a very luminous wash is used. When the tail is painted, in one stroke, it is made even more transparent.

4. Alternate the painting of the two parakeets so that the drying times do not interrupt the work on the watercolor. If only one bird were being painted it would be necessary to stop every time you wished to do a brushstroke on top of a dry background. With the same tone as was used to paint the last part of the body, the rear of the head is painted and the shadows on the wing. Using black and with small brushstrokes, add the strokes which characterize the plumage.

5. *Before starting to paint the feathers of the parakeet on the left, to avoid the dark colors of the just painted tones blending, it is necessary to let them dry. Meanwhile, pay special attention to the parakeet on the right. On the head, a very transparent gray layer is painted which outlines the upper highlight, which is now seen as a white circle. While this zone is still damp, some small shadows are added to the base of the neck. This color is put on with the tip of the brush and blends into the limits of the just painted wash.*

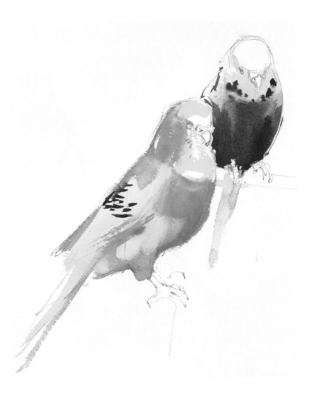

6. *All the strokes on the back of the bird are done. As can be seen, the lines are curved and help to suggest its volume.*

If you were only painting one animal you would have to stop every time you wanted to do a brushstroke on top of the dry background.

7. *Use the color blue to rework the parakeet on the right. Repaint all the right hand side of the chest. This shadow is oval shaped and gives more volume to the bird.*

8. *This is an exercise that can be done very quickly. On the one hand because of the simplicity of the shape of the two parakeets, and, on the other, because of the possibility of alternating the painting of the two birds, giving each one sufficient drying times. All that remains to be done is to paint the contrasts on the beaks, without touching the highlights, and carefully paint the eyes of each bird.*

SUMMARY

The initial paint on the bird on the left is yellow. Before it dries it is painted green.

The tails of the parakeets are done with one brushstroke. Afterwards the necessary contrasts are added.

The head of the bird on the right is reserved with a very transparent layer, on top of which the dots of the neck are painted.

On the back of the parakeet on the left multiple brushstrokes of black are used to complete the texture of its characteristic plumage.

The way they painted:
William Turner
(London 1775-London 1851)

Saint Mark's Square

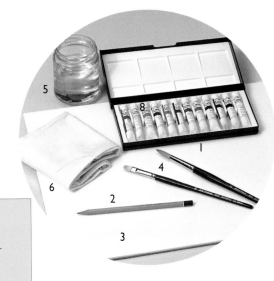

MATERIALS

Tube colors (1), pencil (2), watercolor paper (3), watercolor brushes (4), water jar (5), and a rag (6).

This English painter was famous for his landscapes and sea views. He started painting watercolors and then later he switched to oils. A journey to Italy marked the beginning of a period characterized by luminosity and highly intense and vivid colors. Later, he began to make light itself the center of the paintings, as can be appreciated in his very dreamlike views of Venice. His work, which was very romantic, is one of the precedents of Impressionism.

In recreating this work, the aim of which is not to do an exact copy, we are going to study some of the techniques that Turner used constantly, and which have been explained throughout the previous chapters. The techniques that Turner employed are not complicated. However, they are executed with precision and great care in each of the different parts of the painting. Painting on wet gives a characteristic style to the fusion of colors and forms: it is the degree of moistness of the paint on the paper which conditions the blending of the tones. Turner had perfected working with different drying times; this is what is going to be attempted in this exercise. Before starting, look at the subject carefully. Let's see if you can guess the areas that he painted first and how he did them.

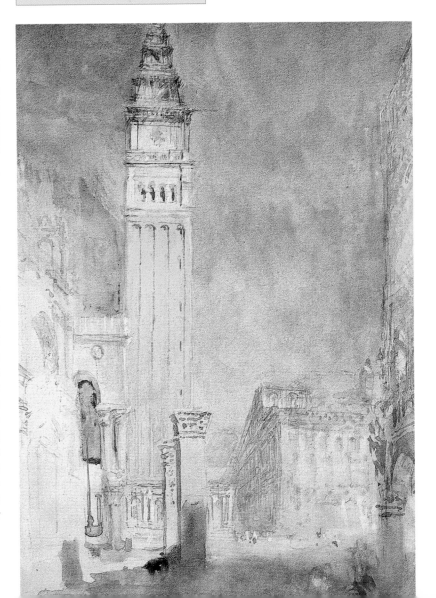

1. It is important, before doing anything else, to start with a good drawing for the work that is going to be done later will be conditioned by this. It is not necessary that the drawing be exactly like the model, but the different elements must be approximately in proportion. In the drawing any possible change in the inclination of the line must be observable. Here, for example, compare the perspective of the upper part of the building on the right of the model. Doesn't the building that has just been painted seem less inclined? These are the type of corrections that must be done.

2. If you look closely at the original work you can appreciate the total lack of whites. Instead, the lightest tones are yellow, the product of the initial layer. A very watery yellowish mix is obtained with ocher. It is used to paint all the buildings area. However, the sky is left unpainted. How do we know that for the base of the sky Turner did not paint a yellow layer? We know because the blue would have turned greenish and this is not the case.

> You have to be very careful with the chromatic effects that are produced by the superimpositions of color.

3. *Paint the area on the right with an orange wash. This color will blend with the just painted part of the sky; it does not matter for it can be corrected later. It is certain that this also happened to Turner, if we judge by the earth tone that the sky takes on in certain areas. It can be perceived in the model that the sky was not painted in one go. Rather, it has several layers of color that allow the brushstrokes to show through. A very clear wash of a little umber mixed with dark blue is used to repaint the sky, letting the brushstrokes be very evident. On the left, it can be seen how Turner made a correction. Here, one is made, too, by absorbing the excess of tone with a clean, dry cloth.*

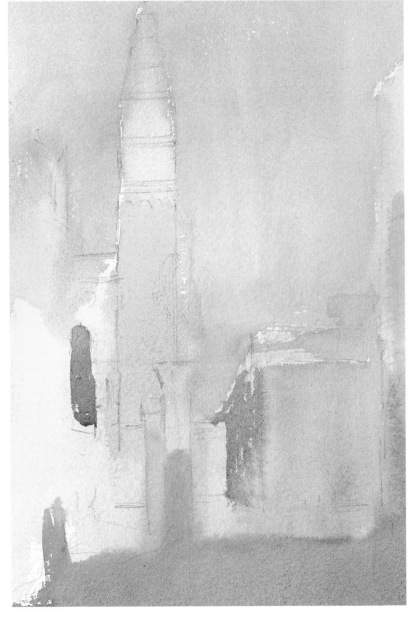

4. *Some parts of the buildings, above all, on the left and the building in the background, appear merged into or gradated with the blue of the sky. This happened because when the painter was painting the sky these zones were not completely dry and the first color mixed with the new one. In the same way, the color of the buildings is allowed to penetrate into the first layer on the white of the paper. When color is superimposed on top of an already dry one, the tone darkens. In this way dark tones can be achieved that modify the first tones of the upper part of the buildings. Wait until the background is almost dry and repaint it with blue mixed with a little sienna. The dark parts of the buildings are painted in burnt umber.*

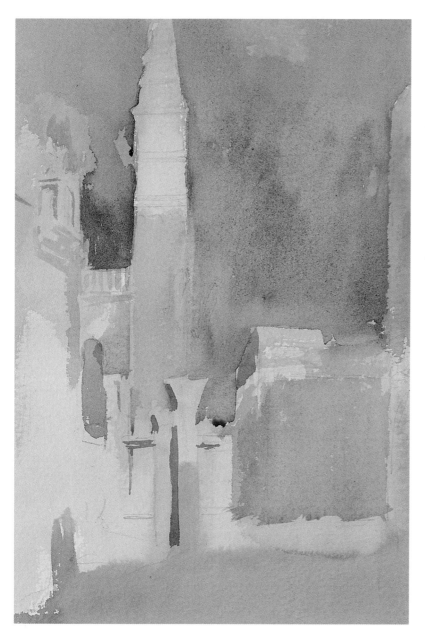

6. *As you can see in the illustration, you have to continue drawing throughout the exercise. A brush is used to paint the lines that define the relief of the buildings, after having painted in the first colors. Paint the decorations on the buildings in the same way. The strokes have to be precise, without either blending or forming flows. Draw the lines with a sufficiently transparent sienna so that although the first color is not totally covered, the drawing of the well-constructed strokes can be seen.*

5. *It is necessary to wait until the background and the later additions of color are completely dry before proceeding. Then, a blue wash with a little sienna is prepared and applied over the background with vertical brushstrokes. This new layer of color is what finishes off the outline of the buildings. Afterwards, with a burnt sienna lightly tinted with blue, but only as a very transparent layer, the shadows of the buildings in the background are painted. The base color changes appreciably the dark tone of this layer.*

The colors that are superimposed produce an overall effect when the lower layers are dry.

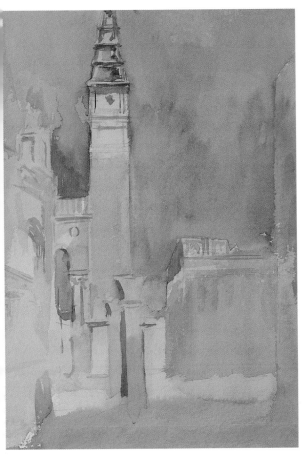

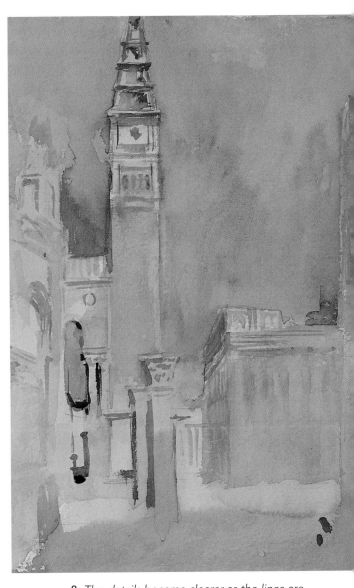

7. The drawing done on top of the first color washes gives a sharp definition, and the cornices, the nuances of the walls and the entrance arch on the left are perfectly traced. It is important that the strokes do not stand out too much. The color must be sufficiently watered down in the palette. Pay attention to the drying process of every tone. When a brushstroke dries completely, its tone intensity diminishes.

8. The details become clearer as the lines are defined. First, the principal lines of the cornice on the tower are drawn, and on top of these the ornamental details are filled in. Finish off the area on the right of the picture with an orange tone, making a mesh of brushstrokes that blend to a great extent. Go over the drawing of the window on the left and the contrasts of the colonnade with a darker tone than the ones used till now. Some carmine tones are painted on the lower right side. Before they are completely dry you must move on to the next stage.

The colors superimposed on top of wet colors merge into each other.

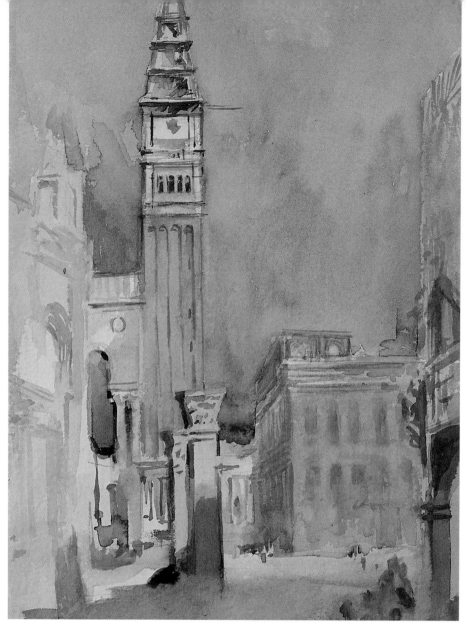

9. *Burnt umber is painted around the carmine tones and blends into them. Draw on the tower the vertical strokes that define it and finish off contrasting the entrance of the building on the right. Finally, all that remains to be done is apply a small touch of color to the lower part of the shadow and add nuances where the contrast can be intensified. The similarity with the original is very close, although rather than do an exact copy, what has been attempted is to experiment with the principal techniques that Turner put into practice. The differences in brushstrokes between the original and the finished work can be explained by the degree of absorption of the paper and the drying times of the wet layers. Moreover, there are more similarities than differences. Of course, the style, the brushwork, and the expression are unique to each artist.*

SUMMARY

The sketch is done beforehand in pencil, setting out the forms of all the buildings.

A first, almost transparent, yellow wash covers all the urban landscape and will be a support for the other, darker, colors.

The background color shows through in the upper part of the tower.

The sky is painted with successive layers of blue, every application becoming darker.

The windows of the building in the background are suggested on top of the almost wet background.

The way they painted
Henri de Toulouse-Lautrec
(Albi 1864-Malromé 1901)

La belle Hélène

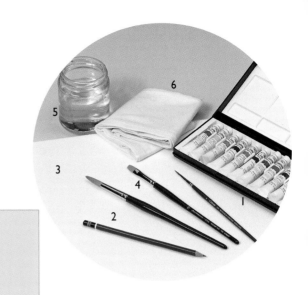

Two accidents that he suffered in his adolescence left this artist scarred and injured for life. He led a bohemian life in Paris, where he fell under the influence of Bonnat and Degás. He hung out in cafés, theaters, music halls, and brothels, where what he saw and the people he met became an important source of ideas. His works, excellently drawn, are characterized by the spontaneity of the brushstrokes and the expression and freedom of movement.

This watercolor proves that simplicity can be a solid base for a painting. In this exercise the aim is to practice one of the most difficult decisions to make. However, it is also simple: how to know when a painting is finished. Often a not too experienced enthusiast, when practicing, becomes desperate when they see that the work which was progressing well has become so saturated that it is almost completely spoiled. The secret of success in painting, in great part, lies in knowing when to stop: only painting what is necessary.

Besides practicing the synthesis of the forms and applying colors, we will also study how the most transparent layers work on the white of the paper and the superimposition of brushstrokes with the background.

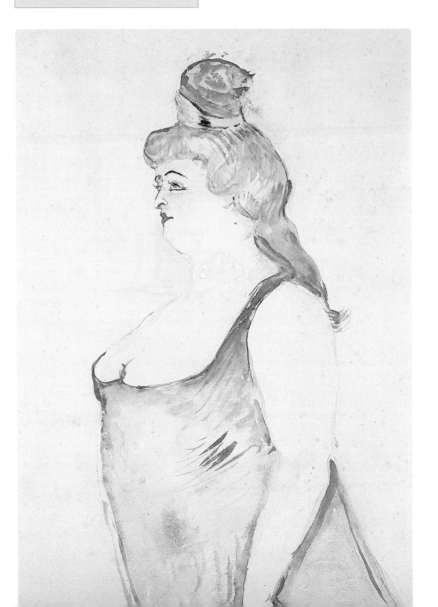

2. *Once the drawing is completed, a very transparent layer of color is applied homogenously over all the picture. This color is yellowish, a mixture of ochre and yellow. Despite being highly transparent, this first layer changes the luminosity of the paper. The colors that will be applied afterwards will be affected by this base tone. This layer must be dried before continuing, for any addition on the wet background will make the tones blend. This is not the objective.*

1. *Although you could start right away with watercolor, as has been done on other occasions, in this case, in which the transparency of the colors is intense, it is wiser not to do so for some zones must be reserved next to others slightly darker. It is important that the drawing is well defined before starting to paint and also that the brushstrokes are extremely clean. This is because, owing to the transparency of the work, any badly placed pencil line can be perceived.*

In all watercolor work, the initial drawing is a vital guide so that later developments find a good structure into which to fit.

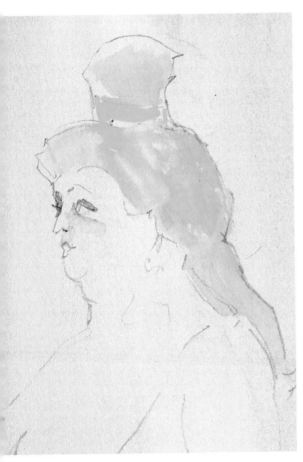

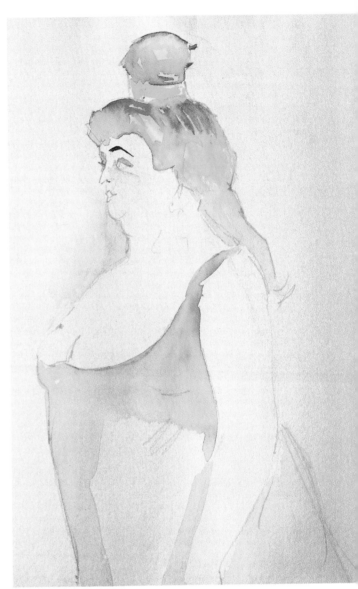

3. *Once the background color has dried, the first base color is painted, which here corresponds to the first layer of the hair. The woman is blond. This hair color uses a luminous yellow as the base, although it is much less transparent than the background. Observe the difference between the painting of a general coat (in the background) and the other more specific layer that is put down now. Not all the hair is painted with the same intensity; the color is applied with different transparencies and qualities, allowing in some zones that the background of the paper shows through completely.*

4. *Paint the upper area of the fringe in cadmium red and add a few brushstrokes of burnt umber to the back of the head. In this zone the background has already dried, and therefore some yellow reserved areas show through. The picture is allowed to dry and another wash is applied around the figure to make the color of the skin stand out from the background. The features of the face are painted with transparent sienna. This work must be carefully done so that the colors do not mix with each other. The dress is painted with a very transparent red wash and the most luminous zone is left unpainted. The following steps must be done quickly so that there is no break in the blending of this area with the background.*

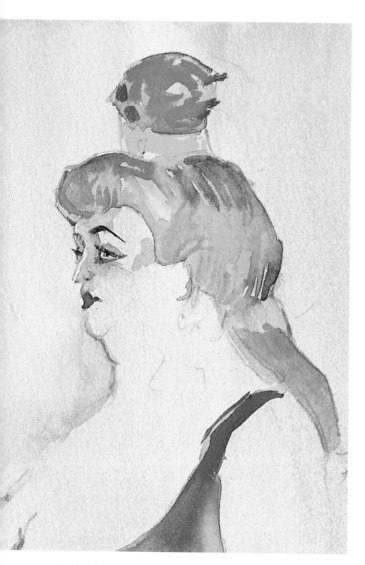

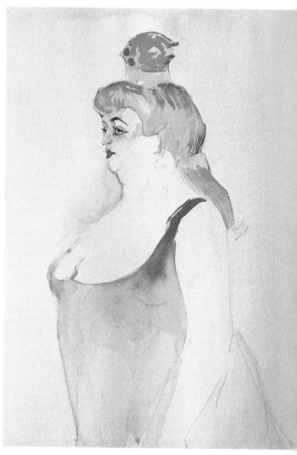

6. With a slightly wet brush, go over the dress unt/
the bright area starts to blend into the background
As the dress has been dampened, it is possible to
introduce a redder and denser tone to the shoulde/
strap. Start to apply red to the upper part. I/
will blend due to the moistness of the paper

5. The face and the hair are the areas which
involve the most complex work, above all, the
white reserves on the face. It is important that the
sienna tones and the eyebrow, painted before, are
completely dry, otherwise the colors will mix. The
shadows of the face are painted with a transparent
sienna and the brightest parts are left blank. The
eyelashes are painted once this shadow is dry. The
hair is enhanced by adding sienna and orange.

Using high quality paper is
very important because with
ordinary paper merging colors
is practically impossible once
the color has dried.

7. *Focus your attention on the dress while it is still drying. This is especially delicate as the effect that you want to achieve is one of successive layers that are superimposed with free brushstrokes, without the colors blending together, so as to get adequate volume. However, in spite of the work on the hair and the delicacy with which it must be treated, this area is not very difficult, provided that the drying times of the previous layers are respected.*

8. *The arm and a large part of the flesh of the chest and the face have been reserved since the beginning of the exercise. This color is the first coat on the paper. With red mixed with a little carmine the outline of the dress is reinforced in the area of the breasts. In the part surrounding the form of the arm, paint with a cadmium red wash, without penetrating into the arm, which will now be perfectly outlined. Once again a transparent sienna wash with which to paint the background is prepared. Leave the right side a little darker so that it contrasts with the back of the figure.*

When putting down layers on the background, it is always prudent to start with the lightest tones and then, afterwards, if necessary, to intensify them progressively with successive layers of color.

9. *When the background is completely dry the strokes that give texture to the cloth of the dress are painted. This last step requires special mastery of the paint and of the brush as the wet paint must be combined with very defining stokes. The colors that are used on this part of the dress are carmine and cadmium red, always very transparent, respecting the parts that contain the highlights. The creases of the cloth are painted with firm strokes. Now the painting is finished. The similarity with the original is close. It must be emphasised that the object of the exercise is, above all, to interpret the technique of the great painter.*

SUMMARY

The initial drawing must be as clean and as precise as possible as all the color additions that will be done later will be very transparent.

The background is painted with a very transparent yellow tone so as to soften the white of the paper.

The base color of the hair is yellow. On this the darker colors are applied, although in different reserved zones the yellow comes through.

The dress is painted in successive layers of red and carmine, leaving luminous zones as reserves in the lower layers.

The way they painted:

Marià Fortuny
(Reus unknown-Roma 1874)

An Andalusian House

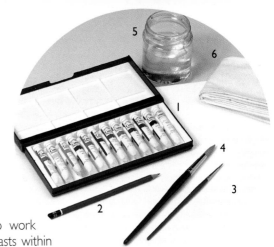

Among his more convention-al pictures and etchings there are figures that remind one of Goya while the very original chromatic effects stand out. His color palette is very luminous and so explosive that he has been associated with Impress-ionism, although within the art world he has been considered to be academic and pretentious.

This exercise allows you to work with whites and shadow contrasts within the zones or spaces structured by the walls of the building. In general, rural or village houses with a fresh and clean aspect are selected. This is what Marià Fortuny did to paint this magnificent watercolor.

In this exercise the complexity does not lie in the techniques used but in when to use them and in observing the drying times of each intervention.

MATERIALS
Tube colors (1), pencil (2), watercolor paper (3), watercolor brushes (4), water jar (5), and a rag (6).

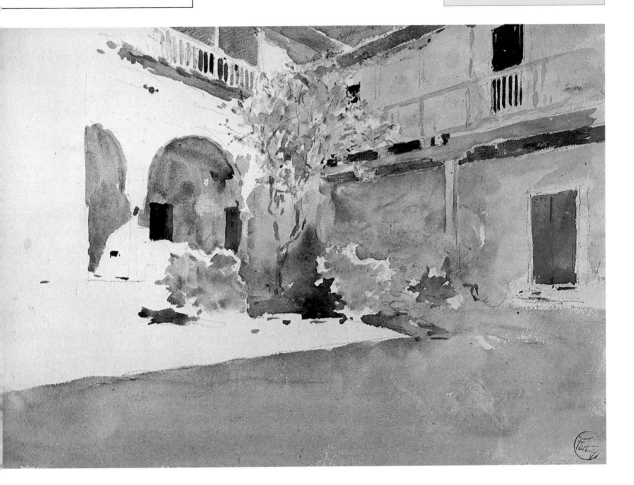

STEP BY STEP: *An Andalusian House by Marià Fortuny*

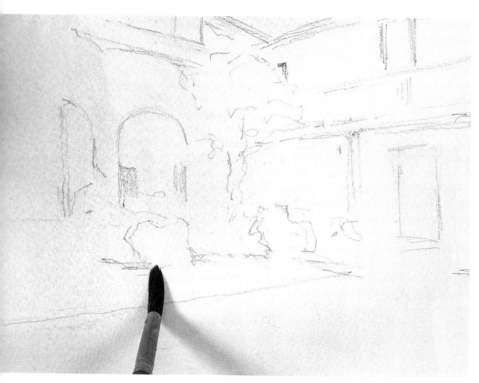

1. *If the subject appears very simple it is because Fortuny started from a perfectly defined drawing. Only in this way is it possible to apply each color in its exact place. The drawing has to be clean. Define with the minimum stroke expression the planes and the objects therein, like the tree, the plants, or the openings of the doors, arches or windows. Once all the patio has been drawn, paint an almost transparent ocher in the most illuminated area, so as to soften the excessive whiteness of the paper.*

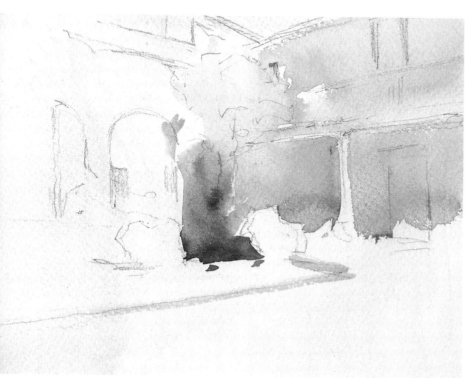

2. *Start painting the upper part of the shadow. In this area there will be the greatest number of color tones, always very transparent and carefully situated so as to outline and define the most luminous zones, like the column in the corner on the right, or the tone differences between the background and the upper part of the wall in the shadow. The tree is situated with a transparent green tone. Below it, the darkest part of the patio is painted with burnt umber.*

3. *Paint part of the patio with burnt umber and a little blue to cool the tone. This color establishes the principal light areas in the picture. It has to be painted in one go so that there are no borders to the color. Each one of the areas that has been painted respects the drying times of the adjacent areas. Here, however, part of the dark tone is brushed towards the wall on the right, permitting the color to play a role in the texture of the wall.*

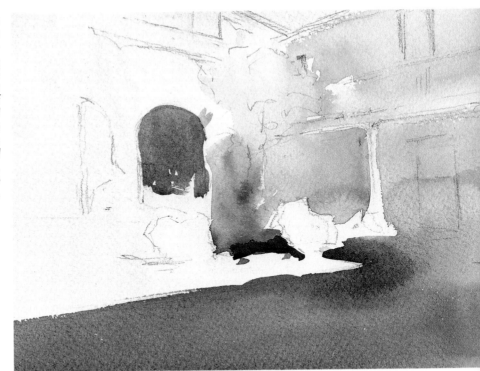

4. *By perfectly molding the shadows to the drawing, not only is the necessary depth given to the little patio, but also the column and the wall on the left are defined. The painting of the shadows of the upper floor is done in sienna. However, in this area the luminous zones must be carefully reserved for the clear spaces which define the balustrade.*

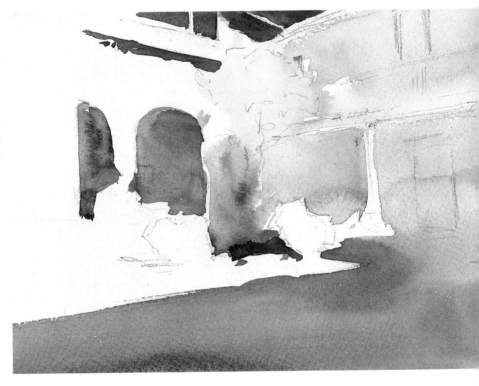

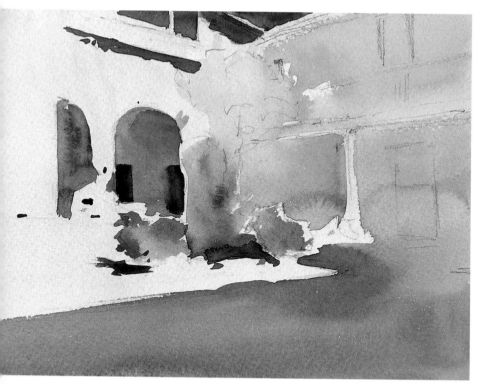

5. *Paint the darkest zones of the interior of the house. Within the shadow zone, on the left, the darkest entrances to the rooms are painted. In the patio, the plants are painted in luminous green. Every clump of green is painted with different intensities of the color.*

> Each part of the picture is painted when the adjacent zones have dried completely. This is fundamental so that the tones of each of the zones do not mix.

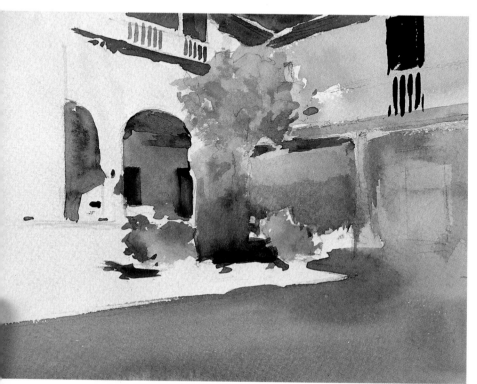

6. *Transparent sienna is used to paint the dark parts of the upper floor and the roof. In the interior of the passage, the dark areas are intensified with layers of sienna. The tree is painted with different tones of green, always of the dry background. The bars of the balustrade are defined by the shadow that is painted behind them, through which the passage is suggested. On the right, the door is painted in brownish gray. The bars of the balustrade are also defined.*

7. *Before the balustrade of the upper floor is completely dry, some of the brownish gray is taken off with a quick clean-up with the wet brush. Then the bars are barely suggested by the strokes of sienna that are mixed and blended on top of this wet background. The shadow on the upper floor above the corridor is painted with very dense burnt umber. A transparent wash of this same color darkens this area, leaving the column unpainted.*

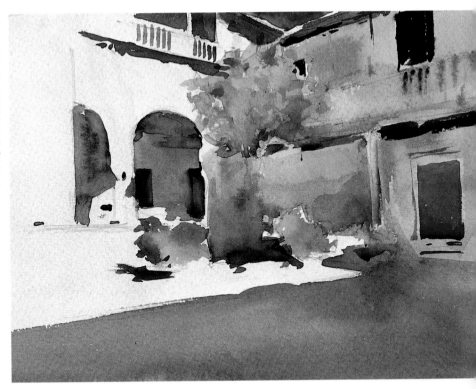

8. *The main part of the floor on the upper storey is painted with sienna which blends into the base color. The tree trunk is depicted in burnt umber, with a thin and curved brush-stroke, cutting across the brightest areas. Continue to paint the soft contrasts that shape the top of the tree with different additions of green.*

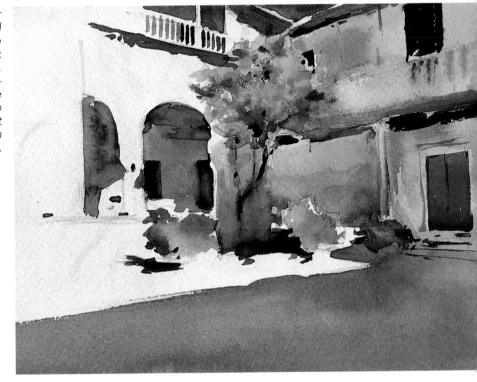

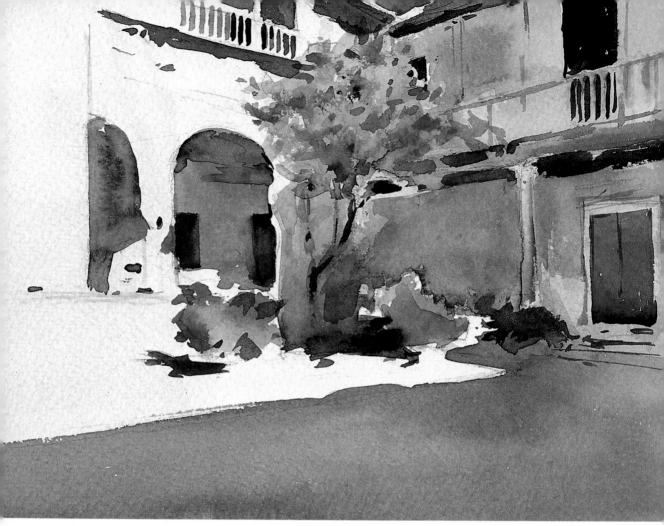

9. *The upper floor balustrade is painted with a very luminous green mixed with sienna. The brushstrokes are not continuous, they stand out in the areas that would otherwise be luminous. The same tone is used to paint* the lines of the embellishments. Once again the dark behind the bars of the balustrade and of the door in the background are repainted. This finishes off the work.

SUMMARY

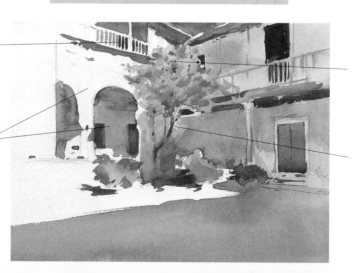

The railings are defined by the darkness of the shadow behind them.

The backlight means that the light zones are clearly defined in two areas; one completely white and the other where the shadows give form to the planes and darknesses.

The top of the tree is painted in several tones of green, always on the dry background, so that the brushstroke can be controlled with precision.

The tree trunk is painted with burnt umber. The brushstroke is fine and breaks up in the most illuminated zones.

The way they painted:

Emil Nolde
(Nolde 1867-Seebüll 1956)

Flowers

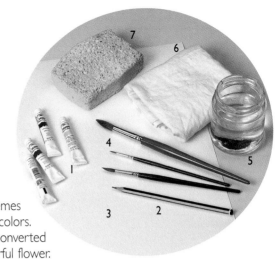

Nolde is the pseudonym of the German painter Emil Hansen. His style recalls that of Van Gogh and Ensor, painters for whom he felt a great admiration. Many of his paintings, full of religious scenes that in their day caused much scandal because of their sensuality, abound in striking colors and expressionist forms.

Flowers are one of the themes that gives most play in a watercolors. A simple green shadow is converted almost by art into a fresh, colorful flower. This allows the development of very gestural pieces, full of vigor and color, as in the present example. This exercise aims at doing rapid, enjoyable work that gives a very effective result.

Once again, it is not a question of copying the model, but rather of trying to understand the technique that the artist used.

MATERIALS
Tube colors (1), pencil (2), watercolor paper (3), watercolor brushes (4), water jar (5), rag (6), and sponge (7).

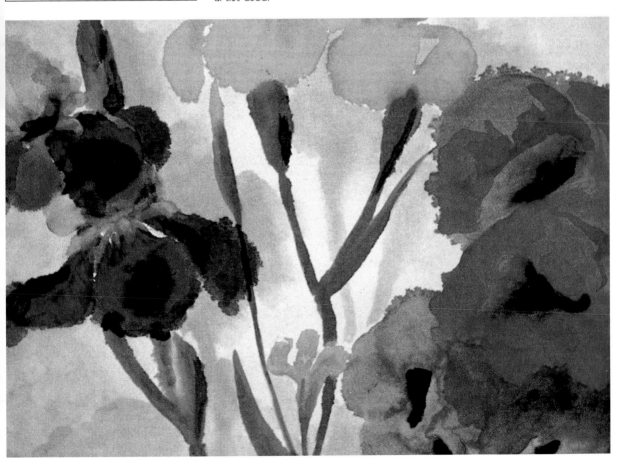

STEP BY STEP: *Flowers* by Emil Nolde

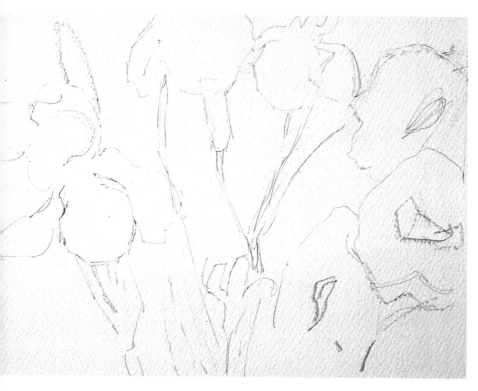

1. *It is certain that Nolde did not start painting from a pencil sketch, but this is what we opt for here as it will be easier to follow. What must be sought after in the drawing is the proportion between the forms that will become flowers. Although we are not trying to obtain an exact copy of the model, just an interpretation of the artist's painting style, try to be as exact as possible. A subject painted by another artist is as valid as any photo or natural model.*

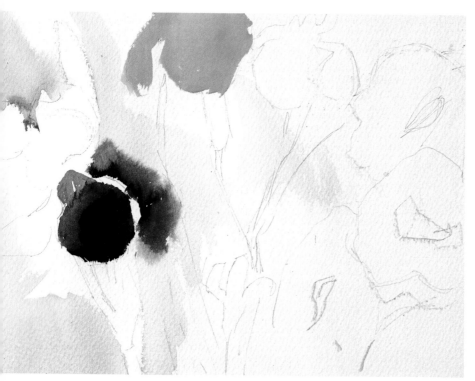

2. *First, a very transparent violet wash is put down over the background, leaving reserved spaces for the white of the paper or to separate shades that must not be blended. Bearing this in mind, the painting of the violet flower is started. The central part of the flower coincides with an area that is untouched by any wash, thus allowing painting with precision. Just to the right, the blended petal seen in the illustration is painted. The color mixes immediately on top of the wet background. Start painting the yellow flowers in the upper section.*

3. *In the center of the flowers a very luminous, almost transparent red tone can be seen. On this color, darker coats can be perceived, as well as much more precise brushstrokes. The red flower in the upper section has the most tones of red. To paint it, it is first necessary to give it a transparent wash and allow it to dry before applying the second layer. The lower flower is painted with a much more opaque red tone. The flowers on the bottom right are painted in shades of violet. In doing this, a part of the color of the red flower is blended in.*

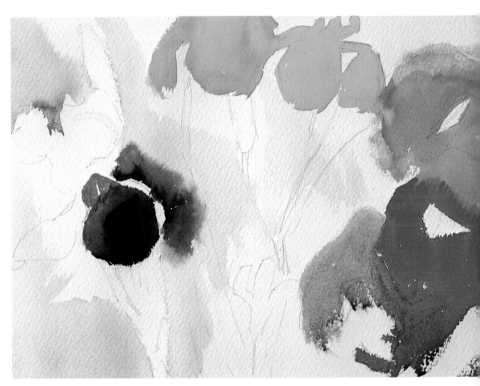

4. *With a somewhat dirty violet tone, this area is completed, allowing the different tones to blend together. Black is used to paint the center part of the poppies on the right, and red tones are superimposed on the already dry first layers. Paint the upper part of the first flower, slightly pressing down with the point of the brush. The same yellow color that was used for the flowers is also used to sketch in the stems. Before these dry, go over them with green brushstrokes and let the color mix in for most of the stroke.*

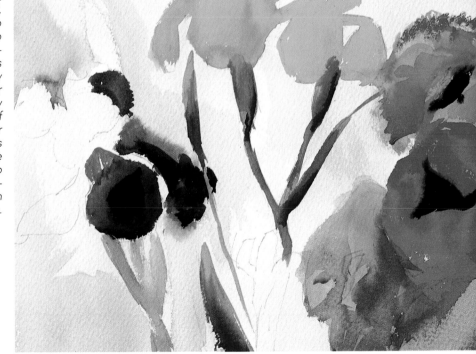

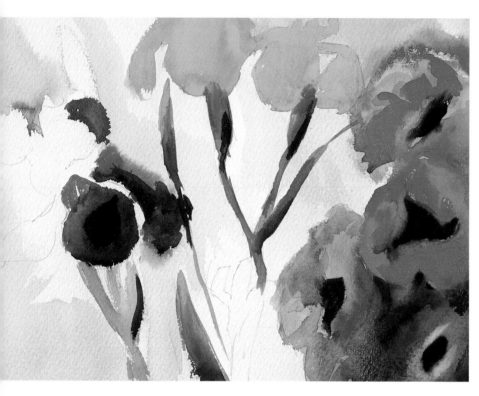

5. *The principal painting of the picture is complete. Now the first contrasts that separate the flowers can be painted. The background of the flowers must not be completely dry if you want to achieve an effect similar to Nolde's. To create the dark shadows use a very dense cobalt blue. As for the flowers lower down, just below the poppies, some of the red color is blended in to get a violet tone. Black is used to paint the darkest part of the flowers.*

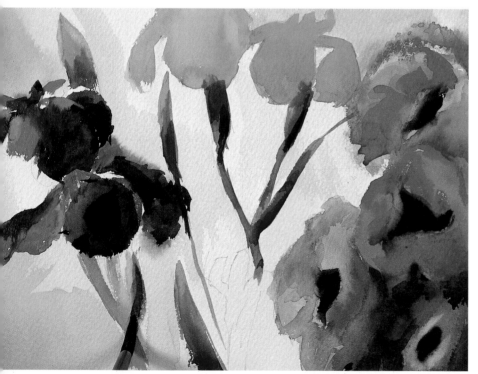

6. *Next to the lilac-colored shadows on the left of the picture, the petals are painted in a strong orange color. But first, make a splash of very dense golden yellow so that the color that is painted on afterwards has a firm base on which to mix. Then, superimpose cadmium red brushstrokes. When they mix, they become a luminous orange. Before the orange tone is dry on the paper, paint the violet again, allowing the color to mix with the lower tones that are still wet.*

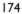

7. *Allow everything to dry before applying layers that darken the background so that these will not alter the colors by blending. When the background is dry, paint it with a violet tone, somewhat stained by sienna to make the tone much warmer. This shade is painted on the layer that was painted in the beginning. It does not encroach on the most luminous colors.*

Yellow is one of the colors that permit the most luminous staining.

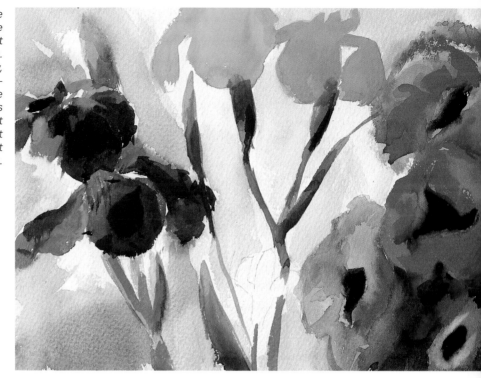

8. *Continue working on the flowers on the left, giving the petals form with somewhat darker tones, but without contrasting too much with the previous colors. The only remaining flower, which is still outlined in pencil, is painted with the same yellow as was used to paint the flowers in the upper section. As can be seen the final retouches do not have to be too obvious.*

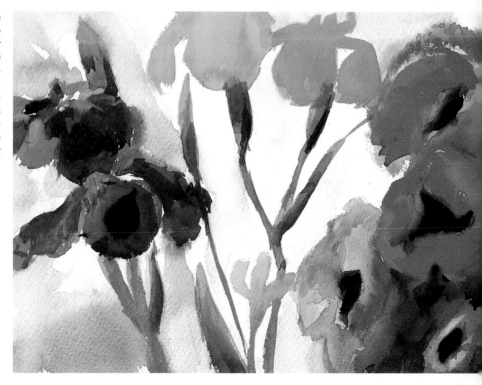

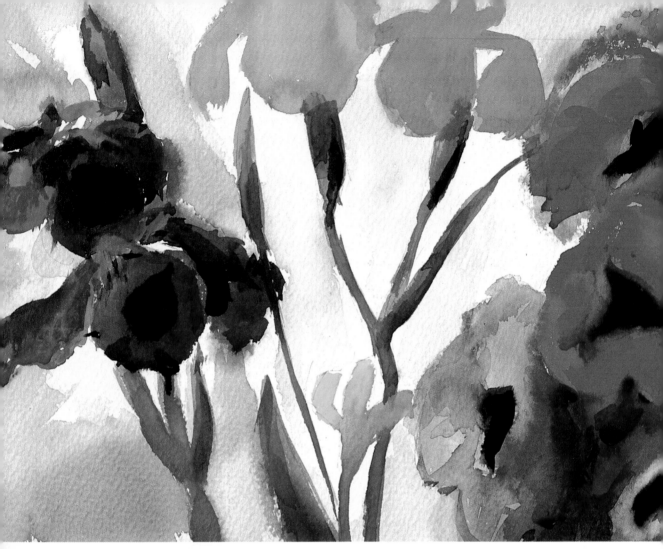

9. *All that remains is to darken the orange petal on the left a little. This contrast is obtained by violet paint that is complemented by the original orange. On top of the violet flower, a new layer of the same color is applied, and it is allowed to blend* *in with the green stem. These final retouches finish off this interesting gestural work. Once the piece is finished it is important to reflect on the steps that have been taken and how the work of the artist has been interpreted.*

SUMMARY

The first application of color is the violet layer on top of which the violet flowers on the left are painted.

Next to the lilac color on the left, the petals are painted in a strong orange.

The poppies are painted in several phases; first, with a very light wash and then afterwards in denser tones.

The painting of the stems is started in yellow. Before the zone dries, the brushstrokes are gone over with green.